# A TRIBUTE TO ROBERT A. KOCH

## STUDIES IN THE
## NORTHERN RENAISSANCE

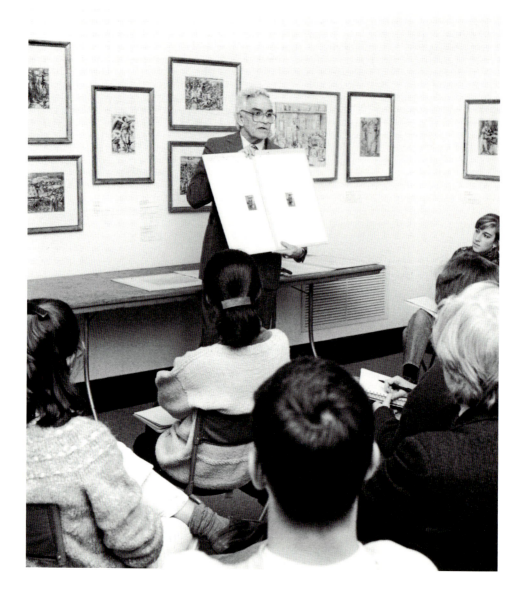

# A TRIBUTE TO ROBERT A. KOCH

## STUDIES IN THE

## NORTHERN RENAISSANCE

DEPARTMENT OF ART AND ARCHAEOLOGY

PRINCETON UNIVERSITY

Copyright © 1994 by the Trustees of Princeton University
Published by the Department of Art and Archaeology,
Princeton University, Princeton, New Jersey 08544-1018

*Library of Congress Cataloging-in-Publication Data*

A tribute to Robert A. Koch : studies in the northern Renaissance /
Gregory T. Clark . . . [et al.].
p.   cm.
Includes bibliographical references.
ISBN 0-691-04340-X
1. Art, Renaissance—Europe, Northern.   2. Art—Europe,
Northern.   I. Koch, Robert A., 1919–   .
II. Clark, Gregory Thomas.
N6370.S78   1995
709′.02′4—dc20   94-22519

This book has been composed in Linotron Sabon.

Books published by the Department of Art and Archaeology are
printed on acid-free paper and meet the guidelines for permanence
and durability of the Committee on Production Guidelines for
Book Longevity of the Council on Library Resources.

Printed in the United States of America by
Princeton Academic Press, Princeton, New Jersey 08540

1   3   5   7   9   10   8   6   4   2

# Contents

# Acknowledgments

THE IDEA OF HONORING Bob Koch began even before his retirement from the Department of Art and Archaeology in 1990. The initial proposal, for a symposium in Northern Renaissance art in Bob's honor, attracted no small measure of enthusiasm and support, spearheaded by his dedicated former students, who were eager to express their thanks to him in a public forum. So it is fitting that this volume should begin with an acknowledgment of those who supported our efforts in the early stages: James Mundy, Andrew Robison, Charles Talbot, and Joel Upton.

The seeds of that early proposal have now happily blossomed into the present volume, for which I have served as a kind of coordinator. But the real credit must go to all those whose efforts made this festschrift a reality. Most of all, we thank the authors for their contributions and their patient faith. We also acknowledge the considerable contribution of Jody Hoppe, who edited Burr Wallen's paper, and the assistance of Larry M. Ayres. We sincerely thank the four anonymous individuals who read this manuscript. We are also grateful for the generous support of three successive chairmen of the Department of Art and Archaeology, Yoshiaki Shimizu, John Pinto, and John Wilmerding, as well as the director of The Art Museum, Allen Rosenbaum. James Marrow deserves our special thanks for his considerable advice and influence in bringing this book into being. We gratefully acknowledge as well the financial support of the Publications Committee of the Department of Art and Archaeology, which underwrote the costs of publication. The book was very ably edited and guided through the process of publication by Christopher Moss, the department's editor of publications, and Katherine Kiefer, editorial assistant. We also thank the staff of Princeton University Press, particularly Anju Makhijani and Betsy Litz, for their good advice at many stages, and Carol Starnes, for her fine work on the design of the book.

Although Bob has known of our plans from nearly the beginning (and responded graciously to our requests for bibliography, photograph, advice on bindings, etc.), the contents will be a surprise to him.

We present this tribute to you, Bob—mentor, colleague, and friend—with great affection, in celebration of your 75th birthday, November 23, 1994.

BARBARA T. ROSS
ASSOCIATE CURATOR OF PRINTS AND DRAWINGS
THE ART MUSEUM, PRINCETON UNIVERSITY

# Introduction

THE ARTICLES IN THIS VOLUME constitute a *florilegium* offered by some of the many students of Robert Alan Koch, known to his friends and colleagues as Bob. Six of the authors wrote their doctoral dissertations for Princeton University under Bob Koch's tutelage; two others—Lynn Jacobs and the late Burr Wallen—were Princeton undergraduates who were inspired by Bob's teaching and went on to write dissertations in northern Renaissance art for the Institute of Fine Arts, New York University.

In June of 1990, after more than forty years of teaching, Bob retired from the Department of Art and Archaeology and attained the rank of Professor Emeritus. In 1994 he celebrates his seventy-fifth birthday. We hope that this bouquet of tributes will make its appearance in time for that event, but, as any gardener knows, the most interesting and beautiful flowers often bloom when and where they want.

Although it is perhaps difficult to think of Bob apart from the environs of Princeton, his origins lie further below the Mason-Dixon line than southern New Jersey. He was born in Durham, North Carolina, on November 23, 1919. In western astrology he is a Sagittarius yet virtually on the cusp of Scorpio; the archer's straightforward honesty and love of the outdoors are tempered by the scorpion's darker realism. In the Chinese astrological system 1919 is the year of the Sheep, whose inhabitants are born connoisseurs, gentle and compassionate, but inwardly determined.

Bob Koch belongs to that significant generation of American art historians whose early lives were shaped by the events of the 1930s and '40s. He received his B.A. degree in 1940 and M.A. degree in art history in 1942 from the University of North Carolina at Chapel Hill. As it did for many, the Second World War disrupted his academic career, yet, ironically, it was the war that provided first-hand exposure to works of art in Europe. Bob served in the U.S. Army from 1942 to 1946 and was stationed in Germany and France as a first lieutenant in the Division of Monuments, Fine Arts, and Archives.

Bob's association with Princeton University began after the war, and he lost no time in earning his M.F.A. degree in 1948, followed by his Ph.D. in 1954. The subject of his dissertation was the central portal sculpture of the church of Saint-Maurice at Vienne. In 1949 he joined the faculty of the Department of Art and Archaeology, becoming a full professor in 1966. At the same time, he was

assistant director of the Princeton University Art Museum from 1949 to 1962, and faculty curator of prints from 1962 until his retirement.

This rather dry recitation of his *curriculum vitae* only hints at the variety and magnitude of Bob Koch's accomplishments. For more than four decades Bob has been a superb and inspiring teacher of undergraduates. Both in the classroom and in museums he has introduced countless students to the wonders of northern Renaissance art. One of the most sought-after undergraduate courses at Princeton was the one Bob offered on the history and connoisseurship of prints taught entirely from original works of art in the collection of the Art Museum.

Bob's graduate seminars were equally outstanding, combining rigorous intellectual investigation with delight in the individual work of art, examined at first hand whenever possible. I still remember the excitement and privilege of studying Petrus Christus's *Saint Eloy* in Robert Lehman's Manhattan townhouse in 1970, long before the paintings went to the Metropolitan Museum of Art. The trip was, of course, arranged by Bob as part of a seminar on Petrus Christus. As an advisor Bob was at once exacting, informative, and unfailingly sympathetic to the emotional and financial anxieties that are part of being a graduate student in a world of increasing competition and diminishing opportunities.

Writing with grace, clarity, and wit, Bob has significantly enlarged and deepened our understanding of painting, drawing, and graphic art in northern Europe during the Renaissance. His articles on plant and animal symbolism in the art of Hugo van der Goes are classics of their kind, while his monograph on Joachim Patinir, the standard reference on this artist, is an elegant and accessible distillation of years of thought and research. In both his teaching and his scholarship, Bob's mastery of the material makes it look easy; the famous "aw shucks" with which he responds to praise masks the hard work.

On a personal note, one of the reasons I applied to Princeton was Bob Koch's reputation both as a teacher and as a leading authority in what was to be my new area of specialization. His career embodies the greatness of Princeton's art history program: a commitment to superior undergraduate instruction combined with specialized research and the preparation of graduate students for professional careers. To be sure, this tradition continues, but, from the vantage point of my generation, I think that the achievement of Bob Koch and his "litter mates" from the graduate classes of the late 1940s and early '50s, such as John Rupert Martin, David R. Coffin, and Wen C. Fong, has not been surpassed.

To the fortunate delight of all that know him, Bob Koch's interests extend in many directions. His knowledge of plants and flowers, stamp collecting, shells, animals, and myriad other things is offered enthusiastically and infectiously. As a result, Bob is capable of quicksilver segues from Jean Fouquet's *Madonna and Child* to the availability of Indian River grapefruit. He worries about why there

is no Saint John's wort in Rogier van der Weyden's Saint John Altarpiece. Aided perhaps by a theatrical gene on his father's side, Bob is a wonderful raconteur and, as is well known, an incorrigible punster, whether incorriged or not. If Bob knows why ferns protect against the Devil, he also knows that, with fronds like that, who needs anemones. Bob knows that a good pun is its own reword.

In his book *Bosch in Perspective*, the late James Snyder (himself a Koch pupil) observed that "some of the finest and most approachable people one meets in art history" inhabit Netherlandish paintings. In Bob's case we would emend this to say that one of the nicest people one meets in art history studies Netherlandish painting. It is with the deepest affection and admiration that these papers are offered to Robert Alan Koch, *il miglior fabbro*.

JOHN OLIVER HAND
NATIONAL GALLERY OF ART
WASHINGTON, D.C.

# Selected Bibliography of
# Robert A. Koch

"A Mother-of-Pearl Carving after the Master E.S.," *Journal of the Walters Art Gallery* 5 (1942), 119–121

"Two Sculpture Groups after Rogier's 'Descent from the Cross' in the Escorial," *Journal of the Walters Art Gallery* 11 (1948), 38–43, 85

"The Sculptures of the Church of Saint-Maurice at Vienne, the *Biblia Pauperum* and the *Speculum Humanae Salvationis*," *Art Bulletin* 32 (1950), 151–155

"Geertgen tot Sint Jans in Bruges," *Art Bulletin* 33 (1951), 259–260

"A Sacramental Triptych from Spain," *Record of The Art Museum, Princeton University* 13 (1954), 24–32

"A Rediscovered Painting, 'The Road to Calvary,' by Herri met de Bles," *Record of The Art Museum, Princeton University* 14 (1955), 32–51

"An Unrecorded Printed Book of Hours," *Record of The Art Museum, Princeton University* 16 (1957), 18–25

"A Rediscovered Painting by Petrus Christus," *Connoisseur* 140 (1958), 271–276

"Elijah the Prophet, Founder of the Carmelite Order," *Speculum* 34 (1959), 547–560

"A Gothic Sculpture of the Ascending Christ," *Record of The Art Museum, Princeton University* 19 (1960), 37–43

Book Review: L. Behling, *Die Pflanze in der mittelalterischen Tafelmalerei* (Weimar, 1957), in *Art Bulletin* 42 (1960), 236–237

"Flower Symbolism in the Portinari Altar," *Art Bulletin* 46 (1964), 70–77

"The Salamander in Van der Goes' *Garden of Eden*," *Journal of the Warburg and Courtauld Institutes* 28 (1965), 323–326

"La Sainte-Baume in Flemish Landscape Painting of the Sixteenth Century," *Gazette des Beaux-Arts*, ser. 6, 66 (1965), 273–282

*Joachim Patinir* (Princeton, 1968)

"Master E.S. and a Gothic Mother-of-Pearl Roundel," *North Carolina Museum of Art Bulletin* 9 (1970), 58–65

"Saint Anne with Her Daughter and Grandson: Notes on a Late Gothic Sculpture," *Record of The Art Museum, Princeton University* 29 (1970), 8–15

*Hans Baldung Grien: Eve, the Serpent, and Death*, Masterpieces in the National Gallery of Canada, no. 2 (Ottawa, 1974)

"Martin Schongauer's Dragon Tree," *Print Review* 5 (1976), 114–119

[editor] *The Illustrated Bartsch*, vols. 14 (New York, 1980), 15 (New York, 1978), 16 (New York, 1980), 17 (New York, 1981)

"New Criteria for Dating the Netherlands *Biblia Pauperum* Blockbook," in *Studies in Late Medieval and Renaissance Painting in Honor of Millard Meiss* (New York, 1978), 283–289

Exhibition Review: *Hans Baldung Grien, Prints and Drawings*, National Gallery of Art, Washington, and Yale University Art Gallery, New Haven, in *Master Drawings* 19 (1981), 180–183

"The Origin of the Fleur-de-Lis and the *Lilium Candidum* in Art," in *Approaches to Nature in the Middle Ages* (Binghamton, N.Y., 1982), 109–130

"A Reflection in Princeton of a Lost *Epiphany* by Hugo van der Goes," in *Tribute to Lotte Brand Philip* (New York, 1985), 82–87

"The Getty 'Annunciation' by Dieric Bouts," *Burlington Magazine* 130 (1988), 509–516

*Flemish Paintings in America: A Survey of Early Netherlandish and Flemish Paintings in Public Collections of North America* (Antwerp, 1992), 52–53, 70–71, 72–73, 76–77, 104–105, 106–107, 108–111, 132–134

# List of Illustrations

# A TRIBUTE TO ROBERT A. KOCH

## STUDIES IN THE
## NORTHERN RENAISSANCE

# Bosch's *Saint John the Baptist in the Wilderness* and the Artist's "Fleurs du Mal"*

## GREGORY T. CLARK

❧

OF THE MANY ENIGMATIC vegetal forms that wax and wane in the paintings of Hieronymus Bosch, none has attracted as much scholarly attention as the large, globular growth in the foreground of the *Saint John the Baptist in the Wilderness* in the Museo Lázaro-Galdiano in Madrid (Fig. 1).[1] The panel is usually included among the artist's mature works and has been dated between about 1500 and 1510.[2]

The identifications and interpretations offered for the growth have been both numerous and surprisingly heterogenous. Some have considered it to be an entirely fantastic creation, while others have identified it with forms as disparate and improbable as eggs, mandrake berries, gourds, and calabashes.[3] Most

---

* This study began as a paper for a graduate seminar on plant symbolism in northern European art conducted by Robert A. Koch at Princeton University in the spring of 1980. A shortened version of that paper was delivered at The Frick Collection, New York, in April of 1982. I would like to thank Walter Gibson, Jeffrey Hamburger, Robert A. Koch, James Marrow, and John Plummer for critical readings of earlier versions of this study and David Loggie of the Pierpont Morgan Library for his help with photographs.

[1] For this painting, see most recently René Graziani, "La planta del *San Juan en el desierto* del Bosco," *Archivo español de arte* 56 (1983), 379–382; and Roger H. Marijnissen with Peter Ruyffelaere, *Hieronymus Bosch, The Complete Works* (New York, 1987), 394–397.

[2] For the dating, see Charles de Tolnay, *Hieronymus Bosch* (New York, 1966 [orig. ed. Basel, 1937]), 367–368; and Walter S. Gibson, *Hieronymus Bosch* (New York, 1973), 154–155.

[3] The growth was described as fantastic by both de Tolnay, *Bosch* (as in note 2), 36–37; and Ludwig Baldass, *Hieronymus Bosch* (New York, 1960 [orig. ed. Vienna, 1943]), 24, 41. In contrast, Wilhelm Fraenger believed the form was an egg ("John the Baptist, a Meditational Painting for the Community of the Free Spirit," in *Hieronymus Bosch* [New York, 1983], 227–246; originally published as "Johannes der Täufer. Eine Meditationstafel des Freien Geistes," *Zeitschrift für Kunst* 2 [1948], 163–175); Robert Delevoy thought it might be the fruit of the mandrake (*Bosch* [Geneva, 1960], 121); Jacques Chailley described it as a gourd (*Jérôme Bosch et ses symboles: Essai de décryptage*, Académie royale de Belgique, Mémoires de la classe des beaux-arts, 2 série, tome 15, fascicle 1 [Brussels, 1978], 195–196); and René Graziani thought that it was a specific North African calabash, *Citrullus colicynthis* ("La planta del *San Juan*" [as in note 1], 379).

interpreters have seen the growth as a symbol of concupiscence, a Baudelairean "fleur du mal."[4] On the other hand, at least two interpreters have argued that the form was at the same time a positive symbol of natural regeneration.[5]

---

However, it is difficult to reconcile the globular shape, gray white color, and fissured surface of the Lázaro-Galdiano growth with the egg's ovoid shape, the mandrake berry's yellow color, the gourd's unfissured rind, or the calabash's longitudinal striations.

[4] De Tolnay, *Bosch* (as in note 2), 36–37, described the composite plant as a whole as a symbol of the "evil path" of "carnal joys" which the artist contrasts with the "good path" embodied in the lamb, symbol of Christ. In this way "the painter . . . sets the saint before the alternative of the good and evil path." Baldass, *Bosch* (as in note 3), 41, specifically described the fissured growth as a "fruit of evil" and compared it with the two "flowers of evil" which sprout from the thorny plant above the outer portal of Paradise in the left panel of the Haywain Triptych in the Prado. De Tolnay's and Baldass's interpretations were accepted by Gibson, *Bosch* (as in note 2), fig. 139; and Rosemarie Schuder, *Hieronymus Bosch* (East Berlin, 1975), 59–60.

In a similar vein, Jan V. L. Brans described the composite plant as a mandragora, symbol of carnal lust ("Los ermitaños de Jerónimo Bosco: San Juan Bautista en el desierto," *Goya* 4 [Jan.–Feb. 1955], 196–201); and Chailley, *Jérôme Bosch et ses symboles* (as in note 3), 195–196, interpreted the plant as a symbol of the "sins of the world." In contrast, Delevoy, *Bosch*, (as in note 3), 121, identified the entire composite plant with the tree mentioned in Luke (3:9) and Matthew (3:10) which did not bring forth good fruit and had to be cut down; while Graziani, "La planta del *San Juan*" (as in note 1), 381, felt that the plant's bitterness alluded to the coming passions of both the Baptist and the Lamb.

[5] One of those interpreters was Patrik Reuterswärd (*Hieronymus Bosch*, Acta Universitatis Upsaliensis, Figura Nova, Series 7 [Uppsala, 1970], 37–38, 150–160), who compared the fissured growth with the round form resting on a column and supporting a pagan idol in the *Flight into Egypt* painted by an anonymous Netherlandish artist around 1510 for a *Schnitzaltar*, today in the parish church of Valö, Sweden (here, Fig. 13). In his view, the botanic nature of the Valö form was demonstrated by the branch that pierces its side, and its unsavory character made clear by the cloud of black powder, the numerous black birds, and the single toad which escape from an opening in its surface at the holy family's passing. Given the resemblance between the Lázaro-Galdiano and Valö forms and the unkempt, uninviting appearance of the Lázaro-Galdiano plant as a whole, Reuterswärd conceded that the latter must have struck Bosch's contemporaries as somewhat sinister.

In contrast, Reuterswärd believed that the two growths over the door of Paradise in the left wing of the Haywain Triptych in the Prado were symbols of natural regeneration and of God's command in Genesis (1:22, 28) to all living things to "increase and multiply." This interpretation of the two growths was suggested both by their location and by their "warm" coloring, which Reuterswärd contrasted with the pale, deathly pigmentation of the mushroomlike growth atop the mound of earth at the far right in the triptych's middle panel. Since Reuterswärd also considered the fissured growth at the center of the Lázaro-Galdiano panel to be warmly colored, he wondered whether that plant might also have had a positive as a well as a negative connotation. (R. Gordon Wasson has specifically identified the growth in the Haywain's middle panel as a *Boletus satanus* mushroom: "Bliksemstralen en paddestoelen: Studie over een oud cultuurverschijnsel," *Antiquity and Survival* [Nederlandse uitgave] 3/1 [1960], 73.)

The second interpreter, Hans Holländer (*Hieronymus Bosch, Weltbilder und Traumwerk* [Cologne, 1975], 106–109), observed that fantastic flora like those in the Lázaro-Galdiano and Prado panels never grow in such sinister locations as hells, but instead are always found in landscapes. In Holländer's view, this peculiarity supported Reuterswärd's thesis that such plants could not have had an exclusively negative meaning. Holländer specifically proposed that the Lázaro-Galdiano growth was a symbol of the physical world, and especially of its endless cycle of death and renewal, while the lamb represented the spiritual world, and more specifically the continuum which began with the coming of the Savior and which will end in the faithful's final redemption at the Last Judgment. The Baptist thus presents the viewer with the choice between the earthly and heavenly roads and indicates with his pointed right index finger the more fruitful one.

In my opinion, Reuterswärd's belief that the grayish white pigmentation of the fissured Lázaro-Galdiano growth suggests vitality and regeneration is not especially convincing, since that hue could equally be associated with overripeness and decay. Similarly, Holländer's observation that fantastic plants like that in the Lázaro-Galdiano panel are found only in landscapes need not preclude a negative interpretation of the plant,

In this study I will present what I believe to be a more probable model both for the Lázaro-Galdiano growth and for the similar forms in two other paintings by Bosch. I will also propose models for two other vegetal growths in the same three panels. Finally, I will seek to demonstrate that the physical characteristics and popular names of Bosch's models make it possible to suggest more plausible interpretations both for the individual forms in the three paintings and for the group of works as a whole.

The Lázaro-Galdiano growth is joined by a desiccated brown involucre to a round, spiny stem which emerges from a patch of dense, verdant brush in the painting's center foreground (Fig. 2). The plant is considerably larger than the head of the Baptist, who lies just behind the patch of verdant brush, and so heavy that the stem bows from its weight. A small section of the growth's grayish white, fissured outer surface has fallen away to reveal an inner mass of reddish, seedlike pellets, some of which have spilled out onto the elliptical leaf beneath it. A tiny bird perches on a branch which curves around and beneath the growth, feeding on its contents.

The growth closely resembles the common fungus known as the giant puffball (*Lycoperdon maximum*; Fig. 4).[6] Round or ovoid in shape, the giant puffball roots directly in the soil and frequently attains a diameter of ten inches or more (Fig. 5). The waxing fungus is white and pleasant of odor, with a smooth outer surface and a firm inner mass which is excellent for eating.

Once the puffball reaches its full size, however, its outer surface turns hazel-white and splits irregularly from the top into fragments resembling paving tiles (Fig. 6). These eventually fall away to reveal an off-white inner covering which turns yellow and finally gray. At the same time, the inner mass becomes yellow and flaccid, then olive brown and mushy, and finally tobacco brown and pulverulent. This powder can be made to spurt out by squeezing or striking the fungus.

The size, the shape, the grayish white, fissured outer surface, and the dark, powdery inner mass of the Lázaro-Galdiano growth suggest that Bosch modeled his fantastic efflorescence on a giant puffball in an advanced stage of decomposition. The peduncle with which an actual puffball would have anchored itself to the soil has been replaced with an involucre, enabling the artist to hang the growth upside-down like a fruit from the end of a spiny stem. The growth also lacks an inner covering, enabling the bird to feed directly on its rotting inner mass, the latter turned from a fine powder into grain-sized seeds.

The giant puffball may also have been the model for the mottled green,

---

as many sinister elements and brutal events are depicted in Bosch's outdoor settings, the Lázaro-Galdiano landscape among them.

[6] The giant puffball is described in Lucius von Frieden, *Mushrooms of the World* (New York, 1969), no. 160.

globular form at the top of the Lázaro-Galdiano panel (Fig. 3). That growth is joined by an involucre to a stem which shoots up from the patch of verdant brush below and perforates the form to emerge from the round opening at the plant's opposite end. A portion of the form's dark, stringy inner mass hangs out of the opening and a black bird perches on top of the growth.

While the mottled surface, perfectly round opening, and stringy inner mass of this Lázaro-Galdiano growth are not characteristic of any species of puffball known to me, the shape and color of the growth and its general resemblance to the fissured form below raise the possibility that Bosch had in mind a giant puffball in its gray inner covering when he conceived that growth.

Forms probably modeled on the giant puffball appear in at least two other paintings by or after Bosch. One of these, the Haywain Triptych in the Prado, has traditionally been attributed to Bosch and dated around 1490, but more recently has been described as a close copy of about 1500 of a Bosch original.[7]

In the left wing, a woody stem bearing two large growths sprouts on the worldly side of the rocky portal which divides Paradise from the mortal world (Figs. 7 and 8). One of the growths is orange yellow and pear shaped, with a long, lanceolate leaf at its crown. The other, like the large Lázaro-Galdiano growth, is round and joined by an involucre to the end of a thorny stem which bends under its weight. A bird also perches just beneath that growth and consumes the dark inner mass, which is visible through a gaping, irregularly shaped hole in its bottom half. However, the round Prado growth is unfissured, orange yellow in color, and distinguished by a dagged involucre reminiscent of that of a persimmon.

A similar form can be seen in the *Saint Jerome in the Wilderness* in the Museum voor Schone Kunsten in Ghent (Fig. 9), a work usually dated around 1500 or shortly after.[8] The globular growth is anchored to a cleft between the grotto just behind the prostrate saint and the rocky outcroppings beyond it. Like the large Lázaro-Galdiano and round Prado forms, the Ghent growth is joined to a bowed stem with an involucre and has a large opening in its surface which reveals a dark inner mass. The surface of the Ghent growth is also divided into sections by fissures like those in the large Lázaro-Galdiano form.

In contrast to those growths, however, the stem in the Ghent panel is thornless and splintered, the involucre perfectly round, and the different sections of

---

[7] For the earlier attribution and dating of the Prado triptych, see de Tolnay, *Bosch* (as in note 2), 355; and Gibson, *Bosch* (as in note 2), 153–154. The triptych was later included in Gerd Unverfehrt, *Hieronymus Bosch: Die Rezeption seiner Kunst im frühen 16. Jahrhundert* (Berlin, 1980), 239–240, no. 1, where it was treated as a close copy after Bosch of about 1500 by a student whom Unverfehrt dubbed the Master of the Bruges Altarpiece of the Last Judgment.

[8] For the dating of the Ghent panel, see de Tolnay, *Bosch* (as in note 2), 366; and Gibson, *Bosch* (as in note 2), 154–155. The most recent discussion of the work is by Wendy Ruppel, "Salvation through Imitation: The Meaning of Bosch's St. Jerome in the Wilderness," *Simiolus* 18 (1988), 4–12.

the form's fissured surface colored red, yellow, and blue black. The Ghent stem is also joined to a papillated, teardrop-shaped base which has split open irregularly to reveal a hollow interior, from which a thorny leaf resembling an ace of spades has sprouted.

The shape and size of the round Prado form are like those of the giant puffball in its yellow inner covering, and the fissured surface of the Ghent growth recalls that of the giant puffball in its outer covering. Admittedly, the puffball's inner covering does not fall away in pieces as does that of the Prado growth and the polychromy of the Ghent growth's sections is like that of no puffball known to me. Even so, the general resemblance of the Prado and Ghent forms both to the actual fungus and to the similarly stemmed and (in the Prado example) consumed Lázaro-Galdiano form makes it seem most likely that a giant puffball was the original model for both.

The gourdlike growth in the Prado panel (Fig. 8) resembles another member of the puffball family, the pear-shaped puffball (*Lycoperdon pyriforme*; Fig. 10).[9] That fungus waxes in the autumn to a height of about three inches. Its yellow outer surface is speckled with minute reddish brown warts which eventually fall away, leaving just the yellow covering. At the same time the puffball's white, edible inner mass turns greenish yellow, then olive brown and soggy, and finally tobacco brown and powdery. At this stage an opening appears in the covering at the fungus's apex through which the noxious spores spurt if the puffball is struck.

The shape and color of the Prado efflorescence and its attachment to a stem bearing another puffball-like form suggest that Bosch modeled his growth on the pear-shaped puffball. The artist has considerably enlarged the form, widened its base, and turned it upside down so that its apex could be joined to the thorny stem and its peduncle replaced with a single leaf.

Bosch almost certainly had another species of fungus in mind when he fashioned the grayish beige efflorescence that rests on the block-shaped ledge just before the Lázaro-Galdiano Baptist (Fig. 2). Hollow and cuplike in shape, the growth originally contained eleven white seeds or pellets, six of which have spilled out onto the ledge. The form is joined by a calyx sprouting two lanceolate leaves to a thorny stem which emerges from the verdant brush just in front of the saint. The stem and upper half of a larger cuplike efflorescence which has been broken off from its parent plant can just be seen in the painting's lower left-hand corner (Fig. 1).

The two forms resemble an inedible mushroom known as the bird's-nest

---

[9] For the pear-shaped puffball, see von Frieden, *Mushrooms* (as in note 6), no. 165. Chailley, *Jérôme Bosch et ses symboles* (as in note 3), 121, described the growth as an actual pear, an identification which does not take into account the form's attachment to a stem bearing another species of puffball.

fungus (genus *Nidularia*; Fig. 11).[10] Those tiny mushrooms, measuring about half an inch in diameter, range in color from cinnamon brown to gray and are found alone or in groups on dead wood or other rotting organic matter. As their popular name suggests, they are shaped like bird's nests and are filled with egg-shaped spore masses called peridioles. The latter are knocked out of the "nests" by raindrops and then break up, releasing the spores.

The shape and color of the Lázaro-Galdiano efflorescences and the manner in which the smaller growth's seedlike contents spill out onto the ledge beneath it suggest that a bird's-nest fungus provided the model for both. The artist has considerably enlarged the cuplike part of the mushroom and has markedly reduced the size of the peridioles. As he also did with the giant puffball, Bosch has removed the fungus from its usual environment and affixed it to the end of a limb.

The unappealing physical characteristics of the recast fungi in the Lázaro-Galdiano, Prado, and Ghent panels and their correspondingly unsavory Middle Dutch names leave little doubt that those forms were intended as negative symbols. For example, the ability of the giant puffball to spew a cloud of spores when struck and the powder's nauseating odor led to the Greek name of *Lycoperdon* and corresponding Middle Dutch names of *wolfscheet* and *wolf-sveest*, or "wolf's fart," for puffballs as a genus (Fig. 12).[11] Bosch's medieval audience may also have been familiar with the German folk belief that the puffball sprouted on the nocturnal sites of witches' dances.[12]

While the bird's-nest fungus remained botanically unidentified and unnamed before the seventeenth century, it would always have been referred to as a *paddenstoel* or toadstool, an unflattering designation which linked all poisonous or inedible fungi with the toad, a creature invariably associated with evil in the Middle Ages.[13] The parasitic character of all fungi and their ability to flourish on rotting organic matter must also have contributed to their sinister reputation.

The association of the puffball with evil in Bosch's time is confirmed by the round form resting on a column and supporting a pagan idol in a *Flight into Egypt* painted about 1510 by an anonymous Netherlandish artist (Fig. 13).

---

[10] For the bird's-nest fungus, see W. P. K. Findlay, *Wayside and Woodland Fungi* (London and New York, 1967), 82.

[11] The Middle Dutch names for the puffball and their origins are detailed in *Middelnederlandsch woordenboek*, vol. 9, ed. E. Verwijs, J. Verdam, and F. A. Stoett (The Hague, 1929), col. 2760 (under *Wolfschete*).

[12] For this belief, see E. Hoffmann-Krayer and Hanns Bächtold-Stäubli, *Handwörterbuch des deutschen Aberglaubens*, vol. 1 (Berlin and Leipzig, 1927), col. 1485.

[13] For the botanical history of the bird's-nest fungus in Europe and America, see V. S. White, "The Nidulariaceae of North America," *Bulletin of the Torrey Botanical Club* 29/5 (May 1902), 255–256. The name *paddenstoel* and its origins are detailed in Verwijs et al., *Middelnederlandsch woordenboek* (as in note 11), vol. 6, cols. 9–10. For the evil connotations of the toad both in medieval writings and in the work of Bosch, see Jeffrey Hamburger, "Bosch's Conjurer: An Attack on Magic and Sacramental Heresy," *Simiolus* 14 (1984), 8–12.

Now part of a *Schnitzaltar* in the parish church of Valö, Sweden, the panel was first connected with Bosch's painting by Patrik Reuterswärd.[14] The botanical nature of the Valö form is made clear by the branch that perforates its side. Its size, shape, grayish color, fissured surface, and the cloud of black powder that spurts from it identify it as a ripe puffball; and the toppling of the idol atop it and its expulsion of spores, black birds, and a toad just as the holy family passes confirm its unclean and evil character.

A more precise meaning for the fungi in Bosch's three paintings is indicated by the anchors and location of the two puffballs in the Prado panel (Fig. 8). The thorny stems to which the two growths are joined and the composite plant's position on the earthly side of the portal of Paradise suggest that it was intended as a symbol of the bitter creation described in Genesis 3:18, where the Lord tells Adam and Eve that because they ate the forbidden fruit of the Tree of Knowledge:

> Accursed shall be the ground on your account.
> With labor you shall win your food from it
> all the days of your life.
> It will grow thorns and thistles for you,
> none but wild plants for you to eat.

The Prado plant thus appears to be both a part of and a symbol for the unhappy physical world which the first couple were condemned to occupy as punishment for their transgression.

Many medieval thinkers believed that the first sin committed by Adam and Eve after eating the forbidden fruit was carnal lust.[15] As the Middle Dutch word for thorn (*doorn*) was also used to refer to the penis, the prickly stems in the Prado panel and the "fruit" that they bear may also refer specifically to that wanton act.[16] Whatever the case, the slithering amphibian on the worldly side of the portal leaves little doubt as to the character of the creation into which humankind was cast as a result of Original Sin.

The unsavory, sinister, and menacing forms which fill the Lázaro-Galdiano landscape clearly identify the setting as the unhappy world inherited by Adam and Eve's descendants (Fig. 1). A jagged leaf winding around a flattened stalk, thorny twigs and stems, and a deeply cleft green leaf bearing a lurking rodent all emerge from the same verdant brush as the thorny stem that terminates in

[14] See note 5 above.

[15] For this belief, see Gibson, *Bosch* (as in note 2), 92–93; and, more recently, Larry Silver and Susan Smith, "Carnal Knowledge: The Late Engravings of Lucas van Leyden," *Nederlands kunsthistorisch jaarboek* 29 (1978), 247–251.

[16] For the secondary meanings of the Dutch word *doorn*, see Dirk Bax, *Hieronymus Bosch, His Picture-Writing Deciphered* (Rotterdam, 1979; trans. of *Ontcijfering van Jeroen Bosch* [The Hague, 1949]), 82.

the fissured puffball, the smooth stem bearing the mottled puffball, and the prickly stem joined to the bird's-nest fungus. The dark, stringy inner mass hanging out of the mottled puffball suggests that the bird perched upon it has turned it into a loathsome and untidy nest. The placement of this repellent vegetal assemblage just before the loins of the Baptist recalls medieval depictions of the Tree of Jesse and seems intended to remind the viewer that even Christ's forefathers were tainted by the first couple's transgression.[17]

More thornlike forms emerge from holes and crevices in the rocky outcropping in the left background, and spiny, leafless limbs stick out of the leaning pinnacle of rock or mud in the right. An amphibious monster promenades on the square block just before the Baptist, a bearlike predator feeds on a bloody mass of flesh as birds gather around for scraps in the left middle ground, and an unidentifiable animal stands on its hindquarters in the right middle ground, grasping the trunk of a tree with its forelimbs as if about to climb it, perhaps out of fear of the crouching animal nearby.

Surrounded by these symbols of humankind's fall from grace, the saint closes his eyes and points at the lamb, the symbol of Christ, which rests on folded legs in the right foreground. By turning his attention away from the corrupted world of the flesh and toward the untainted world of the spirit embodied in the lamb, Christ's precursor encourages the viewer to do the same and thereby to achieve salvation.

The unhappy results of Original Sin also litter the foreground of the Ghent panel with the penitent Saint Jerome (Fig. 9). One of these is the hollow, shattered red globe pierced by a thorny twig and topped with a prickly stem which lies partly submerged in the dank pond to Jerome's left. Similar thorny twigs litter the foreground and the rocky outcroppings and forms behind the saint. A red fruit skin with a green involucre composed of limp lanceolate leaves hangs over the lip of the escarpment just behind Jerome, the jagged and thorny plant bearing the decaying puffball is anchored to the crevice just beyond the escarpment, and two amphibians slither around and near the rocky forms, one of which recalls an altar table and another a Mosaic law tablet.

While Jerome's lion eyes the putrid scene with dismay, his back arching like that of a threatened house cat, the saint closes his eyes and concentrates his attention on the crucifix which he supports between his arms. Like the Lázaro-Galdiano Baptist, then, Jerome encourages the onlooker to turn away from the corrupt physical world and to strive instead for a place in the incorruptible heavenly realm made accessible to humankind by the Savior's sacrifice on the cross.

---

[17] For representations of the Tree of Jesse, see Alois Thomas, "Wurzel Jesse," in *Lexikon der christlichen Ikonographie*, ed. Engelbert Kirschbaum, vol. 4 (Freiburg i.B., 1972), cols. 549–558. According to de Tolnay, *Bosch* (as in note 2), 367, the similarity of the Lázaro-Galdiano composite form with the Tree of Jesse was first noted by H. Devoghelaere, "Une oeuvre peu connue de Jérôme Bosch, le 'Saint Jean-Baptiste' de la collection J. Lazaro," *L'art et la vie* 3 (1936), 372–374, a study which I have not been able to consult.

My identification in three paintings by Hieronymus Bosch of improbably situated but recognizable fungi with demonstrably negative associations for the medieval viewer reveals the existence of a surprising and previously unrecognized vehicle of meaning in Bosch's work. Those identifications also raise the possibility that all or parts of other seemingly "fantastic" flora in the paintings of Bosch and his followers might be based on recognizable plants whose character and reputation could play a role in the works' overall meaning.[18]

Even more importantly, my proposed interpretations for the three Bosch panels serve to remind us of the artist's profoundly negative view of the material world. Sinister creatures, forms, and events can be found in virtually all of Bosch's paintings and at every material stratum, from the many hells to even the terrestrial paradise in the Doges' Palace in Venice.[19] Interestingly, the latter painting's companion piece, which represents the ascent of the blessed into the empyrean, is alone among Bosch's works in being both entirely free of corrupt forms and truly blissful in character. The artist's contempt for the material world thus appears to have been counterbalanced by a genuine reverence, and perhaps even a longing, for the spiritual one.

THE UNIVERSITY OF THE SOUTH
SEWANEE, TENNESSEE

[18] For example, the writer wonders whether the papillated ovary at the end of the branch that provides the support for the bird feeding on the fissured puffball in the Lázaro-Galdiano panel might have been modeled on that of the Irish spurge (*Euphorbia hyberna*). Native to the Netherlands, despite its name, the spurge would have been an especially appropriate model, for it was known in medieval Dutch as wolf's milk (*wolfsmelck*), presumably because of its lacteal sap, which is a severe skin irritant and poisonous if taken internally. For the name *wolfsmelck* and its origins, see Verwijs et al., *Middelnederlandsch woordenboek* (as in note 11), vol. 9, col. 2759; for the unpleasant aspects of the spurge, see Oleg Polunin, *Flowers of Europe, A Field Guide* (New York, 1969), 223.

In addition, might any of the round, fissured, partly opened forms in the central panel of Bosch's triptych of the so-called *Garden of Earthly Delights* (see, for example, *Bosch*, ed. Roger H. Marijnissen [Geneva, 1972], figs. 47, 99, 107) have also eventually been modeled on the puffball fungus? Ernst Gombrich has plausibly proposed that the panel actually depicts the carefree world before the Flood ("Bosch's Garden of Earthly Delights: A Progress Report," *Journal of the Warburg and Courtauld Institutes* 32 [1969], 162–170). If this is correct, might such forms be intended to show how our antediluvian forebears made light of the evil forms that surrounded them, like the figures in the same panel (Marijnissen, *Bosch*, fig. 57) who gleefully carry a number of their compatriots about in what appears to be a scorpion's abdomen?

The fissured, shell-like "portico" which hangs over the entrance of the sanctuary in the central panel of Bosch's triptych of the Temptation of St. Anthony resembles a fragment of a giant puffball's outer surface (Marijnissen, *Bosch*, fig. 252). A piece of a decaying puffball would certainly be at home among the monstrous creatures and forms that overrun the panel. An even larger number of forms reminiscent of the giant puffball appear in the works of Bosch's followers (see, for example, Unverfehrt, *Bosch-Rezeption* [as in note 7], figs. 48, 116, 131, 176, 193).

[19] For the Venice panel and its companion piece, see most recently Gibson, *Bosch* (as in note 2), 61–66; and Marijnissen and Ruyffelaere, *Bosch* (as in note 1), 300–304. The "paradise" is marred by the presence of a strange beast with a bird on its back at the upper left and a feline predator tearing apart its cervine prey and a waiting scavenger bird at the upper right. Similar carnivorous activities are shown in the "paradises" which fill the left wings of the triptychs of the *Garden of Earthly Delights* in Madrid and *Last Judgment* in Vienna: Marijnissen, *Bosch* (as in note 18), fig. 19; and de Tolnay, *Bosch* (as in note 2), 170.

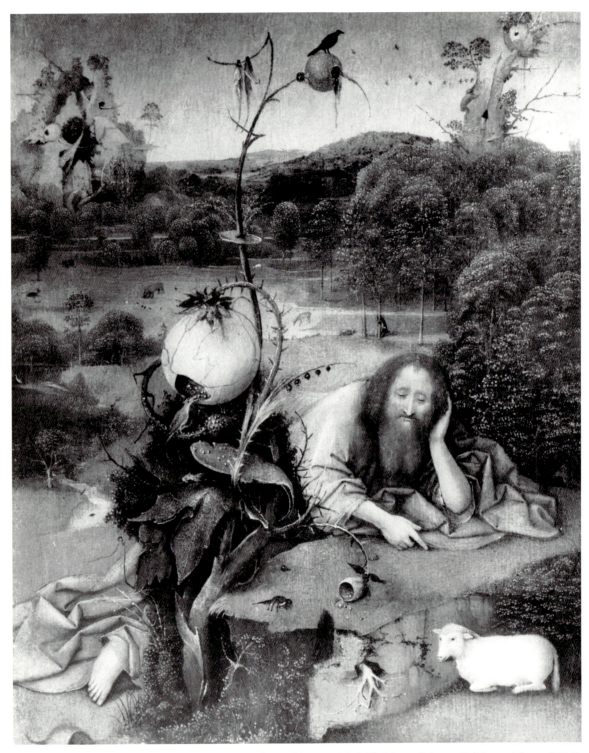

1. Hieronymus Bosch, *Saint John the Baptist in the Wilderness*. Madrid, Museo Lázaro-Galdiano (photo: MAS)

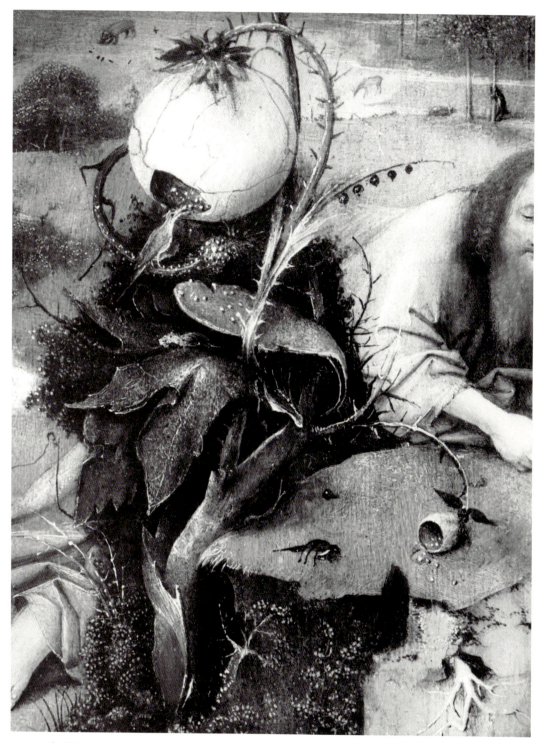

2. Hieronymus Bosch, *Saint John the Baptist in the Wilderness*, detail, lower half of the foreground plant. Madrid, Museo Lázaro-Galdiano (photo: MAS)

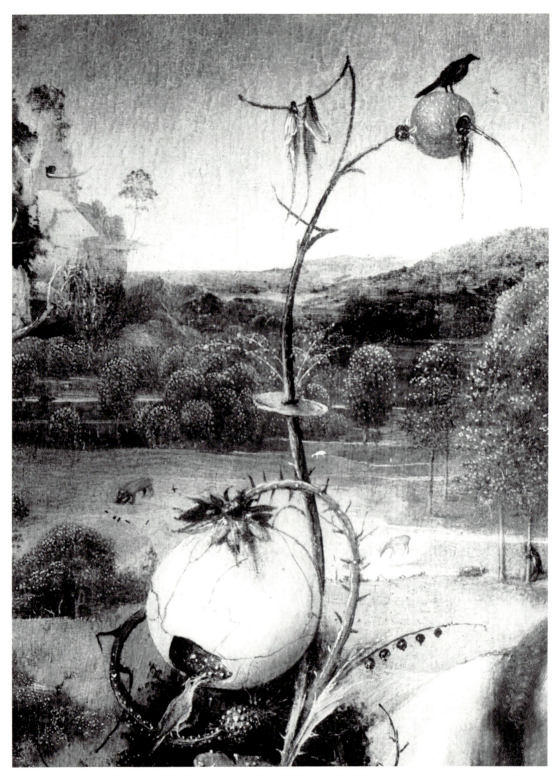

3. Hieronymus Bosch, *Saint John the Baptist in the Wilderness*, detail, upper half of the foreground plant. Madrid, Museo Lázaro-Galdiano (photo: MAS)

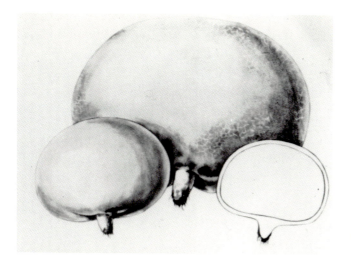

4. Giant puffball (*Lycoperdon maximum*) (after L. von Frieden, *Mushrooms of the World*, New York, 1969)

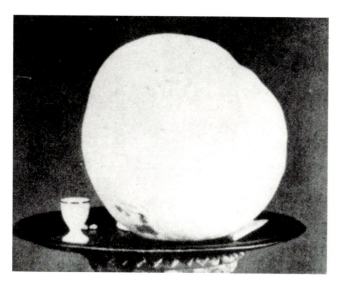

5. Giant puffball next to eggcup (after R. T. and F. W. Rolfe, *The Romance of the Fungus World*, London, 1925)

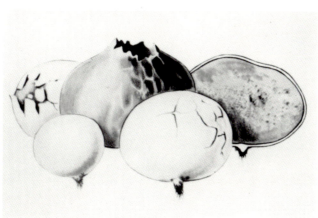

6. Round puffball (*Bovista nigrescens*) showing the disintegration of the outer surface (after L. von Frieden, *Mushrooms of the World*, New York, 1969)

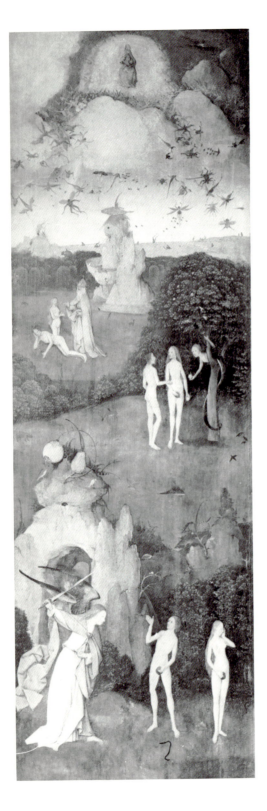

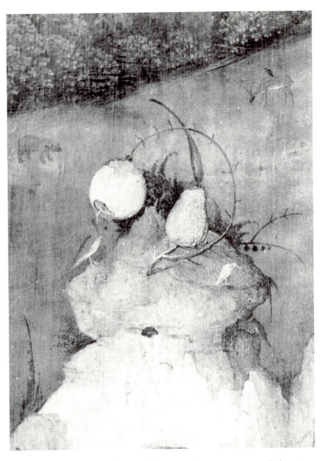

8. Hieronymus Bosch or follower, Genesis scenes, left wing of the Haywain Triptych, detail. Madrid, Museo del Prado (photo: MAS)

7. Hieronymus Bosch or follower, Genesis scenes, left wing of the Haywain Triptych. Madrid, Museo del Prado (photo: MAS)

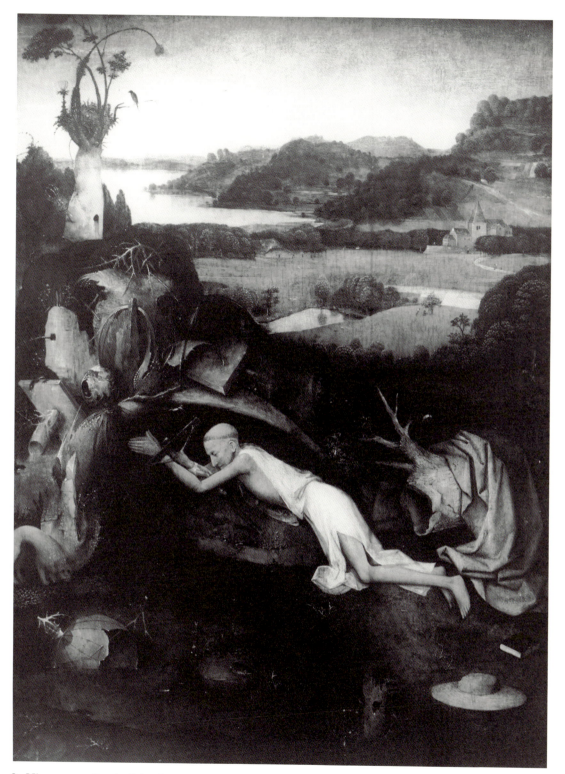

9. Hieronymus Bosch, *Saint Jerome in Penitence*. Ghent, Museum voor Schone Kunsten (photo: museum)

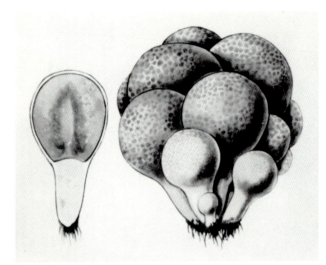

10. Pear-shaped puffball (*Lycoperdon pyriforme*) (after
L. von Frieden, *Mushrooms of the World*, New York, 1969)

11. Bird's-nest fungi (*Crucibulum vulgare*) (after R. T. and
F. W. Rolfe, *The Romance of the Fungus World*, London,
1925)

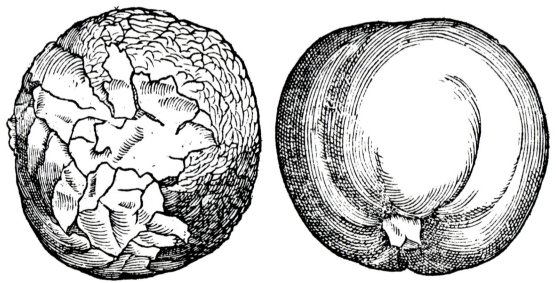

12. Round (or giant?) puffball, called "Wof's [*sic*] Fart" (after Rembertus Dodonaeus,
*Cruydt-Boeck*, Leiden, 1618)

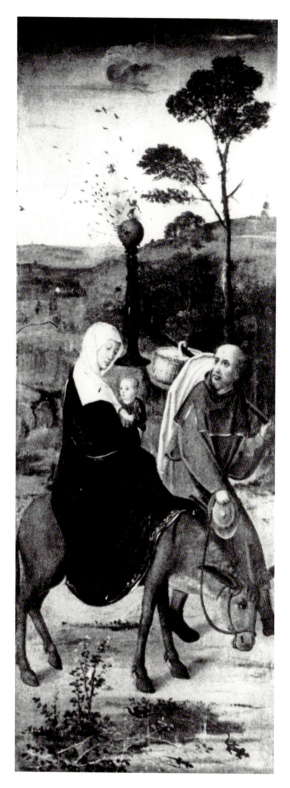

13. Netherlandish artist, *Flight into Egypt* (wing of an altarpiece with scenes from the life of the Virgin). Valö (Sweden), parish church (photo: Antikvarisk-Topografiska Arkivet, Stockholm)

# How One Workshop Worked:
# Bernard van Orley's Atelier
# in Early Sixteenth-Century Brussels

J. DAVID FARMER

❦

## Introduction

ARTISTS' WORKSHOPS in the Northern Renaissance, their structure and practice, have only recently become the subject of concentrated study.[1] Perhaps because so much of the evidence is from indirect and diverse sources, scholarly work on this topic is still in an early state. Study of the atelier of the productive and successful Bernard van Orley (ca. 1488–1541) offers an opportunity to construct a fuller picture of an era in which the older, guild-controlled artistic structure was evolving into a more free-market system. Van Orley's shop is particularly informative because he was the principal artist in early sixteenth-century Brussels, a city known for its paintings, tapestries, sculptured altarpieces, and stained glass. Van Orley participated in all of these areas as the city's dominant artistic figure and court artist for over a quarter of a century.

With few exceptions, most inquiries into workshop practices are found within larger studies. Larry Silver, for instance, in his recent comprehensive summary of the state of research in Northern Renaissance art, mentions the topic only in passing, and J. M. Montias, in a subsequent survey of research, is able to cite a mere handful of articles, while still recommending the usefulness of Hanns Floerke's classic work from the beginning of the century.[2] However,

---

[1] Some of this material appeared, in different form, in my doctoral dissertation, "Bernard van Orley of Brussels," written under the direction of Robert A. Koch and presented to the Department of Art and Archaeology, Princeton University, in 1981. I am pleased to have this opportunity to thank him for his friendship and guidance.

[2] Larry Silver, "The State of Research in Northern European Art of the Renaissance," *Art Bulletin* 68 (1986), 518–535; J. M. Montias, "Socio-Economic Aspects of Netherlandish Art from the Fifteenth to the Seventeenth Century: A Survey," *Art Bulletin* 72 (1990), 358–373, esp. 361ff.; Hanns Floerke, *Studien zur niederländischen Kunst- und Kulturgeschichte—Die Formen des Kunsthandels, das Atelier und die Sammler in den Niederlanden vom 15.–18. Jahrhundert* (Munich and Leipzig, 1905).

recent research into guild, market, and patronage questions by such scholars as
J.-P. Sosson, Jean Wilson, and Dan Ewing introduces important new informa-
tion.[3] Workshop practice is but one aspect of Michael Baxandall's synthetic
study of artists' relationships with patrons, the public, and other artists. Al-
though concentrating on Germany, this work offers useful documentation for
the study of Netherlandish art.[4] Among those who address the subject most
directly, Lorne Campbell provides extensive examples of relevant guild records,
lists, legal documents, and accounts of various civic, government, court, and
ecclesiastical bodies.[5] Lynn Jacobs and Catheline Périer-d'Ieteren analyze sculp-
tured altarpieces—many of them produced in Brussels during the years of Van Or-
ley's activity—presenting many interesting parallels for the study of Van Or-
ley, such as the pattern of reproducing similar, if not identical, models for a
diverse audience.[6] Stephen Goddard's publication on the Master of Frankfurt, a
contemporary of Van Orley in neighboring Antwerp, combines a statistical
analysis of workshop variants with perceptive visual evaluation.[7] Van Orley as
a designer (particularly of tapestries) is the subject of Maryan Ainsworth's re-
search; she, Périer-d'Ieteren, and other scholars are also adding considerably to
our knowledge of the way in which a work of art is actually made.[8] These
inquiries, combined with significant archival and historical studies, provide a
substantial basis for the continued examination of the Northern workshop.

Bernard van Orley (Fig. 1) was born about 1488 into a family of artists and

[3] J.-P. Sosson, "Une approche des structures économique d'un métier d'art: La corporation des peintres et
selliers de Bruges (XVᵉ–XVI siècles)," *Revue des archéologues et historiens de l'art de Louvain* 3 (1970), 91–
100; Jean C. Wilson, "Marketing Painting in Late Medieval Flanders and Brabant," in *Artistes, artisans et
production artistique au moyen âge. Colloque international*, vol. 3 (Paris, 1990), 621–627; idem, "The
Participation of Painters in the Bruges 'Pandt' Market, 1512–1550," *Burlington Magazine* 125 (1983), 476–
479; idem, "Workshop Patterns and the Production of Paintings in Sixteenth-Century Bruges," *Burlington
Magazine* 132 (1990), 523–527; Dan Ewing, "Marketing Art in Antwerp, 1460–1560: Our Lady's *Pand*,"
*Art Bulletin* 72 (1990), 558–584.

[4] Michael Baxandall, *The Limewood Sculptors of Renaissance Germany* (New Haven and London,
1980).

[5] Lorne Campbell, "The Art Market in the Southern Netherlands in the Fifteenth Century," *Burlington
Magazine* 118 (1976), 188–198; idem, "The Early Netherlandish Painters and Their Workshops," in *Le
dessin sous-jacent dans la peinture. Le problème Maître de Flémalle-van der Weyden*, colloque III, 1979
(Louvain-la-Neuve, 1981), 43–61.

[6] Lynn F. Jacobs, "The Marketing and Standardization of South Netherlandish Carved Altarpieces: Limits
on the Role of the Patron," *Art Bulletin* 71 (1989), 208–229; Catheline Périer-d'Ieteren, *Les volets peints des
retables Bruxellois conservés en Suède et le rayonnement de Colyn de Coter* (Stockholm, 1984), 9–18.

[7] Stephen Goddard, *The Master of Frankfurt and His Shop* (Brussels, 1984).

[8] Maryan Wynn Ainsworth, "Bernart van Orley as a Designer of Tapestry" (Ph.D. diss., Yale University,
1982); idem, "Bernart van Orley, Peintre-Inventeur," *Studies in the History of Art* 24 (1990), 41–64; idem,
"Northern Renaissance Drawings and Underdrawings: A Proposed Method of Study," *Master Drawings* 27
(1989), 5–38; Catheline Périer-d'Ieteren, "Dessin au poncif et dessin perforé. Leur utilisation dans les anciens
Pays-Bas du XV siècle," *Bulletin Institut royal du patrimoine artistique* 19 (1982–83), 74–94; Johannes
Taubert, "Pauspunkte in Tafelbildern des 15. und 16. Jahrhunderts," *Bulletin Institut royal du patrimoine
artistique* 15 (1975), 387–401.

was undoubtedly trained by his father, Valentin, about whom little is known.[9] Bernard was a precocious talent; his earliest works, datable only on the basis of style (but with no serious scholarly disagreement) to about 1512, are already important commissions, one of which carries an extraordinarily prominent artist's monogram.[10] By 1515, documents record his work for Margaret of Austria, regent of the Netherlands, for whom he produced many portraits and his *chef-d'oeuvre*, the *Vertu de Patience* Triptych (Fig. 2); he served as court painter until her death in 1530.[11] Until about 1525, a large and diverse body of paintings bears his evident imprimatur, whether by signature and date or stylistic stamp. By then, designing tapestries had become an important aspect of his work. Both series and individual weavings can be attributed to him on the basis of style, documents, or drawings. Drawings also exist for series that have either disappeared or were never woven, creating a substantial corpus in this medium.[12] There are few documented paintings after about 1525, but numerous tapestries certainly date from this period until the end of his life. Van Orley's final great work is the series of stained-glass windows in the cathedral of St. Michel in Brussels, begun in the late 1530s and completed by Michiel Coxcie after Van Orley's death in 1541.[13]

For the purposes of this paper, the characteristics of Van Orley's production can be defined as:

· A considerable corpus of surviving works associated with his personal style, indicating an ability to produce diverse work at every level of cost and patronage
· Documentary evidence for lost works in various mediums
· A wide stylistic range within the oeuvre that can be associated with him, from indisputably autograph drawings and paintings to derivative work revealing other hands and denoting his pervasive influence in artistic circles in Brussels.

[9] Max J. Friedländer, *Early Netherlandish Painting*, vol. 8 (Brussels and Leiden, 1972), hereafter cited as Friedländer 1972 with his catalogue numbers for works by Van Orley. For a more recent bibliography, see Farmer, "Bernard van Orley" (as in note 1), 351ff. The most recent discussion about Valentin is J. de Coo, "Twee Orley-retables," *Jaarboek van het Koninklijk Museum voor Schone Kunsten Antwerpen* (1979), 67–104.

[10] The Sts. Thomas and Matthias Triptych, today divided between the Musées Royaux des Beaux-Arts, Brussels, and the Kunsthistorisches Museum, Vienna; Friedländer 1972, no. 82, pls. 71–73.

[11] Farmer, "Bernard van Orley" (as in note 1), 18ff., 123ff. for the documents and discussion. For the *Vertu de Patience* Triptych, see most recently *Un chef-d'oeuvre à la loupe: La vertu de patience* (Brussels, Musées Royaux des Beaux-Arts, 1989), although it repeats some earlier assumptions that I believe are erroneous.

[12] Ainsworth, "Orley as a Designer" (as in note 8); Farmer, "Bernard van Orley" (as in note 1), 273ff.

[13] Jules Helbig and Yvette Vanden Bemden, *Les vitraux de la première moitié du XVIe siècle conservés en Belgique, Brabant et Limbourg*, Corpus Vitrearum Medii Aevii, Belgique, III (Ledeberg-Gent, 1974), 88–130; Bob C. van den Boogert, "Habsburgs imperialisme en de verspreiding van renaissance-vormen in de Nederlanden: De vensters van Michiel Coxcie in de Sint-Goedele te Brussel," *Oud Holland* 106 (1992), 57–80.

Occasionally, a composition began in Van Orley's stylistic orbit and then moved outside it or was translated into other mediums.

· Evidence of activity in a multiplicity of mediums: painting, drawing, tapestry, and stained glass

These characteristics, together with historical evidence, suggest a number of conclusions about working practices in an early sixteenth-century atelier. Some conclusions are similar to those reached by Goddard in his study of the Master of Frankfurt, particularly in the area of panel-painting production, since both artists were notably prolific, and it is reasonable to assume that they and other contemporary painters employed similar means to engender such a substantial output. Van Orley, however, had an added advantage: the significant productivity of his shop was certainly due in some part to his position with the court and to its demands, which must also have allowed him to stretch traditional guild regulations.

## Bernard van Orley's Workshop

The first consideration in studying this workshop is to note the magnitude of Van Orley's production and to define the limits of his direct participation in works traditionally attributed to him. This complex problem cannot be answered simply and requires a great deal of further attention beyond the scope of this paper. In my dissertation, I defined standards and boundaries within the Van Orley oeuvre, which early scholars (Friedländer in particular) had established but which was exceptionally indiscriminate for such a significant artist.[14] Fortunately, Van Orley produced numerous signed, dated, documented, and securely attributable works throughout his career, so that a central corpus can be systematically established. From this core, lesser works radiate outward, gradually diminishing in quality or stylistic relationship. These latter works have been called "workshop" of Van Orley in traditional art-historical nomenclature. Many of this group—paintings produced in the second, third, and fourth decades of the sixteenth century—are so closely related in some way to Van Orley's undisputed work that they indicate extensive workshop activity. To this body may be added documented paintings that have disappeared, such as many portraits known only through commissions or payments.[15] Finally, it is relevant to mention activities that seem to have been part of even a very impor-

[14] Friedländer 1972. Of the many other early and extensive treatments of Van Orley, see especially the publication by the Société Royale d'Archéologie de Belgique, *Bernard van Orley* (Brussels, 1943); and Ludwig Baldass, "Die Entwicklung des Bernart van Orley," *Jahrbuch des Kunsthistorischen Sammlungen in Wien*, N.F. 13 (1944), 141–191.

[15] Summarized in Farmer, "Bernard van Orley" (as in note 1), 18–25.

tant painter's occasional duties. Two of these tasks were actually hard-won, very profitable practices, giving painters a clear advantage over other artisans: polychroming sculpture and providing the compositions for historiated tapestries. A series of agreements in the 1450s gave painters in Brussels the exclusive right to market the sculpture they had polychromed, and this practice seems to have been the norm throughout northern Europe.[16] In one example, the painter Cornelis van Coninxlo, a Brussels artist very close to Van Orley, signed his name on the polychromy of an altarpiece, further suggesting the primacy of painters over sculptors.[17] Surviving payment records document at least one example of such work by Van Orley in 1520 and we may assume that he received other commissions of this sort, given the level of sculptural activity in Brussels and his preeminent position in that city.[18] Other miscellaneous tasks recorded in the documents include painting a saint on cloth (perhaps a banner) and serving as an appraiser for the paintings in Margaret of Austria's chapel.[19]

The crown jewels of any workshop are the major commissions. Between about 1512 and 1525, Van Orley produced many important altarpieces, large-scale devotional works, and unique portraits. While still in his mid-twenties, Van Orley showed that he was already an important figure and not shy about signing his work. His first known great commission, the Sts. Thomas and Matthias Altarpiece, is prominently signed and monogrammed on a central pillar which dominates the composition.[20] The 1521 *Vertu de Patience* Triptych (Fig. 2) is signed and monogrammed twice, and even includes the Orley family motto—all presented in a very ostentatious manner. These and other clearly autograph paintings are of the highest quality, indicating the vision and facility of a master painter. Technical evidence also indicates the presence of a strong artistic personality in the actual process of composition, e.g., pentimenti—often evident to the naked eye, as in the background architecture of the *St.*

[16] For the Brussels agreements, see Hans Nieuwdorp, "Die oorspronkelijke betekenis en interpretatie van de keurmerken op brabantse retables en beeldsnijwerk (15de–begin 16de eeuw)," *Archivium artis lovaniense. Bijdragen tot de geschiedenis van de kunst der Nederlanden. Opgedragen aan Prof. Em. Dr. J. K. Steppe* (Leuven, 1981), 85–98. See also Ewing, "Marketing Art in Antwerp" (as in note 3), 559; Baxandall, *Limewood Sculptors* (as in note 4), 106ff.; Jacobs, "Marketing and Standardization" (as in note 6), 210ff.

[17] For this carved and painted altarpiece in Skepptuna, Sweden, see R. Josephson and I. Wilke, *Sveriges Kyrkor, Province Uppland*, vol. 4 (Stockholm, 1919), 227ff.

[18] Van Orley gilded and painted a sculptured image of the Virgin. The document is in Brussels, Archives du Royaume de Belgique, Papiers d'Etat et d'Audience, reg. no. 1474. Published in J. Duverger, "Conrad Meijt," *Académie Royale de Belgique. Mémoires, Classes des Beaux-Arts* 5 (1934), 74, doc. XVI.

[19] For the painting on cloth, Brussels, Archives du Royaume de Belgique, Chambre des Comptes, reg. 1797 (1521), fol. 202. For the appraisal, Lille, Archives du Nord, B 459, no. 22932. A seventeenth-century inventory also credits Van Orley with a painted view or plan of Brussels, cited in J. Denucé, *The Antwerp Art-Galleries. Inventories of the Art Collections in Antwerp in the Sixteenth and Seventeenth Centuries* (Antwerp, 1932), 100.

[20] See note 10 above.

*Helen* panel in Brussels and the *Marriage of the Virgin* and *Christ among the Doctors* panels in Washington—and lively, sure underdrawing (either visible or revealed by infrared reflectography).[21] No preparatory drawing for a Van Orley painting exists today, leading to the belief that whatever study process may have preceded his actual painting, he could compose directly and forcefully on the panel. Of the many drawings by Van Orley that have survived, in fact, only one is related in any way to a painting: the *Parable of Lazarus and the Rich Man* in the British Museum, which treats the same subject as the exterior wing panels of the *Vertu de Patience* Triptych.[22] Since this sheet is beautifully finished in a chiaroscuro technique and represents the scene in a totally different format, it is probably an independent presentation drawing rather than a compositional study for the *Vertu de Patience* wings. The compositional study is a category of drawing very rare at this time, as Robinson and Wolff note.[23]

Until about 1525, Van Orley remained personally active in painting. His workshop was, in addition, producing a substantial number of portraits and frankly commercial works. This level of activity, especially the repetitive and onerous tasks, indicates a lively, versatile and prolific shop—and the need for numerous assistants to fulfill its demands. Unfortunately, no existing records specify the actual staffing of any workshop in that period. Culling data from a variety of sources, Campbell concludes that an active workshop comprised the master, his apprentices (who served from two to four years, depending on the city—four in Brussels), journeymen, and sometimes subcontractors.[24] Some apprentices advanced to become masters, and their existence is often documented in guild lists and contracts. Others, however, remained journeymen, a category that resists documentary scrutiny because they were not inscribed in guild lists and probably moved about as work was available—at a court, for example, or temporarily in an atelier when a major project was underway.[25] Given the quantity of work from Van Orley's shop and the occasional large-scale commission, such as a major altarpiece or a request for a body of court portraits, we can assume that the number of assistants was always substantial, although varying as necessary. Campbell cites one instance of Van Orley's use of a subcontractor, the Namur painter Christophe de Hongrie, who joined him for a project.[26]

21 Friedländer 1972, nos. 90, 99, pls. 88, 98. For the National Gallery paintings: John Oliver Hand, in *Early Netherlandish Painting*, The Collections of the National Gallery of Art Systematic Catalogue (Washington, D.C., 1986), 216–223, with an infrared reflectogram of the *Marriage* panel, fig. 1.

22 British Museum, inv. 1899.7.13.216. A. E. Popham, *Catalogue of Drawings by Dutch and Flemish Artists in the British Museum*, vol. 5 (London, 1932), 34–35.

23 William W. Robinson and Martha Wolff, "The Function of Drawings in the Netherlands in the Sixteenth Century," in *The Age of Bruegel: Netherlandish Drawings in the Sixteenth Century*, exhib. cat., National Gallery of Art (Washington, D.C., 1986), 26, 34–36.

24 Campbell, "Painters and Their Workshops" (as in note 5), 46–48.

25 Ibid., 49–50.

26 Campbell, "The Art Market" (as in note 5), 194.

While we cannot know the exact number of Van Orley's assistants, we can divine some knowledge of the general areas for which they were responsible and the level of competence shown in work they produced. A study of existing examples of multiple portraits, for example, reveals some of his workshop's practices. His court patrons, first Margaret of Austria and then Marie of Hungary, regularly commissioned portraits of court figures, often in more than one copy.[27] Enough imperial likenesses—of Margaret, her nephews Charles (later Charles V) and Ferdinand, and other members of the Habsburg nobility—survive to demonstrate a high degree of homogeneity within each portrait type. While all bear the essentials of Van Orley's style, their compositions show only minimal differences in details like hand positioning, and none rises above mediocrity. Earlier scholars sought an autograph Van Orley within each group or posited a lost original of superior quality, but neither solution is likely to be correct.[28] What is most revealing about these existing portraits is that their sheer numbers and unquestionably assembly-line characteristics prove that the workshop's ability to produce quantity was sometimes more important than the individual talents of its staff. One of the most familiar basic compositions among these groups is a bust-length portrait of Margaret, known today in about a dozen versions, all nearly identical and equally mediocre (Fig. 3).[29] A more elaborate half-length representation of Margaret, apparently intended as the right half of a devotional diptych, has also come down to us in several paintings. All of these are superior to the bust-length works, but none can equal any portrait uniquely attributable to Van Orley.[30] Charles V is the subject of one extraordinarily good portrait, which is certainly autograph, while several related but patently inferior versions are probably the product of "standing-order" commissions and are virtually identical in form and quality.[31] The evidence points to a workshop model of the same quality as the numerous replicas, ready to be reproduced by Van Orley's journeymen assistants on call, rather than to a lost original by the master. The consistency within each workshop portrait group confirms that the model was closely followed and was not necessarily either skillfully made or interesting, such as the best unique likenesses, e.g., the Budapest *Charles V*, *Dr. Zelle*, and the so-called *Minister of State* in Brussels. These were special efforts showing the clear conceptualization and strong creative ability of the workshop's master, Van Orley himself.[32]

[27] See note 15 above.

[28] E.g., Alphonse Wauters, *Bernard van Orley* (Brussels, 1893), 12; M. J. Friedländer, "Bernart van Orley," *Jahrbuch der Königlich Preussischen Kunstsammlungen* 30 (1909), 31–32.

[29] More versions exist than those catalogued by Friedländer 1972, no. 151, pl. 126. See Farmer, "Bernard van Orley" (as in note 1), 18ff. for the documents.

[30] Friedländer 1972, no. 133, pl. 115.

[31] Ibid., no. 143, for the portrait in Budapest, and nos. 142a–c for the workshop variants, all reproduced on pl. 120.

[32] Ibid., no. 144, pl. 121, for the prominently signed and dated portrait of Dr. Zelle; and no. 149, pl. 125, for the *Minister of State*, both in the Musées Royaux des Beaux-Arts, Brussels.

Like the portraits, a number of workshop devotional paintings do not seem to depend on an original of the best quality. A good example is the composition of a seated Virgin nursing the Christ child in an outdoor setting. Unlike the portraits, however, the quality and format of depictions of this theme differ considerably from version to version. Friedländer considered one of them (the panel in Milan) to be an autograph painting, and the rest replicas, but there is, in fact, no substantial difference in quality between that painting and the version in Glasgow (Fig. 4).[33] Indeed, the figures of the Virgin and the child in this painting are good enough to be considered autograph, but the architecture (as in all versions) is awkward and badly proportioned. Van Orley was a good painter of architectural settings, and these are far below his standard in every way. In other versions, details of setting differ, as does the quality of the central figures. Two conclusions may be drawn: first, that artists with notably diverse abilities were involved; second, that the model for the composition was not a rigorously defined template but one with a range of possible details that could be combined to give variety to a basic formula. These ideas echo Goddard's analysis of the figures and elements recurring throughout the work of the Master of Frankfurt.[34] Recent discussions of the early sixteenth-century art market have stressed the immense production of painting and sculpture for sale in the open markets or through dealers, who were sometimes the artists themselves.[35] Baxandall and others have concluded that this kind of work comprises the overwhelming majority of art produced in this period, which is, however, almost completely undocumented.[36] The logic that drove production needs and the body of visual evidence both testify that Van Orley had very little to do with the multiple portraits or the Virgin and child panels once he had provided some form of basic design. I will return later to the nature of these models.

In fact, the lackluster appearance of many aspects of paintings such as the Glasgow *Virgin and Child* and its other versions—inadequacies in perspective, proportion, spatial relationships, and (where the subject is architecture) classicizing intent—suggest that Van Orley quite probably took minimal responsibility for their invention. Here there is some evidence for the presence of specialists in this active workshop. The seventeenth-century critic André Félibien, in his very astute discussion of Van Orley, mentions that the artist "had under him a certain Tons, a fine landscape painter, who has worked with him on the Chasses of Emperor Maximilian . . . ," a spectacular twelve-panel tapestry series featuring extraordinary landscapes which reproduce the actual topog-

---

[33] Ibid., no. 126a, pl. 111.

[34] Goddard, *Master of Frankfurt* (as in note 7), 95ff.

[35] Campbell, "The Art Market" (as in note 5), 194ff.; Ewing, "Marketing Art in Antwerp" (as in note 3), 574; Jacobs, "Marketing and Standardization" (as in note 6), 209–211.

[36] Baxandall, *Limewood Sculptors* (as in note 4), 102.

raphy of Brussels and its environs (Figs. 12 and 13).[37] It is reasonable to accept essential information or tradition regarding the tapestries as related by the French critic, since these panels were already in Paris when he wrote about them in the century following their design and weaving. Félibien provides no further identification of this Tons, but references exist to a Tons family, active in the late fifteenth and early sixteenth centuries, with a demonstrated relationship with Van Orley. Carel van Mander mentions Willem, Hans, Hubert and Guillaume, characterizing the first as outstanding in watercolors and in painting "cartoons (*patronen*) with all sorts of trees, vegetation, animals, birds, eagles and such, all very beautiful and well done after nature (*nae t'leven*)." Hans, Willem's son, is also identified as a watercolorist and, by extension, a cartoon painter.[38] Contemporaneous documents provide biographical details about Jan Tons as early as 1494, when he married Anna van Capenberghe, the sister of Barbele, who was Valentin van Orley's wife. Jan's age is given as 60 or 61 in 1527, when he was cited with his 24- or 25-year-old son Henneken in an inquisition process connected with Bernard van Orley; his name is last mentioned in 1529 in documents concerning an altarpiece in the church of St. Pierre, Brussels.[39] Although this information does not specify the collaboration of a Tons family member on the *Belles Chasses*, it does elucidate their reputation for landscape and nature painting and their relationship to the Van Orley family. Given the character and scope of Van Orley's pictorial production, it is safe to infer that he had at his disposal a number of specialists working at various levels. If the *Belles Chasses* tapestries testify to a landscape specialist of superior quality, the Virgin and child and portrait panels indicate journeymen with differing levels of skill in such areas as portraiture, architecture, and landscape. Furthermore, it is likely that the artists whose names have survived in the writings of Van Mander and Félibien, and who are otherwise documented, were independent figures hired for important commissions such as the *Belles Chasses*, while panels and serial portraits offered on the market were produced by in-shop journeymen.

By examining the permutations of other compositions originating in Van Orley's shop it is possible to infer some of the actual means of their transmission as well as the nature of the relationships between Van Orley and other artists. Most of Van Orley's major commissions are constructed around unique compositions, but there are some interesting exceptions. The most important of these for the present analysis is the Lamentation composition, which exists in two

[37] A. Félibien des Avaux, *Entretiens sur les vies et sur les ouvrages des plus excellens peintres anciens et modernes* (Paris, 1666–1688), translated from the 1725 ed., vol. 2, 328.

[38] Carel van Mander, *Het leven der doorluchtige nederlandtsch en hooghduytsche schilders*, ed. and trans. Hanns Floerke (Munich and Leipzig, 1906), vol. 1, 234.

[39] Citations in Farmer, "Bernard van Orley" (as in note 1), 291–292 nn. 81–84.

superb versions and at least three unimpressive paintings which barely reflect Van Orley's influence. The two prime versions are the central panel in a triptych with wings representing the donor Philippe Haneton, datable on the basis of style to ca. 1521–22 (Fig. 5), and a modestly scaled, beautifully woven tapestry (Fig. 6).[40] Nearly identical in many details, these two works differ radically in others. The painting, with its gold background, is an *Andachtsbild*, as Ainsworth correctly notes, while the tapestry presents the same event in a narrative mode.[41] In the latter, the figures are grouped before an extensive landscape, the tomb is seen in the lower foreground, and the sense of space is palpable. The tapestry includes an additional mourner, and the figures of the two mourners at the upper right differ substantially in the two works. An essential similarity among the five core figures, however, is significant here: the three Marys, St. John, and Christ are generally identical, even to their measurements, strongly suggesting the use of some sort of common, full-scale model.[42] The use of a cartoon or other model of a specific size might also explain the disjunction in scale of certain elements within the triptych, where the figures in the central panel are noticeably larger than the donor figures and patron saints in the wings. This shift—so unexpected in an artist of such "modernist" aspirations as Van Orley—is evident in reproductions, but is especially striking when one stands before the open triptych. In contrast, the tapestry is completely appropriate in scale for a personal, devotional weaving: rich, certainly costly, but small enough to find a place in a home or private chapel. The fact that cartoons were created as a matter of course for tapestries and that the figural scale is entirely proper in the weaving suggests that the original composition was created with a tapestry in mind. Further evidence for this conclusion can be taken from a survey of the other painted versions of the composition. All are evidently based on the painting, rather than the tapestry, but none is in the same scale as the Haneton *Lamentation*, indicating that a cartoon was not the means of transmission. Since normal practice gave the weaver control of the tapestry cartoon, it would not have been available (and evidently *was* not) to these later artists.[43]

Recent studies have shown that both a full composition and a mere detail

[40] For the painting, see Friedländer 1972, no. 86, pls. 82, 83.

[41] Ainsworth, "Orley, Peintre-Inventeur" (as in note 8), 43.

[42] The correspondence and possible common model was first suggested in Farmer, "Bernard van Orley" (as in note 1), 169–170. Ainsworth, "Orley, Peintre-Inventeur" (as in note 8), 43–48, discusses the relationship at some length and (n. 21) gives identical measurements.

[43] For three other versions, see Zygmunt Wdowiszewski, "Straty Artystyczne i Kulturne Zbiorow Przezdzieckich w Warszawie," *Rocznik Muzeum Narodowego w Warszawie* 3 (1958), 358–359, a vertical composition; *Bernard van Orley* (as in note 14), pl. XXIIB, for a horizontal composition formerly in the collection of S. Hartveld, Antwerp; and a version close to the original, apparently unpublished, in the Lefère collection, Brussels.

could be duplicated in panel painting through the use of a cartoon, although no such panel cartoons from this time exist today, and we have only a few full-scale glass or tapestry cartoons from the period. Evidence for their use, therefore, must come from study of the panels. In one case where a significant number of drawings and related paintings have survived, Ainsworth has shown that Holbein scribed over the contours of his drawings directly onto the panel.[44] Another method of transfer which was presumably less damaging to the cartoon and, like the first, also commonly used in Italy for the painting of frescoes, was pouncing, which consisted of pricking holes along the lines of the drawing, placing the paper against the panel, and then dusting the cartoon with chalk or charcoal. When the paper is removed, a series of dots remains on the panel indicating the desired contours. Several scholars have begun to collect data on this method, which can be observed through infrared reflectography in the same way as conventional underdrawing.[45] Although there has been no systematic survey of this phenomenon, laboratory study of at least one work by Van Orley has revealed the use of pouncing to create a copy. This painting, in the Musées Royaux des Beaux-Arts, Brussels, is a close variant of the excellent signed and dated (1522) *Holy Family* in the Prado. Périer-d'Ieteren reports that the pouncing in this work principally defines the faces and is combined throughout with more conventional underdrawing, including connections between the dots, which the painter has followed faithfully. Subtle but clear differences between the two paintings, however, lead her to believe that the cartoon used for the copy was not made directly from the Prado version.[46] Similar investigation of other paintings from Van Orley's studio might define the extent to which this method was used in his shop. Could this be, for instance, how a series of portraits was produced? An interesting specimen for future study is the portrait of Philippe Haneton's daughter, today in Edinburgh, which appears to follow the same lineaments as her representation in the wing of the Haneton *Lamentation*.[47]

Another category of compositional replication is characterized by decided changes in scale, so that the vehicle for transfer cannot have been a full-size cartoon. The odyssey of one composition takes us to the very limits of Van

[44] Maryan Wynn Ainsworth, " 'Paternes for Phiosioneamyes': Holbein's Portraiture Reconsidered," *Burlington Magazine* 132 (1990), 173–186.

[45] See Taubert, "Pauspunkte in Tafelbildern" (as in note 8), for discussion and list of works by David and Ysenbrandt; further Ysenbrandt examples in Wilson, "Workshop Patterns" (as in note 3), 523. See also Périer-d'Ieteren, "Dessin au poncif" (as in note 8).

[46] Catheline Périer-d'Ieteren, "Usage du poncif dans la peinture flamande des XVe et XVIe siècles," in *Le dessin sous-jacent dans la peinture*, colloque I, 1975, et colloque II, 1977 (Louvain-la-Neuve, 1979), 46–48. For the paintings: Friedländer 1972, nos. 140 and 140a, pl. 119. Ainsworth, "Drawings and Underdrawings" (as in note 8), 11, for discussion and further examples.

[47] Friedländer 1972, no. 152, pl. 127.

Orley's workshop and beyond—indicating the extent and complexity of his influence both during and after his lifetime. The subject is the Adoration of the Magi. Elements from the group's fundamental composition appear in a number of panel paintings, two tapestries, and two carved altarpieces originating in Brussels. It is neither easy nor necessary to determine the primacy of the works within this group, but a probable place to start is with those stylistically closest to Van Orley: a very handsome tapestry in the Metropolitan Museum (Fig. 7) and two nearly identical painted versions, one in the Philadelphia Museum of Art and another formerly in the Kisters collection (Fig. 8).[48] As Edith Standen has noted, these three works are also compositionally and spiritually closest to their Italian sources: an *Adoration* tapestry from the Scuola Nuova set, known for its influence on Northern art, and the same subject in Raphael's Vatican loggia.[49] It is easy to explain the influence of the tapestry design, since it may have been sent to Brussels, as Raphael's influential *Acts of the Apostles* cartoons certainly were, but not so easy to explain the exact mechanism by which the loggia painting became a source. By whatever route, however, if any artist in the Low Countries were to have grasped the possibilities of such compositional devices, it would certainly have been Van Orley, who by 1520 was avidly absorbing and developing his own version of a Raphaelesque style. It is highly unlikely that Van Orley traveled to Italy, since the volume of his output indicates no time for such a trip. But prints and drawings after individual works, such as a sheet in Oxford connected with the loggia composition, would have been available in northern centers.[50]

Friedländer and Standen rightly considered the *Adoration* tapestry foremost among this group's related but disparate examples. It is a work displaying all the qualities of Van Orley's fine paintings from the early 1520s, showing spatial clarity, an imposing and intelligently disposed figural group, and well-perceived classical architecture—in addition to strong stylistic similarities.[51] Moreover, these figures are closest to their Italian sources, while the personae in the other versions show a gradual distancing from the "autograph" qualities of the tapestry. The Philadelphia and ex-Kisters panels, although close in style to Van Orley (Friedländer considered the version he knew—that in Philadelphia—to be autograph), are not from his own brush, but were painted by an artist with a recognizable hand. Among this artist's works are the ex-Kisters panel, dated

---

[48] For the paintings: Friedländer 1972, no. 105, pl. 102; and Baldass, "Entwicklung des Bernart van Orley" (as in note 14), pl. 160.

[49] Edith Standen, "Some Sixteenth-Century Flemish Tapestries Related to Raphael's Workshop," *Metropolitan Museum Journal* 4 (1971), 109–121.

[50] Farmer, "Bernard van Orley" (as in note 1), esp. 137–143, for discussion of the plausibility of a Van Orley trip to Italy.

[51] Friedländer 1972, 77; Standen, "Flemish Tapestries" (as in note 49), 115.

1533, an *Ecce Homo* dated 1526 (Musée Henri Boez, Maubeuge), and a third painting derived from a Van Orley composition of the 1530s (*Crucifixion*, Spanish private collection), demonstrating that he was working close to Van Orley, probably in his workshop, in the latter half of Bernard's career. In other ways, as well, both of these painted Adorations seem to be at some remove from a major Van Orley work of the 1520s; while many elements echo those in the New York *Adoration* tapestry, figures and architectural forms are added or transformed so that the narrative becomes more garrulous than intense.

Three further Adoration panels (one of which is illustrated in Fig. 9) are very closely related to each other and, while maintaining some of the compositional elements seen in the tapestry and the first two paintings discussed, are compositionally and stylistically even further removed from Van Orley. All three paintings reveal the hand of an artist related to Van Orley, but so weakly that Friedländer considered these paintings "mediocre replicas."[52] Although actually closer in style to Van Orley's less talented contemporary Jan van Coninxlo, who produced a number of signed and dated altarpieces during a career that can be traced from 1514 to 1546 and perhaps later, this painter patently had access to Van Orley's compositional formula for the Adoration.[53] For these panels he has appropriated the central figural group of the Virgin, the child, the kneeling king, and a king who strides in from the right, while creating a more frontal grouping. The Moorish king at the left does not follow the model of the works already discussed, but is another appropriation, in this case from Dürer's print of the *Standard Bearer* (Meder 92), reversed as well as somewhat misunderstood.[54] Closely related to these three paintings is a scene found in a carved altarpiece at Lombeek, near Brussels (Fig. 10). The identical forms of certain figures, especially the kneeling king and Moorish king, leave no doubt that the same model was used for all of these compositions, despite some significant differences. The altarpiece has been attributed to Pasquier Borman, a member of a Brussels family active in the production of carved altarpieces, some of which include painted panels from Brussels ateliers.[55] Finally, even further from the original model, but certainly related, is an Adoration scene on a carved altarpiece in Tongres, also in the manner of Borman.[56] In evaluating multiple versions of a composition, as above, it is often difficult to say if the model traveled beyond Van Orley's workshop, despite the presence of varied hands. In

[52] Friedländer 1972, nos. 106a–c, pls. 102, 103.

[53] Cecilia Engellau-Gullander, *Jan II van Coninxlo: A Brussels Master of the First Half of the Sixteenth Century* (Stockholm, 1992).

[54] Noted by Julius Held, *Dürers Wirkung und die niederländische Kunst seiner Zeit* (The Hague, 1931), 111–112.

[55] Johnny Roosval, "Retables d'origine néerlandaise dans les pays nordiques," *Revue belge d'archéologie et d'histoire de l'art* 3 (1933), 147.

[56] Ibid., 144 n. 1.

this case, the composition has unambiguously passed into a distinctly separate workshop of sculptors, proving without doubt that workshop models could cross many boundaries. The conjunction of painting and sculpture here is more than fortuitous, because their similar objectives—producing numerous types of work to be available for immediate sale—led both groups of artisans to adopt similar means of production. Jacobs persuasively argues that sculpture workshops typically standardized production in a quasi-industrial manner, deploying "left-over" figures and prefabricated parts where appropriate. Model books, she concludes, were widely used.[57] The persistence of the *Adoration* composition in sculpture indicates how widely such a model could be shared.

Unfortunately, the means for disseminating these figures or compositions have not survived in the work of Van Orley, although recent scholarship—especially using infrared reflectography to study underdrawings—has helped to define drawing modes and techniques, and how artists and workshops employed them.[58] It seems probable that Van Orley's workshop used a full cartoon to reproduce at least one painting composition, as noted above, and historical precedent suggests that repertory drawings existed for figures or compositions like those associated with the *Adoration*.[59] Given the persistence of some compositions and historical documentation attesting to the value of models and patterns, it is surprising that more have not survived, particularly in the oeuvre of an exceptionally prolific artist like Van Orley. Compositions certainly have exceeded the temporal limits of the life of the artist. First, there are examples of paintings in Van Orley's style that originate in earlier models, such as a *Standing Virgin and Child* that appears to go back to a model by the Master of Flémalle.[60] Second, there are devotional formulae that either originate with Van Orley or are an essential part of his workshop's repertoire, then continue as late as the seventeenth century, like the half-length Virgin and child that persists into the circles of Rubens and Jan Breughel.[61] Patterns were a valuable asset, not only during the artist's lifetime, when they were used to produce salable commodities, but also as an inheritance after the artist's death. Vrancke van der Stoct, for instance, bequeathed his patterns and unfinished paintings to his sons, so that they might continue his workshop's activities, and left his finished paintings to his widow, presumably to sell.[62] Two documented

57 Jacobs, "Marketing and Standardization" (as in note 6), 215–220.

58 Ainsworth, "Drawings and Underdrawings" (as in note 8), for an extensive discussion.

59 Robinson and Wolff, "The Function of Drawings" (as in note 23), 26,

60 Friedländer 1972, no. 125, pl. 109.

61 Ibid., no. 135, pl. 116. Several of the many versions appear to be contemporaneous, but from other workshops, and two are as late as the seventeenth century: Pushkin Museum, 1957 catalogue, no. 3086, in the manner of Jan Breughel; and Prado, no. 1250, with a painted floral frame, in the manner of Rubens.

62 Campbell, "The Art Market" (as in note 5), 195; idem, "Early Netherlandish Painters" (as in note 5), 44.

transactions following Van Orley's death also confirm this as an accepted procedure.

In the first instance, a series of documents from 1536 to 1566 allows us to follow the history of a commission left incomplete at Van Orley's death and subsequently sold to another patron. In 1536, Van Orley received partial payment for the purchase of a "beau, esquis et puissant tableau de bois de Dannemarke . . . pour servir sur le grant autel de l'esglise du couvent de Brouz."[63] This altarpiece for Margaret of Austria's funerary chapel was presumably never completed or delivered, because in 1560 a commission established by Philip II purchased it from Van Orley's "enfants et heritiers" for the high altar of the Onze-Lieve-Vrouwkerk in Bruges, and a 1561 entry documents payment to Marcus Gheeraerts for its completion.[64] This work, a giant Crucifixion triptych, remains today in the same church where it has been since 1560, documented without interruption from its origins in Van Orley's workshop to the present. Because Gheeraerts completed the work and Frans Pourbus restored it substantially in 1589, the painting can be considered only as an equivocal document of Van Orley's late style.[65] Nevertheless, even left unfinished in his atelier, this important painting became the basis for lesser workshop paintings, most notably a small Crucifixion triptych, now in a Spanish collection, by the same artist who painted the ex-Kisters and Philadelphia *Adorations*, as well as for both a painting and a tapestry reproducing one of the wing compositions, the *Lamentation at the Foot of the Cross*.[66] For both parties—Bernard's heirs and the Bruges commission—the existence of such a work was a fortunate circumstance, providing one with income and the other with a large-scale altarpiece already substantially composed by a renowned painter.

In the second documented instance, Van Orley's death interrupted his work on the great windows for the cathedral of St. Michel (then St. Gudule). This grand decorative ensemble, which remains nearly intact today and is a major monument of the Northern High Renaissance, comprised two windows in the transepts and five in the Chapel of the Sacrament.[67] The transept windows and

[63] Lille, Archives du Nord, B 459, no. 22915, dated January 22, 1536 (n.s.).

[64] Rijksarchief, Brugge, Verzameling Onze-Lieve-Vrouw, Littera F, no. 178. Documents and history of the altarpiece are summarized in Farmer, "Bernard van Orley" (as in note 1), 189–201.

[65] The only publication of the triptych since its complete conservation and restoration to the high altar is Dirk De Vos, Paul Vanden Bussche, and Hugo Vanden Borre, "De restauratie van het passiedrieluik van Barent van Orley in de Onze-Lieve-Vrouwkerk te Brugge," *Jaarboek stad Brugge Stedelijke Musea* (1983–84), 106–134.

[66] The small triptych is in Madrid, Museo Arqueológico Nacional, inv. 51978, and was published by Jacques Lavalleye, *Les primitifs flamands, II: Repertoire des peintures flamandes du quinzième et seizième siècles, Collections d'Espagnes* 1 (Antwerp, 1953), 16, pls. XIV, XV. The copy of the *Lamentation* panel was last seen at a sale in New York, Parke-Bernet Gallery, October 24, 1962, and the tapestry was reproduced in *Catalogue des tableaux anciens des écoles primitives, italiennes, allemandes et flamandes. Bois sculptés, tapisseries* (Paris, Georges Petit, May 25–26, 1900), no. 163.

[67] Helbig and Vanden Bemden, *Vitraux* (as in note 13).

the first Sacrament window were completed by 1540, and, following Van Orley's demise, the second Sacrament window, representing the patron John III of Portugal, was completed with the assistance of Michiel Coxcie. Documents indicate payments to Jerome van Orley, Bernard's son, for his original drawing for the second Sacrament window, which Coxcie then enlarged to a full cartoon, as well as "diverse, small-scale drawings."[68] The completed version of the John III window closely follows the formulae of Van Orley's earlier windows, but with some stylistic revisions, especially in the architectural decoration, to confirm the assumption that Coxcie made a contribution, albeit a modest one, to this work. The concluding windows in the series, however, differ substantially, particularly in the architectural settings, indicating that Coxcie applied his own design ideals to this group, while following certain predetermined guidelines, namely, the overall compositional schema and the narrative presentation of the miraculous host. It is likely that Van Orley had established these from the beginning and that the "diverse, small-scale drawings" were the records of his original conception.

Three drawings connected with these windows have survived, but none of them is comparable in style to known Van Orley drawings. The only possible candidate, a drawing in the Royal Archives in Brussels for the transitional John III window, is most likely a *vidimus* or contract drawing, as it is essentially identical with the completed window and does not, in my opinion, represent the way Van Orley's version would have looked, nor is it equal to Van Orley's capabilities as a draftsman.[69] In fact, no known drawings by Van Orley for stained-glass commissions exist, although a group of sheets by one of his more active workshop artists is generally believed to have functioned as small cartoons for a glass series (Fig. 11). This artist, whose oeuvre I have codified under the conventional name Master of the Raleigh Ascension and Pentecost, after two paintings in the North Carolina Museum of Art, worked in a style very close to Van Orley's most extravagant manner, best exemplified by the *Vertu de Patience* (Fig. 2).[70] Nothing in Van Orley's drawing oeuvre is comparable to these highly finished charcoal *patronen*, but it is reasonable to assume that their style and technique represent a mode Van Orley could have used for a small cartoon.

If we have no large cartoons or stained-glass drawings by Van Orley, however, we are fortunate to have abundant riches in the area of "small-scale drawings" and cartoons: several dozen studies for tapestries, some of them

[68] Yvette Vanden Bemden, in *Portugal et Flandres. Visions de l'Europe (1550–1680). Europalia Portugal* (Brussels, 1992), 126–128, no. 1; Van den Boogert, "Habsburgs imperialisme" (as in note 13).

[69] Farmer, "Bernard van Orley" (as in note 1), 315–322.

[70] Ibid., 253–258, 301–302. One of the drawings from this group is discussed at length by John Oliver Hand, in *The Age of Bruegel* (as in note 23), 239–241, no. 92.

monogrammed and dated, and all in the same pen-and-ink technique that Van Orley preferred. That they are tapestry studies is also indisputable. Many pre-figure existing weavings, and the rest treat subject matter (courtly, mythological, or allegorical topics) that does not appear in Van Orley's painted oeuvre but is clearly appropriate for court and secular tapestries. This early stage of the design process was dominated by the artist himself, and as Van Orley began to paint less, he focused his personal skill and energies increasingly on designing monumental tapestry compositions. Two of these drawings give enough typical information to exemplify the larger group. The first is the small cartoon for *March: The Departure for the Hunt* (Fig. 12), the initial composition in the *Belles Chasses* series.[71] Despite one recent scholarly demur, critics agree that this series is surely the work of Van Orley: both Van Mander and Félibien report his authorship, which is confirmed by stylistic analysis showing that the drawings and tapestries are firmly in Van Orley's manner.[72] This tapestry series has particularly fascinated historians for its ingenious combination of realism in landscape, narrative, and portraiture, brought together within a traditional zodiacal and allegorical framework. It is, moreover, visually sumptuous, an extraordinary artistic achievement. All these qualities are to a great extent already found in Van Orley's surviving drawings. In the *March* drawing, the hunting party gathers before a panoramic view of Brussels: at the left stands the ancient seat of nobility, the Coudenberg (destroyed in the eighteenth century); in the center is the tower of Brussels' famous Hôtel de Ville; the old city wall is in the middle ground; and at the far right is one tower of the cathedral of St. Gudule.[73] The drawing technique is sure and lively throughout, using pen and ink with freely applied washes to suggest how the massing of form and color would appear in the final, woven version. Presumably there were earlier sketches for all parts of the design, and some of these drawings reveal their working nature, since they are marked with notations and pasted-over corrections.[74] The Leiden drawing evidently represents the summation of the first stage of the design process. It demonstrates that Van Orley was adept at all

[71] Leiden, Kunsthistorisch Instituut der Rijksuniversiteit, Prentenkabinet, inv. 2047.

[72] For this series, see Arnout Balis et al., *Les Chasses de Maximilien* (Paris, 1993). See also Farmer, "Bernard van Orley" (as in note 1), 287–294; Ainsworth, "Orley as a Designer" (as in note 8); Roger d'Hulst, *Flemish Tapestries from the Fifteenth to the Eighteenth Century* (New York, 1967), 171–182. Sophie Schneebalg-Perelman, *Les Chasses de Maximilien. Les énigmes d'un chef-d'oeuvre de la tapisserie* (Brussels, 1982) believes Pieter Coecke van Aelst designed the series and François Borreman the landscapes. Guy Delmarcel, "Les Tapisseries des Chasses de Maximilien: Rêve et réalité," *Revue belge d'archéologie et d'histoire de l'art* 53 (1984), 119–128, refutes her views.

[73] Guy C. Bauman, "A Rosary Picture with a View of the Park of the Ducal Palace in Brussels, Possibly by Goswijn van der Weyden," *Metropolitan Museum Journal* 24 (1989), 135–151, is the most recent of many articles treating contemporaneous views of Brussels and especially the Coudenberg complex.

[74] E.g., drawings for the *Nassau Genealogy* series in Munich and Rennes, and for the *Belles Chasses* series in the Louvre.

aspects of representation—architecture, close observation of nature, landscape, and active figures—and suggests that the intervention of specialists, as discussed above, would not occur until a later stage of a major work, or throughout the creation of less exalted commissions.

Because the right to design historiated tapestries belonged exclusively to the painters, as codified in a 1476 agreement with the weavers, it was only after the final working drawing had been made that cartoon specialists took over and aggrandized the composition. The cartoon that served as the weavers' model was full scale and reversed, since the composition would be properly returned to its original sense during the mirror imaging that took place on the loom. Few of these full-scale cartoons have survived (none from a series by Van Orley), probably because of the way they were used: cut into strips and often brought into service many times if the composition was a popular one, like the many versions of the *Belles Chasses* series. Guy Delmarcel notes that, while thousands of tapestries and even hundreds of small cartoons have survived, full-scale cartoons or fragments number only in the dozens.[75] In fact, the best remaining contemporaneous example of a surviving cartoon, Raphael's *Acts of the Apostles*, now in the Victoria and Albert Museum, is not northern, although it is the model for a series woven in Brussels.[76] Only one drawing connected to a Van Orley series shows evidence for the transitional step to the final cartoon, and its peculiar nature renders it uncertain. In 1927, A. E. Popham recognized that a drawing in the British Museum attributed to Rubens was a fragment of one of the *Belles Chasses* compositions, larger in scale than the small cartoons and reversed, and proposed that this was a rare example of the intermediary step.[77] Because it is only a fragment, and largely overdrawn by Rubens, it is difficult to conclude with any certainty if Van Orley's hand can still be seen at this stage.

Most evidence suggests that Van Orley's contribution typically ended with the working drawing or small cartoon, an idea supported by the *March* sheet. The 1476 agreement essentially created a new category of painters, the *cartonniers*, and the weavers thereafter controlled the cartoons for their own production needs. A well-known contract documents the expenses and creators for

[75] Guy Delmarcel, "L'auteur ou les auteurs en tapisserie. Quelques réflexions critique," in *Le dessin sous-jacent dans la peinture*, colloque IV, 1981 (Louvain-la-Neuve, 1982), 43–48.

[76] John Shearman, *Raphael's Cartoons in the Collection of Her Majesty and the Tapestries for the Sistine Chapel* (London, 1972). For examples of Flemish cartoons, see Nicole Dacos, "Tommaso Vincidor. Un élève de Raphael au Pays-Bas," in *Relations artistique entre les Pays-Bas et l'Italie à la Renaissance. Etudes dédiées à Suzanne Sulzberger* (Brussels and Rome, 1980), 61–90; and idem, "Fortune critique de Pedro Campaña-Peeter de Kempeneer. De Pacheco à Murillo et à Constantin Meunier," *Revue belge d'archéologie et d'histoire de l'art* 53 (1984), 91–117, esp. figs. 13, 14.

[77] A. E. Popham, "An Orley Drawing Retouched by Rubens," *Old Master Drawings* 1 (1927), 45–47, pl. 53.

each stage in the production of the 1513 Herkenbald Tapestry. The Brotherhood of the Holy Sacrament paid 2.5 Rhenish florins and two pots of wine to "maitre Jan van Brussel" for the project (small cartoon), 13.5 Rhenish florins to "Philippe le peintre" for the large cartoon, and 18 and 12 florins to "Leon le tapissier" for the weaving.[78] In this case, probably typical, the master painter provided the small cartoon, a painter (not described as a master and therefore probably a specialist journeyman) enlarged the composition to a full cartoon, and the weaver completed the process.

Although no data survives to suggest that Van Orley was directly involved in any step beyond the small cartoon, comparison of these small cartoons with existing weavings reveals just how closely the cartoonist must have followed Van Orley's sketch. In the *March* tapestry, for example, the most significant differences are to be found in the growing profusion of detail as the scale of the composition increases (Fig 13). In other series, such as the *Battle of Pavia*, the weavings reproduce Van Orley's drawings very faithfully, suggesting a substantial degree of supervision by this designer over the continuing production of the tapestry beyond the small cartoon. The extraordinary quality of every aspect of these large-scale compositions—figures, landscapes, vegetation—indicates that the cartoonists were talented artisans, able to translate Van Orley's shorthand into sumptuous detail, and that the weavers were indeed worthy of their international reputation.

Van Orley's drawings for another series, the so-called *Nassau Genealogy* (Fig. 14), are unusual for the time because two include designs for the tapestry borders.[79] Since this part of the tapestry was normally the domain of the weavers, these drawings indicate that Van Orley was able to overstep boundaries, particularly in the case of a court commission. And, although the tapestries themselves have disappeared, so that we cannot compare drawings and weavings, these border designs are entirely consistent with those in all of his tapestries, displaying a conception that represents a major advance from the typical border of his time. From the earliest attributable work in Van Orley's tapestry oeuvre, the *Legend of Notre-Dame du Sablon* series, dated 1518, his borders are richer, wider, more pictorial, and more inventive than the generic borders presumably devised by the weavers.[80] Because Van Orley sometimes designed his borders to relate to the central composition and would frequently

[78] Guy Delmarcel, in *Tapisseries bruxelloises de la pré-Renaissance*, exhib. cat., Musées Royaux d'Art et d'Histoire (Brussels, 1976), 78–83, no. 19.

[79] Farmer, "Bernard van Orley" (as in note 1), 274, 285–286. The drawings are in Munich, Staatliche Graphische Sammlung; inv. nos. 17 and 20 include border designs. Wolfgang Wegner, *Die niederländischen Handzeichnungen des 15.–18. Jahrhunderts* (Berlin, 1973), 22–25, nos. 82–85, pls. 8–11.

[80] The Sablon series is now divided among several collections. Anne van Ruymbeke, in *Tapisseries bruxelloises* (as in note 78), 85–99, nos. 20–23.

include classical elements in them, it is apparent that he conceived of tapestry and border as a unified composition and, in so doing, was able to transcend the painter/designer's customary limits.

Our knowledge of the continuation of Van Orley's workshop after his death rests on inference. The fact that more paintings and a tapestry related to the Bruges *Crucifixion* were produced while this large painting was still in the workshop suggests that activity continued. It is quite likely that some paintings classified as workshop productions, if dated by scientific means, would prove to postdate Bernard's death. Historically, it was common for children to continue in their father's *métier*, but none of Van Orley's offspring can be securely documented as an artist. Jerome, the son cited in documents certifying the sale of the St. Gudule window cartoons, is described as a *kunstschilder* in a document of 1771 which relates testimony dating from 1602,[81] but no signed or documented works from any of Bernard's progeny are identifiable today.

Van Mander describes Michiel Coxcie as a pupil of Van Orley, and Nicole Dacos hypothesizes that Peeter de Kempeneer's earliest works are to be found among the works attributed to Van Orley or his workshop.[82] It is not likely, however, that either of these artists took over their presumed mentor's workshop, since both had left Brussels for other countries and established their own careers and ateliers long before Van Orley's death. Documents cited above show that Coxcie had to purchase the small drawings for the St. Gudule windows from Van Orley's heirs in order to continue the commission. If the securely attributable works of these two younger artists show little stylistic connection to the work of Van Orley and no documented relationship to the atelier, they do indicate a decidedly similar method of production. Both Coxcie and Kempeneer were productive painters with a rather amorphous oeuvre which includes numerous "workshop quality" paintings. Moreover, both were active as tapestry designers and, in Coxcie's case, demonstrably as a stained-glass designer as well. While their production is not as well defined as that of Van Orley, the interpretation of available information does suggest that his workshop practice was the model for theirs.

## Conclusion

Bernard van Orley was the head of a large and active atelier, ready to manufacture a prolific assortment of art works for every level of patronage as well as the

---

81 Rapport du magistrat de Bruxelles du 27 septembre 1771, copyboeck no. 37, Archives communales, fol. 169.

82 Nicole Dacos, "Autour de Bernard van Orley. Peeter de Kempeneer et son compagnon," *Revue de l'art* 75 (1987), 17–28.

free market. In painting, his range and productivity are comparable to those of other artists of his time, such as the Master of Frankfurt or Joos van Cleve. The highlights of his oeuvre, like theirs, are singular works of very high quality, which were undoubtedly special commissions. Concentrated in the first decade of his known career, these paintings are of a consistent quality, often signed, and reveal his direct role in the conception and actual painting. Alongside these are paintings created for the market, mostly formulaic devotional compositions and repetitious portraits produced for the courts he served. The calibre of these paintings rises and falls considerably from composition to composition, but always remains at a technical and artistic level below that of the major commissions. Moreover, this type of workshop production grew steadily as the output of fine, individual paintings declined in the 1520s.

The quantity of surviving paintings testifies to the presence of numerous assistants, who became increasingly responsible for Van Orley's workshop production. They ranged from poor to talented, including some with distinctive hands, and among this group were undoubtedly specialists in such areas as architecture or landscape. These assistants worked from all manner of models, which can be identified largely through inference: drawings of individual motifs to be combined in diverse ways, small cartoons or sketches, full cartoons allowing mechanical reproduction, and the original paintings themselves. The strengths and weaknesses of these models are also inconsistent. By the late 1510s, even the models may have been prepared by assistants.

As Van Orley's direct involvement in painting diminished, his activity in designing tapestries and then stained glass gained momentum. Works in these mediums could borrow both full compositions and individual motifs from the atelier's store of models. In one case, a tapestry cartoon depicting the Lamentation may have been used for part of the composition of a painting, but most frequently individual elements or larger groups were recycled by some means that allowed for a change in scale. Models were extensively shared, reused well beyond the boundaries of Van Orley's workshop or of his lifetime.

A large number of drawings from Van Orley's hand, almost all small cartoons for tapestries, clarifies the extent and skill of his design activity. Typically, the designer did not work directly beyond the stage of the small cartoon, since these later stages were produced by journeymen specialists or members of other *métiers*, and there is no evidence that Van Orley was an exception to this rule. Still, the close correspondence of finished tapestry to small cartoon indicates that he exercised more than the painter's usual authority throughout the entire process. His inclusion, in two small cartoons, of borders, an aspect of design that was not normally the province of the painter/designer, is one indication that he enjoyed an exceptional status, outside the traditions established for *métiers* in the previous century. That these particular cartoons represent a court

commission and that Van Orley was a court artist is probably significant for his ability to transcend guild limitations.

The survival of so many of Van Orley's small cartoons, some for series or individual tapestries that may never have been woven, suggests that these works were held in high esteem, by his own workshop and heirs as a resource, then perhaps by subsequent artists, and finally by collectors for their artistic value. Evidence for the continuation of his workshop after his death is meager, but it most likely did continue, given some clues and historical precedent. Peeter de Kempeneer and Michiel Coxcie, who may have been his pupils, were active in the same artistic fields he occupied and may have followed the model of his workshop. As Van Orley's atelier evolved into a design center, in fact, it prefigured working methods of the late sixteenth and seventeenth centuries throughout the Netherlands.

THE DAHESH MUSEUM
NEW YORK

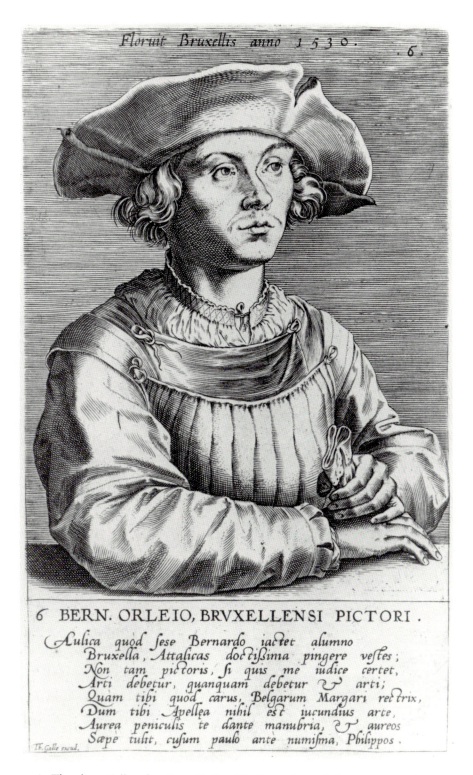

6 BERN. ORLEIO, BRVXELLENSI PICTORI.

Aulica quod sese Bernardo iactet alumno
  Bruxella, Attalicas doctissima pingere vestes;
Non tam pictoris, si quis me iudice certet,
Arti debetur, quanquam debetur & arti;
Quam tibi quod carus, Belgarum Margari rectrix,
Dum tibi Apellea nihil est iucundius arte,
Aurea peniculis te dante manubria, & aureos
Sæpe tulit, cusum paulò antè numisma, Philippos.

Th. Galle excud.

1. Theodoor Galle, after Cornelis Cort(?), *Bernard van Orley*, engraving, from
Domenicus Lampsonius, *Pictorum aliquot celebrium Germaniae inferioris effigies*
(Antwerp, 1573)

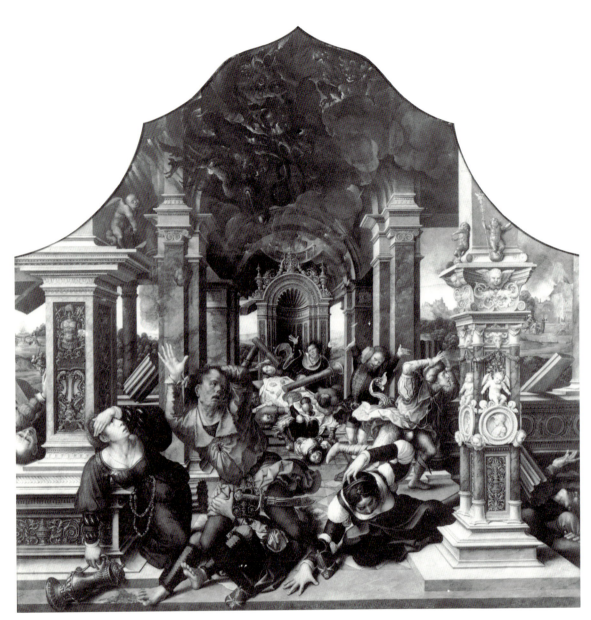

2. Bernard van Orley, *La Vertu de Patience* (center panel), 1521, oil on panel. Brussels, Musées Royaux des Beaux-Arts (photo: ©A.C.L.)

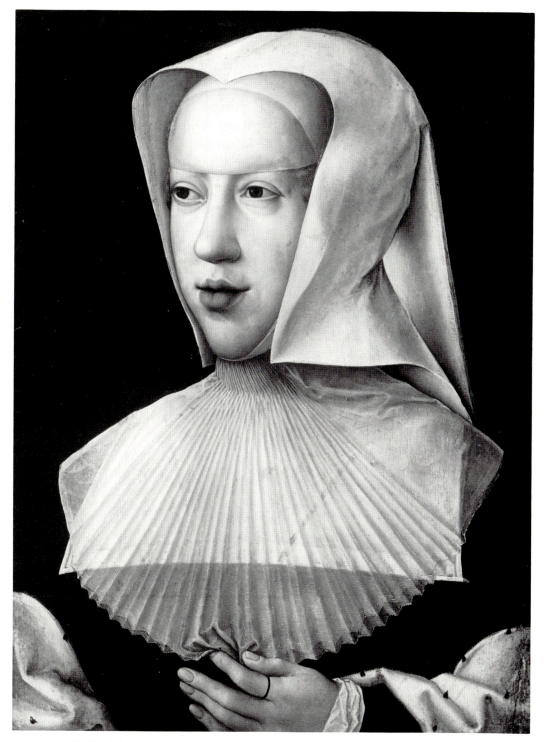

3. Workshop of Bernard van Orley, *Margaret of Austria*, oil on panel. Brussels, Musées Royaux des Beaux-Arts (photo: ©A.C.L.)

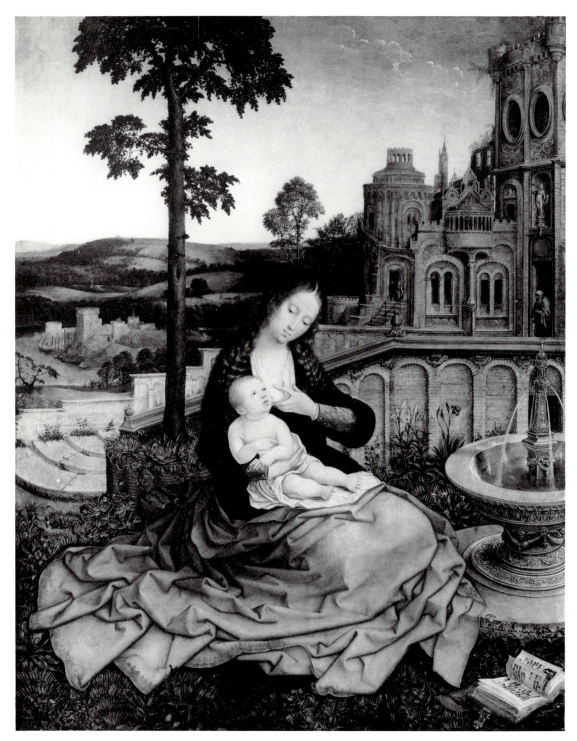

4. Bernard van Orley and workshop, *Virgin and Child*, oil on panel. Glasgow Art Gallery and Museum (photo: museum)

5. Bernard van Orley, *Lamentation with Donors Philippe and Margaret Haneton, Their Children, and Patron Saints*, oil on panel. Brussels, Musées Royaux des Beaux-Arts (photo: ©A.C.L.)

6. After Bernard van Orley, *Lamentation*, tapestry. Washington, D.C., National Gallery of Art, Widener Collection (photo: museum)

7. After Bernard van Orley, *Adoration of the Magi*, tapestry. New York, Metropolitan Museum of Art, Bequest of Benjamin Altman, 1913 (photo: museum)

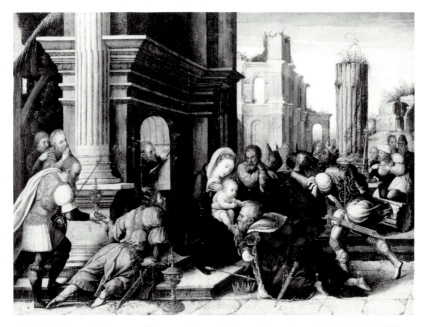

8. Workshop Assistant of Bernard van Orley, *Adoration of the Magi*, 1533, oil on panel. Formerly Kreuzlingen, Kisters Collection, present whereabouts unknown (photo: Schwitter)

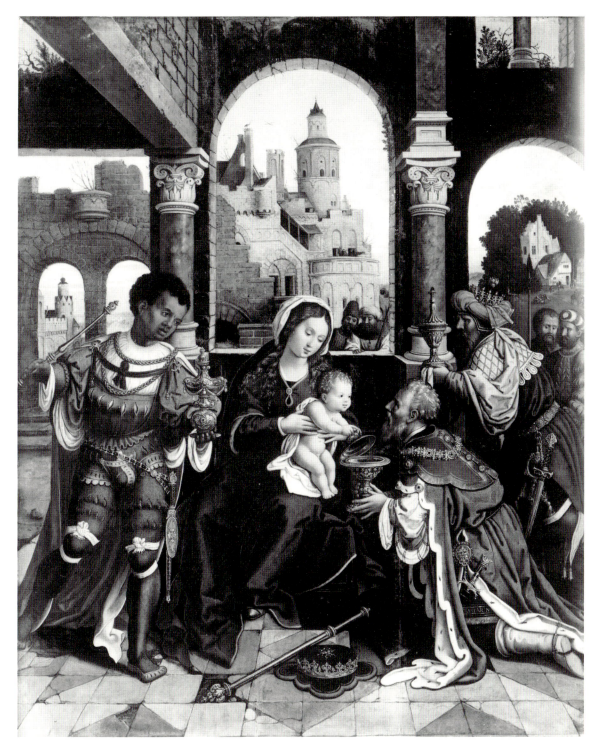

9. Unknown artist, circle of Bernard van Orley, *Adoration of the Magi*, oil on panel. Munich, Schloss Schleissheim (photo: Bayerische Staatsgemäldesammlungen)

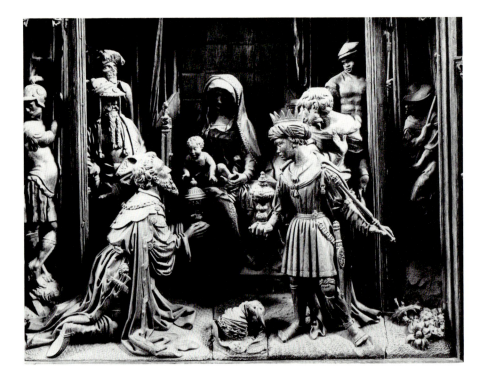

10. Jan Borman(?), *Adoration of the Magi*, detail of carved altarpiece. Lombeek, Onze-Lieve-Vrouwkerk (photo: ©A.C.L.)

11. Master of the Raleigh Ascension and Pentecost, *Christ Appearing to the Apostles*, charcoal, white heightening. Brussels, Musées Royaux d'Art et d'Histoire (photo: ©A.C.L.)

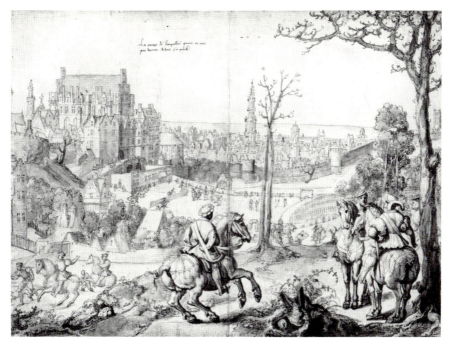

12. Bernard van Orley, *March: Departure for the Hunt*, pen, ink, and wash on paper.
Leiden, Kunsthistorisch Instituut der Rijksuniversiteit, Prentenkabinet (photo: museum)

13. After Bernard van Orley, *March: Departure for the Hunt*, tapestry. Paris, Musée du Louvre
(photo: Cliché des Musées Nationaux)

14. Bernard van Orley, *Johan, Count of Nassau, and His Wife, Elisabeth of Hesse, with His Sister Anna and Sister-in-Law Zimburga*, pen, ink, and wash on paper. Munich, Staatliche Graphische Sammlung (photo: museum)

# *Saint Jerome in His Study* by Joos van Cleve*

## JOHN OLIVER HAND

❖

IN 1982, THROUGH THE GENEROSITY of Joseph F. McCrindle, The Art Museum, Princeton University, acquired a handsome depiction of *Saint Jerome in His Study* (Fig. 1), dated 1528, which I believe to be an autograph work by Joos van Cleve.[1] Apart from two brief citations, the painting is unpublished.[2] Saint Jerome (ca. 342–420) is arguably the most visually interesting and represented of the four Latin church fathers (the other three are Augustine, Gregory, and Ambrose), and he held a position of special significance in northern Renaissance European art and thought. The Princeton panel is one of several Saint Jeromes by Joos van Cleve and his atelier, but before I discuss the theme, I would like to make some remarks on the life of the artist.

Joos van Cleve is mentioned in several Antwerp legal documents as "Joos van der Beke alias van Cleve."[3] The exact date and place of his birth are unknown, but it is likely that he came from the region around the lower Rhenish city of Kleve. He entered the workshop of Jan Joest and assisted him in painting the wings of the high altar in the church of Saint Nicholas in Kalkar, which were

* This article is affectionately and respectfully dedicated to Professor Robert A. Koch, who introduced me to Joos van Cleve and whose erudition, patience, and love of outrageous puns helped guide me through the intricacies of writing my doctoral dissertation on this artist. I am indebted to Allen Rosenbaum, Betsy Rosasco, and Norman Muller for their encouragement and assistance in preparing this article, which originally appeared in the *Record of The Art Museum, Princeton University* 49, no. 2 (1990), 2–10, and is reprinted here with permission.

[1] Gift of Joseph F. McCrindle. Oil on oak, 39.7 × 28.8 cm (y1982-76). The back of the panel is covered with linen, coated with gesso, and painted black. At the top of the reverse are three sets of numbers stenciled in black: *1400 B2/895 EC/756 FV*. No previous provenance is known.

[2] *Record of The Art Museum, Princeton University* 42, no. 1 (1983), 50, repro.; *Selections from The Art Museum, Princeton University* (Princeton, 1986), 79, repro.

[3] For the artist's life through documents, see John Oliver Hand, "Joos van Cleve: The Early and Mature Paintings" (Ph.D. diss., Princeton University, 1978), 12–19.

begun in 1505 and installed in 1508. His participation is confirmed by a self-portrait that appears in the altar's *Raising of Lazarus* panel.[4]

Sometime after 1508 Joos immigrated to the Netherlands; he may have gone first to Bruges before he settled in Antwerp, where in 1511 he was accepted as a freemaster in the guild of Saint Luke. Antwerp, the commercial and financial hub of Europe in the early sixteenth century, was a rapidly growing center for artistic production and thus an attractive city for a young, ambitious painter. Codeacon of the painters' guild in 1519, 1520, and 1525, Joos presented his pupils to the guild in 1516, 1523, 1535, and 1536. From his first marriage to Anna Vydts, two children resulted: a daughter and a son, Cornelis, born in 1520, who became a painter. A measure of his evident prosperity is his purchase in 1528 of a house in Antwerp from his wife's parents.

Joos is not documented in Antwerp between 1529 and 1534 and so it seems probable that he was working in France and Italy during this period. Lodovico Guicciardini wrote in 1567 that Joos's skill as a portraitist caused him to be summoned to the court of Francis I of France.[5] The existence of portraits by Joos of Francis I (John G. Johnson Collection, Philadelphia Museum of Art) and Eleanor of Austria (Royal Collection, Hampton Court), whom Francis married in 1530, helps to verify Guicciardini's statement.

By 1535 Joos was back in Antwerp. On November 10, 1540, he made his will and testament. Although the exact date of his death is not known, we know that it occurred before April 13, 1541, when his second wife, Katlijne van Mispelteeren, is mentioned as a widow.

The name of Joos van Cleve was lost from the seventeenth century to the end of the nineteenth century, at which time several attempts were made to identify the artist named the Master of the Death of the Virgin, after a triptych now in the Wallraf-Richartz-Museum, Cologne. In 1894 Eduard Firmenich-Richartz recognized the complex monogram in the window of the center panel of the Cologne *Death of the Virgin* altarpiece (Figs. 2 and 3) as that of Joos van Cleve, alias Joos van der Beke.[6] During the 1920s and 1930s Joos's oeuvre was reconstituted by Ludwig Baldass and Max J. Friedländer.[7] Joos is now recognized as

[4] Jan Białostocki, "Joos van Cleve in dem Kalkarer Altar," in *Kunsthistorische Forschungen Otto Pächt zu seinem 70. Geburtstag* (Salzburg, 1972), 189–195.

[5] *Descrittione di M. Lodovico Guicciardini Patritio fiorentino di tutti i Paesi Bassi, altrimenti detti Germania Inferiore* (Antwerp, 1567), 98: "Gios di Cleves cittadino d'Anversa rarissimo nel colorire, & tanto eccellente nel ritrarre dal naturale, che havendo il Re Francesco primo mandati qua huomini a posta, per condurre alla Corte qualche maestro egregio, costui fu l'eletto, & condotto in Francia ritrasse il Re, & la Regina."

[6] Eduard Firmenich-Richartz, "Der Meister des Todes Mariä, sein Name und seine Herkunft," *Zeitschrift für bildende Kunst* 5 (1894), 187–194. See Hand, "Joos van Cleve" (as in note 3), 1–11, for the various opinions put forward in the nineteenth century for the possible identity of the Master of the Death of the Virgin.

[7] Ludwig Baldass, *Joos van Cleve. Der Meister des Todes Mariä* (Vienna, 1925); Max J. Friedländer, *Die altniederländische Malerei*, 14 vols. (Berlin and Leiden, 1924–37), vol. 9 (1931).

one of the most important and accomplished artists working in Antwerp in the first decades of the sixteenth century.

Joos produced three types of images of Saint Jerome. The earliest of these, dating ca. 1515/1518, is the *Saint Jerome in Penitence* (Fig. 4) in the Muskegon Museum of Art, Michigan.[8] Here Jerome's penitence is based on an incident in the saint's life between 374 and 376 A.D., when he retired into the solitude of the desert of Chalcis to live as a hermit. He later recounted in a letter written in 384 to his disciple Eustochium:

> Oh, how often, when I was living in the desert, in that lonely waste, scorched by the burning sun, which affords to hermits a savage dwelling place, how often did I fancy myself surrounded by the pleasures of Rome! . . . My face was pale with fasting; but though my limbs were cold as ice my mind was burning with desire, and the fires of lust kept bubbling up before me when my flesh was as good as dead.
>
> And so, when all other help failed me, I used to fling myself at Jesus' feet. . . . I remember that often I joined night to day with my wailings and ceased not from beating my breast till tranquility returned to me at the Lord's behest.[9]

In the Muskegon panel, an emaciated Jerome, kneeling in front of a crucifix and a painting of the Virgin, stone in hand, attempts to overcome his visions of Roman dancing maidens. Behind him are the red hat and cloak of a cardinal. (Apparently in order to elevate him to the same status and rank as the other church fathers, Jerome received the anachronistic title of cardinal in the twelfth century and was often depicted as such from the mid-fourteenth century onward.) At the far left is Jerome's second major attribute, the lion, a reference to the legend in which the saint removed a thorn from the lion's paw, gaining the beast's eternal gratitude and companionship.

The theme of the penitent Saint Jerome, which is basically Italian in origin but was found in the north by the late fifteenth century, could have been known to Joos through Albrecht Dürer's prints and Gerard David's and Jan Gossaert's paintings.[10]

---

[8] Hand, "Joos van Cleve" (as in note 3), 119–122, 296, no. 12; Baldass, *Joos van Cleve* (as in note 7), no. 14; Friedländer, *Altniederländische Malerei* (as in note 7), vol. 9, no. 41. More recently, see Shirley Reiff Howarth, *European Painting, Muskegon Museum of Art* (Muskegon, Michigan, 1981), 12, 78–81.

[9] Saint Jerome, *Select Letters of Saint Jerome* (Loeb Classical Library, London, 1953), 66–69.

[10] See Louis Réau, *Iconographie de l'art chrétien*, vol. 3, pt. 2 (Paris, 1958), 742–744. Dürer's earliest engraving of this theme (Bartsch 61) is dated ca. 1495 and a woodcut (Bartsch 113) is dated 1512; both are reproduced in Wolfgang Hutt, *Albrecht Dürer, 1471 bis 1528. Das gesamte graphische Werk*, 2 vols. (Munich, 1970), vol. 1, 1868, 1703, respectively. Paintings of the penitent Saint Jerome by Gerard David are in the Städelsches Kunstinstitut, Frankfurt, and The National Gallery, London; reproduced in Max J. Friedländer, *Early Netherlandish Painting*, 14 vols. (Leiden and Brussels, 1967–76), vol. 6, pt. 2 (1971), pl. 226, nos. 220, 221. For Jan Gossaert's *Saint Jerome Penitent* in the National Gallery of Art, Washington, D.C., see John Oliver Hand and Martha Wolff, *Early Netherlandish Painting. The Collections of the National Gallery of Art. Systematic Catalogue* (Washington, D.C., 1986), 99–103.

The Princeton *Saint Jerome in His Study* exemplifies Joos's second type of image of Saint Jerome, showing him in an interior as a scholar, linguist, and man of letters.[11] In his youth in Rome, Jerome had studied both Christian and pagan literature and was especially fond of Cicero.[12] As part of his deepening spirituality and asceticism, Jerome undertook a serious study of Greek and later acquired, at great effort, a knowledge of Hebrew. His highest achievement, which occupied him for over twenty years, was his translation into Latin of all of the Old Testament and most of the New Testament, based in large part on his mastery of Greek and Hebrew biblical texts. Jerome's translation, known from the sixteenth century on as the Vulgate Bible (*Biblia Sacra vulgatae editionis*), became the standard authoritative version for the Catholic church. In addition to carrying on a voluminous and often argumentative correspondence, Jerome also wrote substantial commentaries on the four major and twelve minor prophetic books of the Old Testament, the epistles of Paul, the book of Ecclesiastes, and the gospel of Matthew. No wonder that in the minds of many, Saint Jerome was the quintessential scholar. In the foreground of the Princeton painting, the quill pen in the inkpot, the eyeglasses, the scroll of paper, and the book on the lectern refer to Jerome's scholarship and love of learning.

The most famous image of the saint as a peaceful savant hard at work in his monastic cell is Dürer's engraving of 1514 (Fig. 5).[13] Its influence is visible in Joos's Princeton *Saint Jerome in His Study*, most immediately in the lead-shot windows at the left and in the distinctive reflections cast by the circular panes. No source exists for the window with crossed mullions reflected in the stoppered carafe on the shelf at the upper right, but we may speculate whether this convention for illustrating glass also refers to Dürer.[14] The string of beads hanging from the shelf, the aspergillum suspended next to it, and the candlestick holding an extinguished candle at the lower right have their counterparts in Dürer's engraving.

Of even greater importance was Dürer's painting of *Saint Jerome* (Fig. 6) in the Museu de Arte Antiga, Lisbon, dated 1521, which he executed during his stay in Antwerp.[15] Along with other Netherlandish artists, Joos fell under the

---

[11] See Anna Strümpell, "Hieronymus im Gehäuse," *Marburger Jahrbuch für Kunstwissenschaft* 2 (1925/1926), 173–252; Millard Meiss, "French and Italian Variations on an Early Fifteenth-Century Theme: St. Jerome and His Study," *Gazette des Beaux-Arts* 62 (1963), 147–170; Otto Pächt, "Zur Entstehung des 'Hieronymus im Gehäus,'" *Pantheon* 21 (1963), 131–142.

[12] For a *vita* of Saint Jerome, see *Butler's Lives of the Saints*, vol. 3 (New York, 1963), 686–693; Réau, *Iconographie de l'art chrétien* (as in note 10), 740–750; and recently, Eugene F. Rice, Jr., *Saint Jerome in the Renaissance* (Baltimore and London, 1985), 1–22.

[13] Erwin Panofsky, *The Life and Art of Albrecht Dürer* (Princeton, 1955), 154–156.

[14] Jan Białostocki, "The Eye and the Window: Realism and Symbolism of Light-Reflections in the Art of Albrecht Dürer and His Predecessors," in *Festschrift für Gert von der Osten* (Cologne, 1970), 159–176.

[15] Fedja Anzelewsky, *Albrecht Dürer. Das malerische Werk* (Berlin, 1971), 259–260, no. 162, pl. 177. For the influence of Dürer's painting on Netherlandish artists, see Julius S. Held, *Dürers Wirkung auf die niederländische Kunst seiner Zeit* (The Hague, 1931), 87, 139–140.

spell of this painting and in the Princeton panel appropriated the half-length format and the melancholy pose of the saint, who supports his head in his hand and emphatically points to a skull.

The pessimism of Dürer's painting, with its warning of the nearness and inevitability of death, is, if anything, made more explicit in Joos's work. The words *HOMO BULLA* (Man is a Bubble) inscribed on a placard on the back wall sound the theme of the vanity and ephemerality of human life, reinforcing the central meaning of the skull as a memento mori.[16] The extinguished candle may be seen in this context as a symbol of the transience of life.[17]

Through Christianity, however, we overcome death, and in this regard the aspergillum, used in Christian ceremonies to exorcise evil spirits, and the rosary beads, used in Christian prayer, become significant.[18] Further, the fruit on the window ledge may allude to the fruit of original sin and to Christ as the new Adam whose death redeems the sin of humanity.

I have not been able to transcribe fully the Netherlandish text on the page in front of Saint Jerome (Fig. 7), but I believe it is quite possibly Matthew 23:1–4, which begins: "Then said Jesus to the crowds and to his disciples, 'The scribes and the Pharisees sit on Moses' seat; so practice and observe what they tell you, but not what they do; for they preach, but do not practice.'" The chapter continues with Jesus preaching that all men are brothers and are neither masters nor servants, but have one master, the Christ. He castigates, in contrast, the scribes and Pharisees as hypocrites, who in denying others deny themselves entry to the kingdom of heaven. This is a warning against false prophets and false religion. It is deception and vanity to think that superficial observance is the same as true understanding and belief.

A final object in the painting subject to iconographic interpretation is the stoppered carafe holding a red liquid on the shelf at the upper right. The stoppered carafe appears with some regularity in fifteenth- and sixteenth-century Netherlandish paintings, where it is usually interpreted as a symbol of Mary's purity and virginity.[19] Mary is the vessel that contains Christ, symbolized by the carafe containing red wine, the Eucharistic blood of Christ. The presence of this Marian symbol may have a dual explanation: first, Saint Jerome was well

[16] The classic articles on this subject are Horst W. Janson, "The Putto with the Death's Head," *Art Bulletin* 19 (1937), 423–449; and Wolfgang Stechow, "'Homo Bulla,'" *Art Bulletin* 20 (1938), 227–228. The comparison of human life to a bubble is a topos found in the classical writers Lucian and Marcus Terentius Varro. See also the recent article by Brigitte Lymant, "Sic Transit Gloria Mundi, Ein Glasgemälde mit Seifenblasen als Vanitassymbol im Schnütgen-Museum," *Wallraf-Richartz Jahrbuch* 42 (1981), 115–132.

[17] See Ingvar Bergström, *Dutch Still-Life Painting in the Seventeenth Century* (New York, 1956), 15–16.

[18] See George Ferguson, *Signs and Symbols in Christian Art* (New York, 1961), 162; and W. A. Hinnebusch, "Rosary," in *New Catholic Encyclopedia*, vol. 12 (New York, 1967), 667–670.

[19] See Millard Meiss, "Light as Form and Symbol in Some Fifteenth-Century Paintings," *Art Bulletin* 27 (1945), 179, n. 27.

known for his ardent defense of Mary's perpetual virginity and for his insistence on celibacy; and second, as has been suggested in another context, the Virgin made Christ incarnate, in the same way Jerome's translation of the scriptures made the word of God incarnate.[20]

Because of the dependence on Dürer's Lisbon painting, this second type of Saint Jerome must have originated no earlier than 1521. The Princeton panel, however, is the only version of this type known to me to bear a date; Professor Robert Koch has put forth the possibility that the date of 1528 is an homage to Dürer, who died in that year.

Joos's third type of image of Saint Jerome is a composite of the first two types with a third major iconographic element added. In a version from Joos's workshop in The Art Museum (Fig. 8),[21] Jerome is shown in an interior as a scholar and as a penitent holding a stone in his hand, and now also as a witness to the Last Judgment, indicated by the inscription on the paper in front of him ending with the words: "Arise ye dead come to judgment." While Joos was apparently the first to combine these three motifs, somewhat later paintings by Jan Massys and Marinus van Reymerswaele associate Jerome with images of the Last Judgment.

Many of the same objects in *Saint Jerome in His Study* are found here as well and bear the same or similar iconographic meanings. Like the second type, this third type dates from the 1520s onward; one version in the Norton Gallery, West Palm Beach, Florida, is dated 1530.[22]

Interestingly, while apparently only two rather weak replicas of the Muskegon *Saint Jerome in Penitence* exist,[23] there are several replicas of the second and third types from Joos's workshop as well as later copies that date well into the 1540s and 1550s.[24] In his catalogue of Joos's paintings, Friedländer questioned whether any of the various versions of the two later types were by the artist. In my dissertation, I also held to the idea that depictions of Saint Jerome were known only through atelier replicas.[25] I am now, however, prepared to

---

[20] Ingvar Bergström, "Medecina, Fons et Scrinium. A Study in Van Eyckean Symbolism and Its Influences in Italian Art," *Konsthistorisk Tidskrift* 26 (1957), 1–20, as part of his discussion of the Eyckian *Saint Jerome in His Study* in the Detroit Institute of Arts, refers to fol. 171v of the *Heures du maréchal Boucicaut* manuscript by the Boucicaut Master in the Musée Jacquemart-André, Paris, which depicts madonna lilies (*Lilium candidum*) in Jerome's study.

[21] Oil on linen, 67.8 × 57 cm (y1928-40).

[22] See John Oliver Hand, *Joos van Cleve and the Saint Jerome in the Norton Gallery and School of Art* (West Palm Beach, 1972), unpaginated.

[23] Friedländer, *Early Netherlandish Painting* (as in note 10), vol. 9, pt. 1 (1972), 59, no. 42, pl. 58, lists a *Saint Jerome Penitent* and two replicas that are related to the Muskegon composition, but, although I know them solely through photographs, I doubt that any are by Joos.

[24] Friedländer, ibid., 58, nos. 39–40, lists ten paintings, and I have collected information on another ten versions.

[25] Friedländer, ibid., 31–32; Hand, "Joos van Cleve" (as in note 3), 310, nos. 84–85, where several depictions of Saint Jerome are included in the lists of paintings known only through copies.

accept the Princeton *Saint Jerome in His Study* as by Joos van Cleve or by the artist in collaboration with his workshop. This judgment rests in large part on the quality of the execution of the painted surface, the rendering of texture, the thinly painted yet glistening skin tones, and the attention to detail, such as the bit of impasto on the folded corner of the paper on the back wall—all concomitant with the level of excellence we expect of Joos. It also takes into account the increased understanding of the complex relationship between master and assistants; it is not simply a matter of *either* master *or* workshop, both may have participated at various stages of design and execution.[26] This would seem to be particularly true of a popular and commercially successful image such as *Saint Jerome in His Study*. Of the other versions of this composition I have seen, I believe that the version in the collection of Lord Camrose, Hackwood House, Basingstoke, is on an equally high level and that the one in the collection of Prinz August van Hannover, Pattensen, which I know only from a photograph, may also be assigned to Joos van Cleve.[27]

The numerous and varied depictions of Saint Jerome by Joos and other Netherlandish artists point up the saint's importance to the intellectual and spiritual environment of northern Europe from the late fifteenth to the early sixteenth century. A major factor in this process was the interest taken in Jerome by the Dutch scholar and humanist Erasmus of Rotterdam. An admirer of the saint since his youth, Erasmus began his study of Jerome's letters in the 1490s, and in 1514 joined a team of scholars in Basel already at work on the complete writings of Jerome. The nine-volume set, *Divi Eusebii Hieronymi Stridonensis Opera Omnia* (Basel), appeared in 1516; four of the volumes containing the letters and treatises were entirely the result of Erasmus's research. The edition was soon available in Antwerp, Brussels, London, and Paris; Erasmus's depth of learning and scholarship were extravagantly and universally praised. His biography of Saint Jerome, which prefaced the edition, has long been hailed for its historical accuracy and critical acumen.[28]

Moreover, Erasmus paralleled Jerome by preparing an edition of the New

---

[26] On the complex issues of workshop activity and the marketing of art in the Netherlands, see Lorne Campbell, "The Art Market in the Southern Netherlands in the Fifteenth Century," *Burlington Magazine* 118 (1976), 188–197; idem, "The Early Netherlandish Painters and Their Workshops," in *Le dessin sousjacent dans la peinture. Le problème Maître de Flémalle-van der Weyden*, Colloque III, 1979 (Louvain-la-Neuve, 1981), 43–61; Lynn F. Jacobs, "The Marketing and Standardization of South Netherlandish Carved Altarpieces: Limits on the Role of the Patron," *Art Bulletin* 71 (1989), 207–229; Dan Ewing, "Marketing Art in Antwerp, 1460–1560: Our Lady's *Pand*," *Art Bulletin* 72 (1990), 558–581.

[27] Friedländer, *Early Netherlandish Painting* (as in note 10), vol. 9, pt. 1 (1972), 58, nos. 39a–39b, respectively, pl. 57.

[28] Rice, *Saint Jerome* (as in note 12), 116–136. The Department of Rare Books and Special Collections, Firestone Library, Princeton University, contains a copy of Erasmus's *Eximii Doctoris Hieronymi Stridonensis Vita, ex Ipsius Potissimum Literis Contexta*, Coloniae in aedibus Encharii Ceruicorni, Anno MDXVII.

Testament, published in 1516, that contained a Greek text, notes, and Erasmus's Latin translation in which he corrected portions of Jerome's Vulgate.[29] If, for Erasmus, Saint Jerome was the quintessential Christian humanist who admired and understood Christian and pagan writers alike, then, for his contemporaries, Erasmus, with his command of Greek and Latin, must have been a Jeromelike figure. Portraits of Erasmus, including those by Quentin Massys and Hans Holbein the Younger, depict him as a peaceful savant at work in his study, not unlike the saint in Dürer's 1514 engraving.[30]

Scholarly neutrality and quietude were, however, shattered by the political, religious, and economic disruptions that accompanied the Protestant Reformation.[31] Although he had long argued for reform, Erasmus's refusal to take sides caused him to be seen as an enemy of Martin Luther. Conversely, Luther did not hold either Erasmus or Saint Jerome in high regard, preferring Saint Augustine, who in his estimation placed the proper emphasis on salvation through faith alone.[32]

Antwerp during the 1520s and 1530s suffered its share of conflict. Within a year of Luther's proclamation at Wittenberg in 1517 his cause became popular, and in 1519 the Augustinian order in Antwerp declared its support of Luther. From 1521 to 1522 Luther's writings were declared heretical and publicly burned, and the Augustinians were expelled from the city. Lutheranism had nevertheless become entrenched in Antwerp, where the middle- and upper-class citizens were especially anxious in the German Peasants' War of 1525–1526 that the poorer inhabitants would unite with bands of peasants to overthrow all authority. The city magistrates managed to retain something of a separation of church and state, so that while an inquisition was formed to test religious beliefs, it was a purely ecclesiastical affair. Lutheran tracts and pamphlets were thus printed without violating civil ordinances. Although the economy of Antwerp suffered fluctuations and trade with southern Germany was sporadically disrupted, the city retained much of its vigor.

In Antwerp from 1521 onward Joos and his shop created paintings of Saint Jerome. Although it is often misleading to define works of art as simply reflect-

[29] See Johan Huizinga, *Erasmus of Rotterdam* (London, 1952), 90–91.

[30] For a discussion of Erasmus's relationship to Massys and other artists, see Georges Marlier, *Erasmus et la peinture flamande de son temps* (Damme, 1954); Erwin Panofsky, "Erasmus and the Visual Arts," *Journal of the Warburg and Courtauld Institutes* 32 (1969), 220–227.

[31] The literature on this period is enormous, but the account that follows draws heavily on Geoffrey Parker, *The Dutch Revolt* (Harmondsworth, 1985); Hajo Holborn, *A History of Modern Germany* (New York, 1959), vol. 2, *The Reformation*; John C. Olin, ed., *Desiderius Erasmus: Christian Humanism and the Reformation* (New York, Evanston, and London, 1965); Hermann van der Wee, *The Growth of the Antwerp Market and the European Economy*, 3 vols. (The Hague, 1963); Jervis Wegg, *Antwerp 1477–1559* (London, 1916); Leon Voet, *Antwerp: The Golden Age* (Antwerp, 1973).

[32] Rice, *Saint Jerome* (as in note 12), 137–140.

ing the temper of the times, Jerome's pivotal position in northern European thought is significant in the imagery of the Princeton *Saint Jerome in His Study*. The many reminders of death's inevitability and of Christ's warning contained in the gospel of Matthew that many religious leaders do not practice what they preach offer the viewer a fascinating insight into a turbulent and troubled time.

NATIONAL GALLERY OF ART
WASHINGTON, D.C.

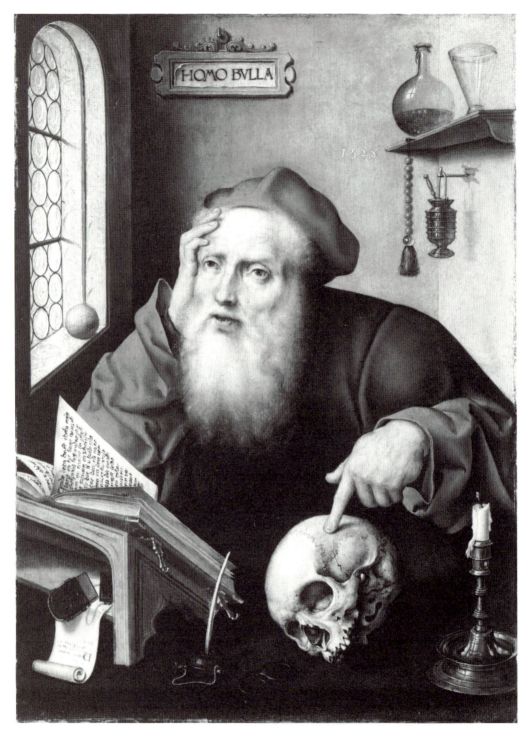

1. Joos van Cleve, *Saint Jerome in His Study*, 1528, oil on oak, 39.7 × 28.8 cm. The Art Museum, Princeton University, gift of Joseph F. McCrindle (photo: museum)

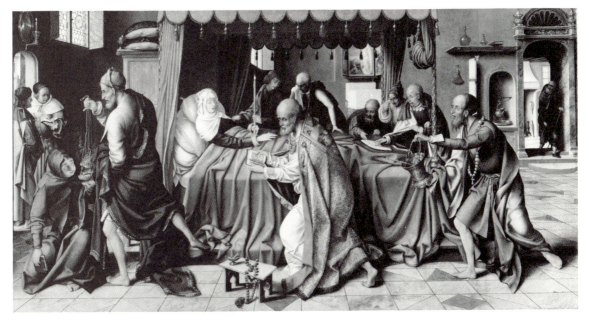

2. Joos van Cleve, *The Death of the Virgin*, 1515, center panel, 65 × 125.5 cm. Wallraf-Richartz-Museum, Cologne (photo: Rheinische Bildarchiv)

3. Detail of Fig. 2

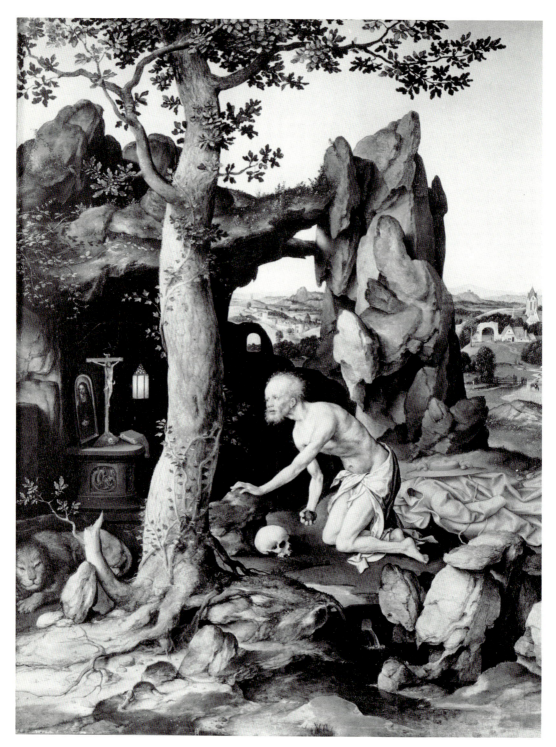

4. Joos van Cleve, *Saint Jerome in Penitence*, ca. 1515/18, oil on wood, 72 × 58.1 cm. Muskegon Museum of Art, Muskegon, Michigan (photo: museum)

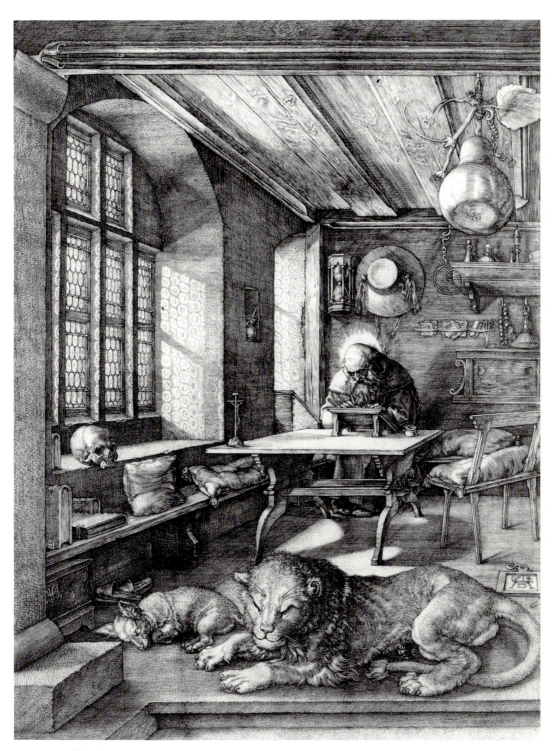

5. Albrecht Dürer, *Saint Jerome in His Study*, 1514, engraving. National Gallery of Art, Washington, D.C., Rosenwald Collection (photo: museum)

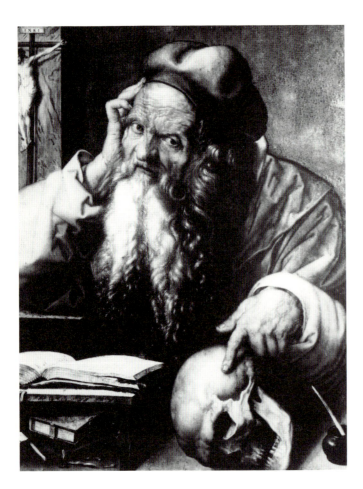

6. Albrecht Dürer, *Saint Jerome*, 1521,
oil on wood, 60 × 48 cm. Museu de Arte
Antiga, Lisbon

7. Detail of Fig. 1

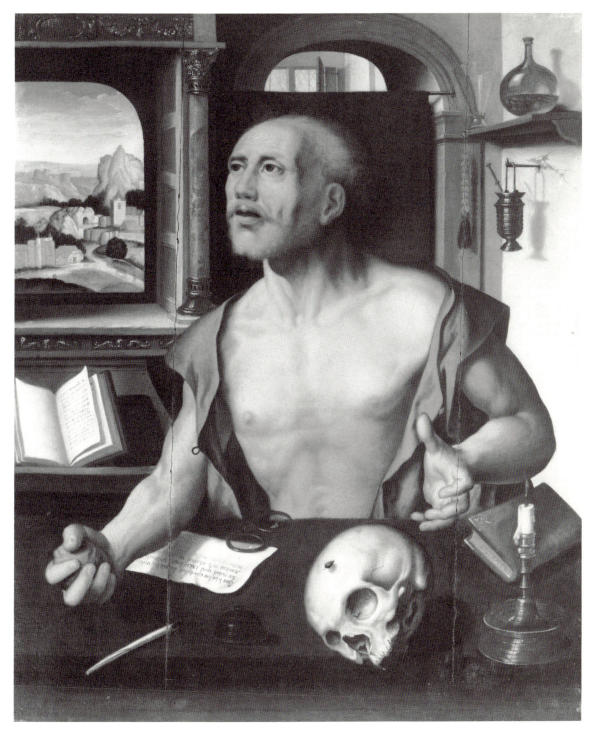

8. Workshop of Joos van Cleve, *Saint Jerome in His Cell*, oil on linen, 67.8 × 57 cm. The Art Museum, Princeton University (photo: museum)

# The Sexuality of Christ in the Early Sixteenth Century in Germany*

## CRAIG HARBISON

❧

ALONE IN A BARREN LANDSCAPE dotted with trees whose dead branches project like the thorns in his crown, the body of Christ is shown bound twice and nailed in four places to the cross (Fig. 1). The T-shaped cross is hard-edged, precisely planed. The landscape is windswept, without mourners or mockers. Christ's face is downcast, betraying anguish, even shame. Perhaps we should relate this to his nakedness: only his penis is hidden from our view. This image of a naked male body is an archetypal depiction of loneliness and, perhaps, degradation.

Although the Bible itself testified that Christ had been stripped of his clothing when he was crucified (John 19:23–24), both literary and artistic tradition throughout the Middle Ages invented ways of covering Christ's loins, most notably with the Virgin Mary's veil.[1] Hans Burgkmair, the artist responsible for the naked Christ woodcut (Fig. 1), is thought to have represented the Crucifixion in seven other woodcuts as well as several paintings.[2] In all seven Christ is

---

* I remember with sadness and thanks the good conversations I had with, and the important references I received from the late Sigrid Brauner. Sean Smith and Colin Harbison helped with the Latin translation of Geiler von Kaysersberg's *Fragmenta passionis*. I am also glad to have had the comments of my wife, Sherrill.

[1] Among the many references that could be cited here, see Sister Marie Brisson, "An Unpublished Detail of the Iconography of the Passion in *Le Chastel Perilleux*," *Journal of the Warburg and Courtauld Institutes* 30 (1967), 398–401; Philipp P. Fehl, "The Naked Christ in Santa Maria Novella in Florence: Reflections on an Exhibition and the Consequences," *Storia dell'arte* 45 (1982), 161–164, esp. 163 n. 12; and Leo Steinberg, *The Sexuality of Christ in Renaissance Art and in Modern Oblivion* (New York, 1983), esp. 28 and 32. The chief medieval source cited in this regard by Steinberg and others is the *Meditations* of pseudo-Bonaventura.

[2] For the woodcuts of the Crucifixion attributed to Burgkmair, other than that reproduced in Fig. 1, see F. W. H. Hollstein, *German Engravings, Etchings and Woodcuts, ca. 1400–1700*, vol. 5 (Amsterdam, n.d. [ca. 1958]), nos. 43–48, 58 (Burkhard 66, 74, 79, 82, 104[2], 112); the dates of these works range from 1494 to 1527. For paintings, see Tilman Falk, *Hans Burgkmair, Studien zum Leben und Werk des Augsburger Malers* (Munich, 1968), 16 (*Basilica of Sta. Croce*, 1504, Augsburg; and *Crucifixion Triptych*, 1519, Munich). The Sta. Croce Crucifixion is reproduced as pl. 14 in Falk; the Munich painting is illustrated in Bayerische Staatsgemäldesammlungen, *Alte Pinakothek München, Erläuterungen zu den ausgestellten Gemälde* (Munich, 1983), 125.

shown with a loincloth, as well as with various attendant figures. In all of them Christ's expression is gentler, resigned; his body more idealized, unbound, and lifted higher off the ground. By the time Burgkmair designed the nude Christ image, he had probably traveled to the Netherlands as well as to Italy. In both places he could have seen earlier paintings or carvings which, in various ways, toyed with the idea of the nude body of Christ beneath the loincloth. But all earlier figures had some cloth, however diaphanous, either painted on or made separately to cover Christ's genitalia.[3] The only other nude crucified Christ from Burgkmair's time known today is an Upper German panel which is almost certainly derived from his woodcut (Fig. 2).[4] The painting presents a bloodier, but also paler and softer image of Christ's body.

Burgkmair's, then, is an unusual image. What might have stimulated the artist, whose initials appear directly below the cross, to create this work in about 1510?[5] What could the artist have been feeling as he designed it? What might the original spectators have felt? How can we evaluate today the power of the image in its original context?

Fortunately, Burgkmair's woodcut has not gone unnoticed by art historians. Tilman Falk observed the existence of a tradition associating the T- or Tau-form of the cross with images used to ward off the plague. And, in fact, Burgkmair's body of Christ was adapted for a *pestblatt* (Fig. 3).[6] The artist of the plague sheet was clearly uncomfortable with Burgkmair's image of a nude godhead and substituted a rather odd loincloth, wrapped around each leg, for one set of ropes. From this it would seem that Christ's nakedness had no necessary relation to the efficacy of the work as an invocation against illness and suffering.

Leo Steinberg reproduced and discussed Burgkmair's woodcut in his analysis of the sexuality of Christ in Renaissance art in a section entitled "The Necessary Nudity of the Suffering Christ."[7] Throughout his study Steinberg eluci-

---

[3] See the references cited in note 1 above.

[4] For this work, see Irmgard Hiller and Horst Vey, *Katalog der deutschen und niederländischen Gemälde bis 1550 im Wallraf-Richartz-Museum* (Cologne, 1969), 119–120. The panel in Cologne is related to Burgkmair's woodcut by Tilman Falk, *Hans Burgkmair, Das graphische Werk, 1473–1973*, Stuttgart, Graphische Sammlung Staatsgalerie (Stuttgart, n.d.), cat. no. 58 (unpaginated). Steinberg, *Sexuality of Christ* (as in note 1), 132–133, neglected to make it clear that his reference to Christ's total nudity in Albrecht Dürer's *Large Calvary* drawing of 1505 (Florence, Uffizi) was not meant for Christ on the cross but for the large figure of Christ mocked at the lower left.

[5] The date of Burgkmair's work is said by Falk, *Graphische Werk* (as in note 4), to be scarcely later than 1510; Hollstein, *Engravings, Etchings and Woodcuts* (as in note 2), 45, no. 49, dates it 1515.

[6] See Falk, *Graphische Werk* (as in note 4). For the print reproduced in Fig. 3, see Ernest Wickersheimer, "Le Signe Tau, faits et hypothèses," *Strasbourg Medical* 88 (1928), 341–348, esp. 343, fig. 6; and Andrée Hayum, "The Meaning and Function of the Isenheim Altarpiece: The Hospital Context Revisited," *Art Bulletin* 59 (1977), 501–517, esp. 509–510, fig. 18. As Falk pointed out, the plague sheet must postdate Burgkmair's work. It copies the collapsed chest of Christ, in Burgkmair dictated by the ropes binding it; the ropes but not the sunken chest are eliminated by the later anonymous artist. Altogether, the lines in the *pestblatt* are weak, lacking the firm meaning and definition of form that they have in Burgkmair's original.

[7] See Steinberg, *Sexuality of Christ* (as in note 1), esp. 131–134.

dated the importance that Renaissance artists placed on Christ's full humanity, as they repeatedly demonstrated that on earth Christ had a male human body "complete in all its parts." While this is surely a relevant general context into which we can fit Burgkmair's image, it does not fully explain the "exceptional poignancy" (to use Steinberg's phrase) of the woodcut: for Burgkmair has isolated the crucifix, hidden Christ's penis and put a grimace on his face. This is an image in which the humanity of Christ seems to have brought with it an overriding feeling of pain.

While not discussing Burgkmair's woodcut in particular, Richard Trexler has recently addressed more generally the fears that at times made theologians, and artists, reluctant to portray a fully nude adult Christ on the cross.[8] Trexler showed not only that such an image was easily considered disrespectful, but, more importantly, that some worried it would titillate its audience, female and male alike. Admittedly, Trexler has found little direct evidence from the Middle Ages and Renaissance that men, in particular, were sexually aroused by images of the nude Christ. Yet he is right to wonder at the unusually vociferous response that greeted suggestions that Christ was crucified naked on the cross: is it only that women might have misunderstood or misused such a portrayal? One example might suffice here: the influential early fifteenth-century Parisian chancellor Jean Gerson was wary of a contemporary confusion between erotic and mystical love, and therefore wrote that he saw a danger even in contemplating the nudity of Christ on the cross.[9] Trexler has advocated searching court records to find the (rare) instance of a man sexually attracted to an image of Christ—a scholarly pursuit whose value others have questioned.[10]

But his general point—that the manipulation of such male imagery was a political act—is still worth considering. What was the particular sexual and political context of Burgkmair's work? Is there any special reason to believe that it might have been appealing to homosexual men in sixteenth-century Augsburg, Burgkmair's home? Indeed, court cases in the early 1530s in Augsburg provide remarkable substantiation for the presence of clandestine groups of homosexual men in the preceding decades.[11] These cases examined the men's

[8] See Richard Trexler, "Gendering Jesus Crucified," in *Iconography at the Crossroads*, ed. B. Cassidy (Princeton, 1993), 107–120.

[9] J. Gerson, *Opera omnia* (Antwerp, 1706), vol. 3, col. 610; cited by Meyer Schapiro, "'Muscipula Diaboli': The Symbolism of the Mérode Altarpiece," *Art Bulletin* 27 (1945), esp. 187 n. 31.

[10] As suggested by Trexler, "Gendering Jesus" (as in note 8), 113 and n. 33; but see the cautious words of Lawrence Stone, "The Revival of Narrative: Reflections on a New Old History," *Past and Present* 85 (1979), 19: "The other fashionable use of criminal records, to chart the quantitative rise and fall of various types of deviance, seems to me to be an almost wholly futile endeavor, since what is being counted is not the number of perpetrated crimes, but criminals who have been arrested and prosecuted, which is an entirely different matter."

[11] See Lyndal Roper, *The Holy Household, Women and Morals in Reformation Augsburg* (Oxford, 1989), esp. 255–257, discussing a ring of men who had committed homosexual acts and were discovered and tried in 1532–34.

sexual practices in great detail and meted out typically harsh punishments (execution, burning, limbs cut off, and exile). They also acknowledged that the men's homosexual involvement had continued for at least ten years. Such trials might mark a backlash against earlier permissiveness. Several other German artists, Albrecht Dürer and Hans Baldung Grien among them, exhibited remarkably suggestive male sexual imagery in works from the first three decades of the century.[12]

Has Burgkmair in this sense hedged his bets? He seems intent both on showing the "necessary nudity of the suffering Christ," and on withholding from view "the most secret parts of his body."[13] The sixteenth-century artist carefully stresses the body of Christ in craggy isolation. Body and landscape are both ridged, marked by harsh but anonymous external events. Does Burgkmair intend in such ways to rob his work of any particular sexual appeal? Or do these artistic devices heighten the viewer's engagement with Christ's sexuality? Burgkmair has created an image of Christ to which the viewer is given direct private access, much like that found in erotic devotional literature of both the Middle Ages and Renaissance.[14] Do the ropes bind or caress the body? Does the facial grimace elicit pity and love in the viewer? Needless to say, the history of homoeroticism in sixteenth-century German art has yet to be written; when it is, Burgkmair's woodcut might well figure in the task.

If one message received by contemporaries from Burgkmair's image was tinged by homophobia and/or homoeroticism, indulging those feelings was probably not the artist's sole purpose. As I have indicated, it is not only ordinary human loneliness that Burgkmair displays. We must go back to Leo Steinberg's insistence on the poignancy of this artist's devotional stance. "Naked to follow the naked cross (or naked Christ)" was a pious truism originated by St.

[12] Dürer's homosexual tendencies have been remarked upon recently by Colin Eisler, review of *Albrecht Dürer*, by Jane Hutchison (1990), in *Renaissance Quarterly* 45 (1992), esp. 165–166. One of Dürer's most provocative works in this regard is the *Men's Bath* woodcut (B. 128). Both Burgkmair in 1512 (Burkhard 32; Hollstein 258) and Hans Baldung Grien in 1514 (Bartsch 37; Hollstein 128) portrayed St. Sebastian in woodcuts where the saint receives an arrow directly in his groin. Similar to Burgkmair's crucified Christ, Baldung's Sebastian has his genitals hidden, if not eliminated—is the arrow a substitute penis/erection? Robert A. Koch, review of *Hans Baldung Grien, Prints and Drawings*, by James Marrow and Alan Shestack (1981), in *Master Drawings* 19 (1981), 182, pointed out that Baldung's woodcut is "susceptible to speculative interpretation." The homoerotic appeal of Sebastian is openly featured in some twentieth-century works, such as Gabriele d'Annunzio's mystery play, *Le martyre de Saint Sébastien* (1911) and the 1966 photograph of Yukio Mishima as St. Sebastian by Kishin Shinoyama (reproduced and discussed by Henry Scott-Stokes, *The Life and Death of Yukio Mishima* [New York, 1974], esp. 78–79 and 225).

[13] This is the expression used by the early sixteenth-century German theologian, Jacob Wimpfeling, for which see Gustav Knod, "Jacob Wimpfeling und Daniel Zanckenried, Ein Streit über die Passion Christi," *Archiv für Litteraturgeschichte* 14 (1886), 1–16, esp. 6 and 9; translated and cited by Trexler, "Gendering Jesus" (as in note 8), 113 and n. 34. See also the further discussion of Wimpfeling below.

[14] See, for instance, the analysis by Richard Rambuss, "Pleasure and Devotion: The Body of Jesus and Seventeenth-Century Religious Lyric," in *Queering the Renaissance*, ed. Jonathan Goldberg (Durham, North Carolina, 1993), 253–279. My thanks to Peter Griffith for this reference as well as helpful conversations.

Jerome and repeated countless times throughout the Middle Ages and into the sixteenth century.[15] In general terms, this phrase was meant to stress the importance of recognizing one's humanity, along with renouncing material wealth, following the supremely selfless ideal of Christ. Fifteenth-century woodcuts show the humble human figure, stripped to a decorous loincloth, offering his heart to a bleeding Christ who is tied to cross and column (Fig. 4).[16] There is a subtle shift between such a work and Burgkmair's Crucifixion, and yet, in part, an analogous spirit is present. The almost naked contemporary man has been eliminated, and Christ's modeling for humanity becomes more insistent in the later work.

It has not been previously noted that there is, following this line of reasoning, a clear theological textual analogy for Burgkmair's imagery. Writing in 1508, Johan Geiler von Kaysersberg, the famous Strasbourg preacher and theologian, detailed the utter and complete humiliation Christ experienced by being stripped of all his clothes before being crucified.[17] Although Geiler admitted that there was a difference of opinion about whether or not Christ's loins were covered at the time of the Crucifixion, he obviously felt that such an extreme suggestion about Christ's shame formed a fitting parallel to his hunger, thirst, and sadness in his Passion.[18] In 1508, Geiler was discussing the issue of Christ's nakedness for at least the second time in his career. Earlier, in 1499, Jacob Wimpfeling had requested Geiler's opinion on the subject. Wimpfeling strenuously opposed the notion that Christ hung naked on the cross. Geiler's published reply to Wimpfeling left the matter undecided; authorities, even church fathers, cited on both sides of the dispute, could never settle the matter absolutely, he wrote.[19]

What emerges from Geiler's sermons and writings is the notion that discussion of Christ's nudity, while a matter of dispute, could and did have a powerful and appropriate devotional effect. The adroit preacher, carefully gauging his rhetoric, could make compelling points—about the extent of Christ's suffering

[15] For the *nudus nudum* formula, see the following sources: Matthäus Bernards, "Nudus nudum Christum sequi," *Wissenschaft und Weisheit* 14 (1951), 148–151; Reginald Grégoire, "L'adage ascètique 'Nudus nudum Christum sequi,'" in *Studi storici in onore di Ottorino Bertolini* (Pisa, 1972), 395–409; and Giles Constable, "*Nudus Nudum Christum Sequi* and Parallel Formulas in the Twelfth Century, A Supplementary Dossier," in *Continuity and Discontinuity in Church History: Essays Presented to George Hunston Williams on the Occasion of His Sixty-Fifth Birthday*, ed. T. F. Church and T. George (Leiden, 1979), 83–91. See also Steinberg, *Sexuality of Christ* (as in note 1), esp. 34. Johan Geiler von Kaysersberg is one early sixteenth-century author who continued to use St. Jerome's expression, "naked to follow the naked cross," in his *Fragmenta passionis domini nostri Jesu Christi* (Strasbourg, 1508), IX.B.

[16] See Richard S. Field, *Fifteenth Century Woodcuts and Metalcuts from the National Gallery of Art* (Washington, D.C., 1965), no. 266.

[17] See Geiler von Kaysersberg, *Fragmenta passionis* (as in note 15), VII.D–E and IX.Z–A.

[18] Ibid., VII.D; cited by E. Jane Dempsey Douglass, *Justification in Late Medieval Preaching. A Study of John Geiler of Keisersberg* (Leiden, 1966), 186.

[19] See Douglass, *Justification* (as in note 18), 71, 185–186; as well as the article by Knod, "Jacob Wimpfeling und Daniel Zanckenried" (as in note 13).

and about the devout person's need to follow humbly his god's renunciation of worldly glory. Avoid bodily nakedness, Geiler warned; but by contemplation of Christ's repeated stripping and exposure, learn to strip yourself of earthly pretension. Thus theological devotion was made congruent with physical imagery.

This early sixteenth-century German discussion is certainly relevant to Burgkmair's work. One of the artist's first securely attributed portraits, from ca. 1490, is of Geiler von Kaysersberg (Fig. 5).[20] Burgkmair also provided the Augsburg editions of two of Geiler's works with woodcut illustrations: the *Predigen teutsch* of 1508 (three woodcuts)[21] and the 1510 edition of *Das Buch Granatapfel* (six woodcuts).[22] Clearly the artist could have been familiar with Geiler's statements concerning Christ's nudity. Yet, I would hasten to add that it is by no means a case of Burgkmair simply illustrating Geiler's texts. This is true if only because Geiler stressed Christ's nudity "in public before all the people";[23] while Burgkmair conceived of a solution linking the nude human body to loneliness—and to direct confrontation with the individual viewer. Clearly both men, theologian and artist, thought this idea or image should be considered. Maybe Christ was clothed at the Crucifixion, as Burgkmair often portrayed him. Geiler, too, allowed that many learned authorities claimed this. But the possibility of Christ's nudity brought to consciousness a powerful message: the shame of a naked Christ on the cross emphasized, at the same time that it transcended, the godhead's humanity—thus providing a model for the spectator who could be similarly stimulated both to understand and overcome his or her own earthly limitations, at least from a theological point of view.

Let us return briefly to the fifteenth-century devotional woodcut of the naked man following the naked Christ (Fig. 4). As already noted, in Burgkmair's work the absent donor figure is, in a sense, countered with a more completely stripped figure of Christ. When sixteenth-century individuals are shown taking up their cross, they more often do it fully clothed, as Duke John Frederick of Saxony is shown in a Cranach woodcut (Fig. 6).[24] This situation suggests some interesting reflections on what might be called the history of shame. One theory, put forth by Norbert Elias, sees the early modern period—in fact, the development of western European civilization since the Middle Ages—as a time of increasing embarrassment at the exposure of certain body parts.[25] For Elias, the

---

20 See Falk, *Leben und Werk* (as in note 2), 11–12, 88 (with further references).

21 See Falk, *Graphische Werk* (as in note 4), cat. nos. 30–32 (Burkhard 88; Hollstein 273–275).

22 See Falk, *Graphische Werk* (as in note 4), cat. nos. 43–48 (Burkhard 90; Hollstein 276–281).

23 Geiler von Kaysersberg, *Fragmenta passionis* (as in note 15), IX.Z.

24 For Lucas Cranach the Younger's woodcut *Difference between Lutheran and Catholic Religions* (Max Geisberg, *Die Reformation in den Kampfbildern der Einblattholzschnitte* [Munich, 1929], no. xxxv, 7–8), see the discussion of Roland H. Bainton, "Dürer and Luther As the Man of Sorrows," *Art Bulletin* 29 (1947), 269–272, esp. 272, fig. 5. Albrecht Dürer's obsession with showing himself nude, or seminude, in such contexts forms a striking exception to the general picture of restraint.

25 Norbert Elias, *The History of Manners*, vol. 1 of *The Civilizing Process* (New York, 1978), esp. 213–215; idem, *Power and Civility*, vol. 2 of *The Civilizing Process* (New York, 1982), esp. 295–296.

civilizing process involves a tightening of controls on behavior and hence a more highly developed sense of shame, ultimately causing great internal stress. Questions can certainly be raised about Elias's theory of change over many generations, especially considering our more recent permissiveness.[26] But the fact remains that the sixteenth century in Germany did witness greater sexual repression and a heightened sense of the need for social control of bodily functions, especially sexual ones.[27] This also provides a larger context for the persecution of homosexuals in Burgkmair's Augsburg.

From our vantage point, the particular way Burgkmair has portrayed Christ's body might be connected to such wider trends in society. There seems a new urgency to Christ's nudity here. Geiler von Kaysersberg had specifically warned against any actual bodily nakedness for his contemporaries. Burgkmair's image and Burgkmair's time can in some ways be said to treat Christ's shame as timeless, not calling for immediate imitation; however, that particular obsession with physical exposure, and even fear of it, was quite timely in early sixteenth-century Germany.

What might we conclude about the meaning of Burgkmair's naked Christ? Certainly it could have acted as a *pestblatt*; it was almost immediately adapted to that purpose and its emphasis on Christ's physical torment makes it effective in that way. It was also a Renaissance devotional image newly emphasizing Christ's complete humanity. The artist's focus on Christ's sexual shame probably corresponded to a latent homoeroticism as well as predicting a more virulent homophobia in sixteenth-century Germany. And, at the same time, this emphasis on shame could be considered one aspect of a recurrent theological debate over the suffering of Christ. In Burgkmair's work we can sense the presence of a variety of artistic, religious, social, and sexual issues, at times even conflicting. Clearly the relative importance of any of these issues might change depending on the observer. The artist might have consciously focused on certain problems; a religious patron like Geiler von Kaysersberg might have found simple confirmation of his own, previously expressed ideas; while the general public in Augsburg might have speculated on wider social and sexual implications. I think we should accept the inevitability that such an image could both betray and affect very different kinds of religious, social, and sexual behavior. With this kind of analysis, I would in part like to erode the notion, often espoused since the 1940s, that a work of art should be seen above all as fulfilling the requirements of a single, specific text, or a single, consciously articulated iconographic program.[28]

[26] Hans Peter Duerr is one of the most outspoken and thorough-going critics of Elias; see his *Nacktheit und Scham*, vol. 1 of *Der Mythos vom Zivilisationsprozess* (Frankfurt, 1988); also the review of Duerr's work by Ioan P. Culianu, in *History of Religions* 29 (1990), 420–422.

[27] See the references in the previous two notes, as well as Roper, *Holy Household* (as in note 11).

[28] I am also reminded of Leo Steinberg's report of a lecture in which he suggested a variety of meanings

Part of this, or indeed any work's greatness lies in its ability to relate meaning-fully—pungently—to a variety of contexts. But to what extent is it the sug-gestiveness of the image, both consciously and unconsciously exploited, that makes Burgkmair's naked Christ on the cross an important work in the six-teenth century, as well as today? We could say that *any* work of art, however trivial or over-determined in its meaning, could still be understood from a num-ber of vantage points, artist's and spectator's, to begin. It seems both vague and weak to argue that the appeal of a work of art is simply due to an ambiguity inherent in the image. And no matter how much clever contextual information we bring to bear on art, it cannot compensate for a weak design. For these reasons, we should not only consider the fact that a work can mean many things to many people—we must wonder just *how* its multi-faceted meaning is achieved.

This may be an obvious point, but it is all too easy to slight it. Something rich and complex in implication needs to have been accomplished in stimulating and original ways. I have several times referred to the visual intrigue of Burgkmair's woodcut: for instance, the spiky trees, the analogy of ridged body and earth, the contrast of iconic, large, and hard-edged cross to the swirling natural forms below and empty sky above. In the woodcut, there are no clouds, no angels, no souls being taken to heaven or hell, as Burgkmair portrayed in his other Cruci-fixions. Above the horizon there is nothing to keep us from fixing on Christ's naked body. The artist forces us to wonder about Christ's physicality, at the same time that he limits our responses to it. His work is a complex but essential visual embodiment of the physical body and shame of Christ. It is an important work of art not only because of the range of cultural issues we can discover there: it embodies these feelings in compelling artistic form.

THE UNIVERSITY OF MASSACHUSETTS AT AMHERST

---

for Michelangelo's Doni Tondo; one listener opined afterward, "Of course, when you come to publish this, you will narrow the possibilities down"; see Steinberg's "Objectivity and the Shrinking Self," *Daedalus* 98 (1969), 824–836, esp. 835.

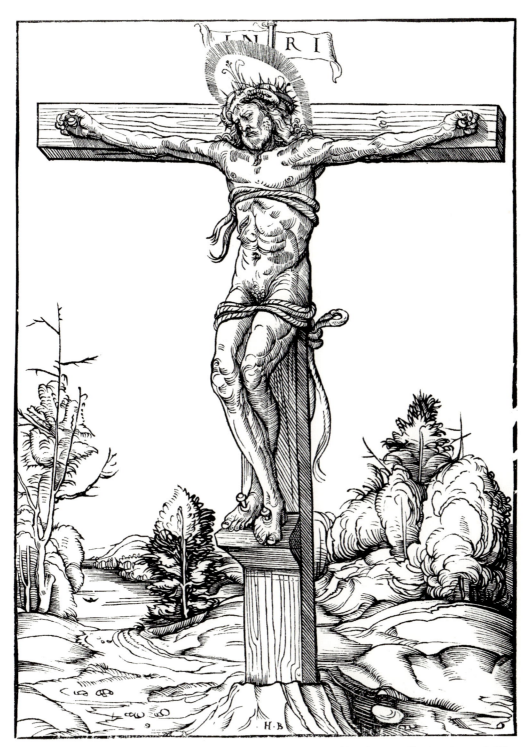

1. Hans Burgkmair, *Naked Christ on the Cross*, woodcut (Burkhard 45; Hollstein 49), ca. 1510.
Basel, Kupferstichkabinett der Öffentliche Kunstsammlung (25.8 × 18.3 cm) (photo: museum)

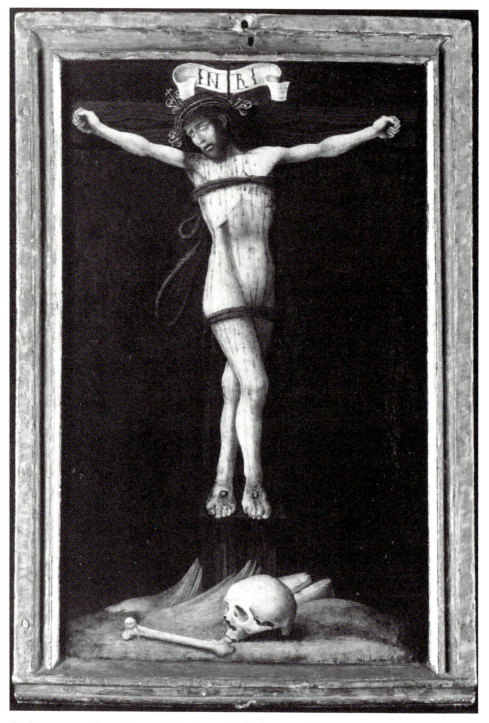

2. Anonymous Upper German(?) artist, *Naked Christ on the Cross*, panel, first third of the sixteenth century. Cologne, Wallraf-Richartz-Museum (KGM A 1056) (37 × 23.2 cm; with original frame, 42.8 × 28.3 cm) (photo: Rheinische Bildarchiv)

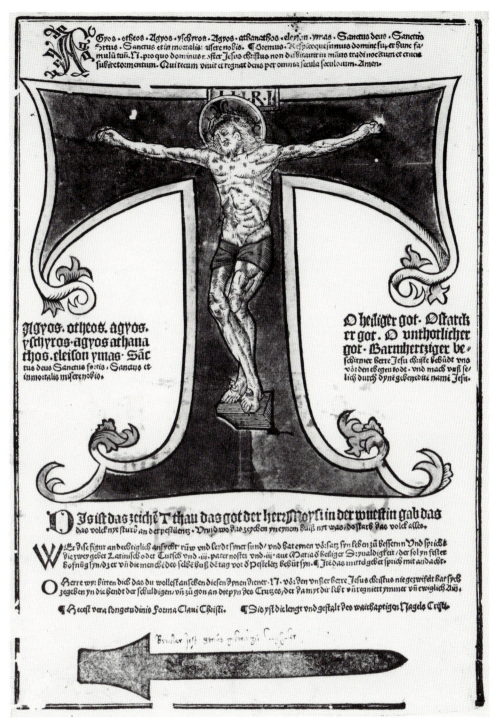

3. Anonymous German artist, plague sheet with Christ on a T-cross, woodcut (Schreiber 931), early sixteenth century. Berlin, Staatliche Museen Preussischer Kulturbesitz, Kupferstichkabinett (36.8 × 25.6 cm) (photo: Jörg P. Anders)

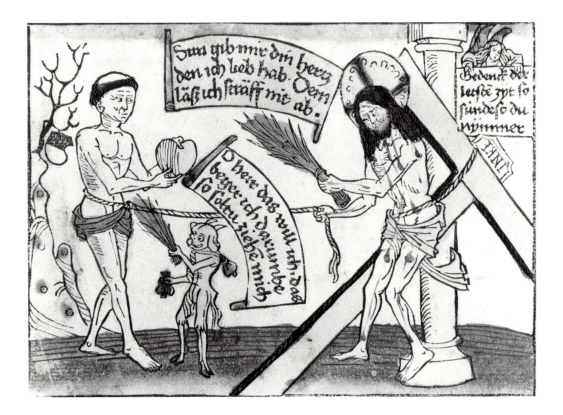

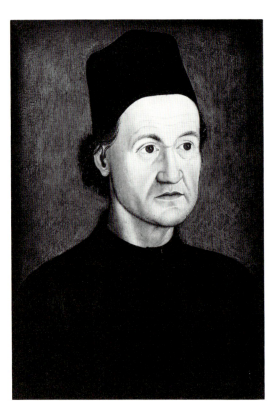

4. Anonymous Ulm artist, *Jesus Attracting the Faithful Heart*, woodcut (Schreiber 1838), ca. 1480–1490. Washington, National Gallery of Art, Rosenwald Collection (B-3409) (12.7 × 18.1 cm) (photo: museum)

5. Hans Burgkmair, *Portrait of Johan Geiler von Kaysersberg*, panel, ca. 1490. Augsburg, Bayerische Staatsgemäldesammlung (inv. 3568) (37.3 × 26.5 cm) (photo: museum)

6. Lucas Cranach the Younger, *Difference between Lutheran and Catholic Religions*, hand-colored woodcut (Geisberg, XXXV, 7–8), ca. 1545. Berlin, Staatliche Museen Preussischer Kulturbesitz, Kupferstichkabinett (35.1 × 58.5 cm) (photo: Jörg P. Anders)

# The Commissioning of Early Netherlandish Carved Altarpieces: Some Documentary Evidence*

## LYNN F. JACOBS

❧

PATRONS OF SOUTH NETHERLANDISH carved altarpieces most often exerted very limited influence over production. In these art works the traditional patronage model—in which the patron initiated production by commissioning the work and influenced production by making specifications about form or content—was in large part replaced by production without commission for the open market.[1] As a result, most Brabantine sculptured retables were not works tailored for a specific individual, but were standardized products designed to attract a wide range of potential buyers who would see the works displayed in artist's workshops or in the Antwerp *pand* and, if interested, purchase them for personal use, for the use of their churches or confraternities, or for resale.[2] Nevertheless, some carved altarpieces were produced under the traditional model of patronage. These can best be identified on the basis of documentation, above all contracts commissioning altarpieces. And while commission contracts for carved altarpieces differ little from those for sculpture in general (or for works of art in other media, particularly painting), a study of these and related documents is critical for an understanding of Brabantine retables.[3]

* I would like to thank Robert Koch, who made me want to do what I ended up doing. I am indebted to Dan Ewing, J. M. Montias, and Larry Silver for comments on a draft of this paper; I benefited as well from comments raised at the Institute of Fine Arts of New York University, the Metropolitan Museum of Art, and the University of California, Santa Barbara, where portions of this paper were presented.

[1] For a full consideration of this form of patronage, see L. F. Jacobs, "The Marketing and Standardization of South Netherlandish Carved Altarpieces: Limits on the Role of the Patron," *Art Bulletin* 71 (1989), 208–229.

[2] On the sale of art in the Antwerp *pand*, see D. Ewing, "Marketing Art in Antwerp, 1460–1560: Our Lady's *Pand*," *Art Bulletin* 72 (1990), 558–584.

[3] See L. Campbell, "The Art Market in the Southern Netherlands in the Fifteenth Century," *Burlington Magazine* 118 (1976), 188–198, for a study of contracts (and related documents) concerning painting; also

In this paper I will examine the documentation of commissioned altarpieces to assess the impact of the traditional patronage system on the production of South Netherlandish sculptured altarpieces of the late Gothic period. I will study the nature and range of the demands made by patrons of commissioned works, and then consider how commissioned and uncommissioned works compare, in terms of the nature and role of their buyers, as well as in their quantity, quality, and price. These comparisons will reveal that the differences between the two patronage systems are not as sharply defined as one might expect: commissioned retables at times exhibit patterns of production and sale that are surprisingly close to those found in market works.

## I. The Holy Sacrament Altarpiece of Averbode

Documentary evidence reveals that patrons typically made a large number of specifications when commissioning an altarpiece. Consider, for example, the Holy Sacrament Altarpiece (Paris, Musée de Cluny, Fig. 1), commissioned from Jan de Molder by the abbey of Averbode in 1513—a rare case in which both the contract (in two versions, one in Latin and one in Flemish) and the altarpiece still survive.[4] The Latin contract begins by stating a required date of completion for the work (the following Easter),[5] and then lays out specifications for the size of the work: 7 feet wide, 1 foot deep, and 9 feet high; the inclusion of a predella 1 foot in height (no longer preserved) is mentioned shortly thereafter.[6] In this section the contract also specifies a key design feature of the *caisse*, namely that the work should be "marked by roundness like the altarpiece of the high altar" (*notis rotundis ad instar tabule summi altaris*)—translated in

---

P. Humfrey, "The Venetian Altarpiece of the Early Renaissance in the Light of Contemporary Business Practice," *Saggi e memorie di storia dell'arte* 15 (1986), 65–82, studies similar issues concerning Venetian altarpieces.

[4] These documents are published in J. Lavalleye, "Le Retable d'Averbode conservé au Musée de Cluny, à Paris," *Revue d'art* (1926), 141–148; and P. Lefèvre, "Documents complémentaires sur deux retables anversois de l'abbaye d'Averbode au XVIᵉ siècle," *Analecta Praemonstratensia* 44 (1968), 105–110. On this retable, see also R. Szmydki, "Jan de Molder, peintre et sculpteur d'Anvers au XVIᵉ siècle," *Jaarboek van het Koninklijk Museum voor Schone Kunsten Antwerpen* (1986), 31ff.

[5] A completion date is not mentioned in the Flemish document.

[6] The Flemish document discusses the predella along with the other measurements, unlike the Latin document, and is a bit more specific at points, e.g., specifying that the height measurement does not include the predella. In addition, the Flemish document discusses the amount of overhang at the end of the altar table. It was not uncommon for the width of the altarpiece to be explicitly determined by the desired amount of overhang beyond the width of the altar table; see also Lefèvre, "Documents" (as in note 4), 110, on the All Saints Altarpiece commissioned by the abbey of Averbode from De Molder in 1518. But the Flemish Holy Sacrament document does contain the rather perplexing calculation that, since the altar is 6 feet long and the altarpiece should overhang 1½ feet on each side, the altarpiece should therefore measure 7 feet in length; the indication of 1½ feet, as opposed to ½ foot, however, probably reflects a scribal or transcriptional error.

the Flemish as "with a round top" (*met eenen ronden hoofde*)—thereby indicating the desired shape of the altarpiece, specifically, the curved profile at the top.[7] Another reference to features of the design may be the request that the work have "six leaves, called 'lover'" (*sex foliis, dictis lover*); the Flemish text similarly refers to "6 *loeveren*," a term that probably designates a form of foliage decoration, perhaps originally placed on the frame, but now lost.[8] The document further specifies that all of the work should be well gilded, presumably referring particularly to the architectural ornament, which in most carved altarpieces was heavily gilded.[9]

The next section of the contract provides rather detailed specifications for the iconographic content of the work. The contract mentions each of the main scenes in the *caisse*: in the center, St. Gregory at mass with the instruments of the Passion; at one side, the Lord's Supper; and at the other side, the story of Melchizedek. Even the paintings on the wings (which are no longer preserved) are specified: the typological scene of the manna is cited. However, for the wings some iconographic leeway is allowed: the contract states that in addition to the scene of the manna, there should be "similar forms representative of the venerable Sacrament, such as Elijah, etc." (*similes figure venerabilis Sacramenti representive sicut Helias, etc.*). In this way the document suggests that the artist can choose among the other scenes associated typologically with the Sacrament, but does not specify exactly how many and exactly which scenes are to be chosen. The possibility of choice is even more explicit in the Flemish version, in

[7] The specification "marked by roundness" is preceded in the document by the phrase "with capitals" (*cum capitellis* in the Latin; *metten capitellen* in the Flemish)—a term which, as Hans Nieuwdorp kindly suggested to me, probably refers to columns used to support statues on top of the *caisse*. Given differences in the Latin and Flemish transcriptions, it is not clear whether the phrase "with capitals" is included primarily to specify another design feature in addition to the rounded top (as suggested by Lavalleye's transcription of the Latin, "Retable d'Averbode" [as in note 4]), or to designate that the specified height of the altarpiece includes the columns (as suggested by Lefèvre's transcription of the Flemish, "Documents" [as in note 4]).

[8] The Flemish term "loever" or "lover" seems to be related to the term "looven," defined in K. Stallaert, *Glossarium van verouderde rechtstermen, kunstwoorden en andere uitdrukkingen* (Leiden, 1890), 176, as "to decorate with leaf ornament"; J. Verdam, *Middelnederlandsch handwoordenboek* (The Hague, 1981), 337, also defines "loof" as "to decorate in the form of a leaf." Such a definition of "lover" corresponds well to the Latin word "folium" used as a synonym here. Moreover, the term "lover" appears in other contexts which relate it to architectural ornament: see J. Crab, *Het Brabants beeldsnijcentrum Leuven* (Leuven, 1977), 324; Lefèvre, "Documents" (as in note 4), 110; and P. Lefèvre, "Textes concernant l'histoire artistique de l'abbaye d'Averbode," *Revue belge d'archéologie et d'histoire de l'art* 5 (1935), 53. I am indebted to Reindert Falkenburg and Jeremy Bangs for assistance in translating this term. Jeremy Bangs also suggested that the reference to six "loeveren" in this document may refer to the placement of six decorative leaves along the six curves of the *caisse* (one at each side and four in the extended center); Bangs proposed that the evidence of repairs on the frame of the *caisse* may indicate that this ornament was originally located there, but has now been lost—a suggestion I find quite compelling.

[9] In the Latin version it is less clear whether the phrase "well gilded through the whole" (*per totum bene deauratum*) refers to the altarpiece overall or to the architectural decoration in particular; but in the Flemish version the gilding seems to be specifically related to the "loeveren," for the full sentence states, "Moreover, it shall have 6 loeveren, all and well gilded" (*Item zij zal hebben 6 loeveren, al ende wel vergult*).

which the document states the artist should paint the manna "and moreover [other scenes] that represent the Holy Sacrament, such as Elijah and others as well" (*ende voirts dat representeert theijlich Sacrament, gelijck Helias ende meer andere*). Furthermore, the contract makes no specifications about the content of the now-lost predella or of the small scene on the bottom tier of the *caisse*, now incomplete, but probably representing an angels' mass; these subsidiary areas may also have been left to the artist's judgment. Nevertheless, the iconographic choices for all of the main scenes of the retable were made not by the artist, Jan de Molder, but by the patrons themselves.

The document concludes with specifications about the quality of the work. Some concerns about quality had already been voiced amidst the iconographic specifications, where the document states that the scenes selected should be "of exalted and skillfully formed images" (*de imaginibus elevatis et artificialiter formatis*), or, in the Flemish version, "well and masterly cut, with a good spirit and form" (*wel ende meesterlijck gesneden, met eenen goeden geeste ende faintsoen*). But the document raises additional quality concerns at the end, requiring that "the shutters shall be sound and the whole altarpiece shall be made of good and dry woods, according to the dictate of the artisans, and shall be polychromed and gilded" (*janue erunt integre et tota tabula erit de bonis et siccis lignis ad dictamen artificium facta, stoffata et deaurata*). The Latin document ends here, but the Flemish version has an attached coda in Latin, which continues the discussion of quality to its logical end: the issue of price. This paragraph states that the prior considered the value of the altarpiece to be 16 Flemish pounds, "under the condition that if the masters and the craftsmen of this type of work, to be chosen by us [the monastery], say that the altarpiece is of lesser value, in this case, he [Jan de Molder] would have less; and if they judge it to be worth more, nevertheless he [De Molder] would not receive more than 16 pounds" (*sub conditione si magistri et artifices hujusmodi operis, per nos assumendi, dictaverint tabulam minoris precii valoris esse, secundum hoc minus haberet, et si judicaverint eam plus valere, plus tamen quam 16 libras non reciperet*). With this final issue settled, the artist is recorded as accepting a payment of 15 pounds; presumably the patrons held back one pound of payment here in case the work might be appraised at under 16 pounds.

This document is quite typical of contracts in the very specific nature of the requirements imposed by the patron. It is also typical in its focus on four key issues: the date of completion, dimensions and design, iconographic content, and quality and cost. These form the basic components addressed in nearly all other surviving commission documents. But within these four areas of concern, other documents reveal a variety of specifications, approaches, and emphases that need to be considered to achieve a fuller picture of the nature of the relationship between the commissioning patron and the artist.

## II. Date of Completion

The first stipulation in the Averbode contract, the date of completion, was a particularly problematic issue in many contracts, since there was often a conflict between what the two parties deemed an appropriate amount of time to complete such complex art works. The Averbode document (of October 25) requested the work by the following Easter, hence allowing about six months for completion. Similarly, in a document of December 2, 1535, Thomas Leich, a merchant from England, commissioned a work from Jan van der Heere of Antwerp to be completed within about seven months, but gave the artist some extra time by specifying two completion dates about a month apart, that is, between Saint John's Mass in the middle of the following summer (presumably June 24), or, at the latest, on Saint James's day after that (i.e., July 25).[10] Others allowed more time: in a document of June 17, 1537, Bernard Lalmant of the abbey of Gembloers commissioned an altarpiece from Robert Moreau to be completed and delivered "between now and two and a half years following" (*entre cy et deux ans et demy ensuyvans*).[11]

To enforce completion by a certain date, patrons could withhold final payment until the work was finished.[12] The Averbode Abbey did not use this approach, since they paid almost the entire amount up front, holding back only a small amount, apparently more in anticipation of the appraisal of value than to encourage prompt completion.[13] But Thomas Leich reserved 10 Flemish pounds of the 33-pound payment to Jan van der Heere until completion of the work.[14] So, too, the joiners' guild of Leuven, when commissioning an altarpiece from the carver Hendrik van Tongerlo in 1506, agreed to pay him a total of 200 Rhine guilders, of which 50 were paid on the signing of the contract, 50 at the following Easter, and "the other hundred Rhine guilders when the work shall be complete and delivered" (*dander hondert Ringsguldenen als dwerck volmack ende gelevert zal zyn*).[15] Sometimes patrons insisted on penalties for late-

---

[10] F. Prims, "Altaarstudien (1)," *Antwerpiensia* 13 (1939) 283.

[11] F. Donnet, "Le sculpteur Robert Moreau," *Annales de l'Académie royale d'archéologie de Belgique* 2 (1899–1900), 50. Although the fairly large size of the work (13 feet wide and 6 feet high) could account for the long time period allotted to the artist, it is more likely that the patron allowed Moreau more latitude simply because of the artist's great fame and the desirability of his works.

[12] The documents indicate that timely completion of work was often of real importance to the patrons because they wanted the new works to be ready in time for a particular liturgical celebration. Moreover, money for altarpieces was sometimes allotted in testaments with the proviso that the art work should be completed within a specified time after the donor's death; see, for example, A. de la Grange, "Choix de testaments tournaisiens antérieurs au XVIe siècle," *Annales de la Société historique et archéologique de Tournai* 2 (1897), 205–206 (no. 714).

[13] On appraisals, see below, section V.

[14] Prims, "Altaarstudien" (as in note 10), 283.

[15] Crab, *Beeldsnijcentrum Leuven* (as in note 8), 331.

ness; for example, an agreement of January 10, 1525, between the kloveniers'
guild of Leuven and the carver Willem Hessels required completion by the fol-
lowing St. Christopher's day "on penalty of one angelot" (*opde pene van eenen
angelot*).[16] So, too, in a contract of October 15, 1538, between the Brussels
carver Joris Asselyns and the church masters of St. Quentin of Leuven, it is
specified that Joris must finish and deliver the work by the St. Bavo's fair (begin-
ning August 15) of 1539 "on penalty of forfeiting one Flemish groat pound for
every week after the above-mentioned time" (*opde pene van te verbueren alle
weken nader tyt voirscreven een pont groot vleemsch*).[17]

Some patrons needed to use other means to enforce completion of a work. In
one instance, the governors of the St. Anne altar in the church of St. Peter in
Leuven brought a suit before the city council of Leuven on April 9, 1505, de-
manding completion of a work commissioned exactly one year earlier from Jan
van Kessele and Jan Petercels, arguing that the artists had already had a year to
complete the work, and had been paid 183 Rhine guilders;[18] the governors
expressed particular anger that, during the period of their contract, the artists
had completed another work (for the St. Catherine altar of St. Peter's) instead
of the St. Anne altarpiece.[19] These same two artists had legal trouble over the
timely completion of work on other occasions: Petercels had to appear before
the magistrate of Leuven in 1509 because of his failure to complete an altar-
piece for the brewers' guild of Leuven.[20] Jan van Kessele had even greater legal
troubles: on October 25, 1508, the brotherhood of St. Quentin of Leuven re-
ceived permission from the city to break into his house and seize his goods,
since he was out of town—indeed, the brotherhood believed him to be hiding—
and had not delivered the work commissioned from him;[21] soon thereafter, on
November 13, 1508, a seemingly penitent Jan van Kessele (now back in town)
promised the brotherhood of St. Quentin that he would "accept no other [com-
missions for] work, nor even appraise any other work, nor work on another
work before the time that the above-mentioned work of St. Quentin shall be
delivered complete" (*gheen ander werck aen te nemen, noch oick ander werck
taenveerden noch aen ander werck te werckenen voir dier tijt dat tselve werck
van Sinte Kwintens voirscreven sal volmaict gelevert*).[22] In fact, despite the
effusiveness of Jan's promises here, a later document reveals that he never did
complete the work: on May 17, 1510, the sculptor Hendrik Mouwe, on the

---

[16] Ibid., 334.

[17] Ibid., 338.

[18] Ibid., 327–328; the previous document related to this dispute is published in ibid., 326–327.

[19] It should be noted that Van Kessele and Petercels never finished this work, and thus the commission
was given over to Metsys; see L. Silver, *The Paintings of Quinten Massys* (Montclair, 1984), 203–204.

[20] Crab, *Beeldsnijcentrum Leuven* (as in note 8), 325.

[21] Ibid., 329.

[22] Ibid.

request of Jan's brothers, Barthelomeus and Sebastiaan van Kessele, agreed to make the altarpiece that had been commissioned by the St. Quentin confraternity from Jan van Kessele.[23]

A lawsuit of January 3, 1526 between the painter Peter de Voocht and the Great Guild of Leuven provides an interesting sidelight on controversy over completion dates.[24] In response to the guild's protest that De Voocht took the altarpiece off the altar and to his home to be painted before it could be appraised by the guild (against the conditions of the contract), the painter argued that "he was apprehensive that he could not have satisfied the aforesaid sworn members [of the guild] within the time itself" (*hy hem beduchtene was dat hy den voirscreven geswoirnen bynnen den selven tyde nyet en hebben connen voldoen*). While this may simply have been an excuse for violating quality control standards—the guilds needed to appraise works before polychromy to assess whether proper wood had been used[25] —his explanation reveals how sensitive artists were to the concerns of patrons for prompt delivery. Peter de Voocht evidently felt that the need to complete the retable on time surpassed the need to observe other requirements of the contract, or at least that it would provide a compelling excuse for violating them.[26]

In order to ensure that they would indeed receive the works they had commissioned, patrons often included in the contracts specific arrangements for the delivery and installation of the completed works. While the contract for the Holy Sacrament Altarpiece of Averbode makes no such arrangements, that made by Ruttger Schipman of the Franciscans of Dortmund states that the artist Master Gelisz has "packed and at his cost will truly deliver [the altarpiece] on wagons, and thenceforth will set up [the altarpiece] at Dortmund at the cost of the prior and the convent with one or more assistants according to his orders" (*gepacket und wol bewartt up sein Kost lefferen soll up die Wagens, und dann fort up dess Guardians und Conventz Kosten to Dortmundt ubsetten sall mit einem offt mehr Knechten na seinen Befallen*).[27] Similarly, in his contract with the abbey of Gembloers, Robert Moreau agreed to deliver the altarpiece to the abbey and install it on the altar, and that the delivery and

---

[23] Ibid., 329–330.

[24] Ibid., 307–309.

[25] On quality of materials, see below, section V.

[26] Indeed, the document itself states that Peter was held to have had a good reason for removing the altarpiece from the church. Other evidence that prompt delivery could overrule quality control mechanisms is found in the fifteenth-century regulations of the Bruges carvers' guild: the rule that carvers could not work at night (a rule clearly designed to prevent sloppy production in low-light situations) could be suspended in cases where the buyers had ships nearby ready to sail; see M. Vanroose, "Twee onbekende 15de-eeuwse dokumenten in verband met de brugse 'beildesniders,'" *Handelingen van het genootschap voor geschiedenis (Société d'emulation de Bruges)* 110 (1973), 172 and 175.

[27] O. Stein, "Die flämischen Altäre Westfalens mit besonderer Berücksichtigung des Altars in der Petrikirche zu Dortmund," *Beiträge zur Geschichte Dortmunds und der Grafschaft Mark* 22 (1913), 290.

installation "will be at the cost and expense of my lord [the abbot], and at his expense [will be] as many boats, wagons, carts, and other things which the above-mentioned work will cost to bring here . . . [and] similarly the costs for food of Robert [Moreau] and his assistants will be at the expense of my lord, the abbot" (*sera aux fraix et despens de mond s<sup>r</sup> et à sa charge tant des bateaulx, chariotz, voictures et autres que led ouvraige coustera dy mener pareillement les despens de bouche dud Robert et ses compaignons lesquels il aura à la charge dud mons<sup>r</sup> labbé*).[28] The abbey thereby covered transportation costs as well as costs for feeding Robert and his assistants during their stay at the abbey to install the retable.[29]

## III. Dimensions and Design

The second issue raised in the Averbode document, the dimensions and design of the altarpiece, was the subject of much less contention between artists and patrons. The listing of dimensions, as in the Averbode document, was standard in commission contracts because altarpieces had to fit onto altars of various sizes. And while specifications about *caisse* design and ornament were somewhat less common, the desire for a round-shaped *caisse* expressed in the Averbode document also appears in a 1510 contract between the carver Jan Petercels and the Holy Sacrament confraternity of Turnhout, wherein the patrons request that the work should be "round on the top" (*booven int ronde*).[30] Moreover, an agreement of 1506 between the carver Hendrik van Tongerlo and the joiners' guild for the altarpiece of St. Leonard's altar in the St. Peter's Church in Leuven, includes the provision that the work should be "divided in a half ogive [arch]" (*versteken op een half ogeve*)—a reference either to the overall profile of the *caisse* or to the shape of the compartments.[31] Other contracts include references to another element of *caisse* design, the architectural ornament. The early sixteenth-century contract between the Liège sculptor Henri Wauthier and Jehan Lagace delle Boverie for an altarpiece for the church of St. Vincent of Fetinne, for example, specifies that the retable should be "all carved at the top and adorned, with so much ornament such as trellis-work and foliage" (*tout sus entretailhie et aornee, tant de machynerie comme de clere et voie et foilhaige*).[32] Similarly, the contract of February 8, 1507 between the St.

---

[28] Donnet, "Robert Moreau" (as in note 11), 50.

[29] Similarly, in the case of a stone retable by Joris van Schutteputte, a contract of 1550 records that the church officials at Diest paid for the freight costs as well as other travel costs, including the lodging of three people; see Crab, *Beeldsnijcentrum Leuven* (as in note 8), 341. Rather complex discussion of delivery is also found in Schutteputte's contract of 1534 with the church of Neerlinter for a stone rood loft; ibid., 330–331.

[30] Ibid., 325.

[31] Ibid., 331.

[32] J. Helbig, "Un contrat de l'an XVe et XXVe, pour la confection d'un retable d'autel," *Revue de l'art chrétien* 5 (1894), 406. I am indebted to J. M. Montias for help in translating this document.

Arnold's confraternity and brewers' guild of Leuven on one side, and the joiner Jan Petercels on the other, makes quite complex specifications about ornament, including the request that Jan shall "place on the predella of the *caisse* a vine of hops and little berries hanging there" (*opden voet vanden backe stellen een rancke van hoppecruyt ende bellekens daer aenhangenne*).[33]

Design features, however, were not usually specified in commission documents, in part because details of design may often have been left to the discretion of the artist,[34] but also because the patrons' desires in this matter could be indicated by other means, namely, design-drawings, usually called *patroons*. While there was evidently no *patroon* for the Averbode Holy Sacrament Altarpiece, a number of other documents indicate that a design drawing formed part of the commission process. For example, Thomas Leich advised the artist Jan van der Heere "to make [the altarpiece] after the appearance of the *patroon* drawn on parchment and signed on the back" (*te maken naar uitwijzen van den patroon beworpen in perkament en geteekend op den rug*).[35] Similarly, the 1507 contract between the St. Arnold's confraternity and brewers' guild of Leuven and Jan Petercels specifies that the ornament and tabernacle should be "like the *patroon* that shows [the altarpiece] and as Matthys Keldermans of this city, a master sculptor, has drawn on the bottom of the same *patroon*" (*gelyc den patroen dat uutwyst ende gelyck Mathys Keldermans deser stadt meester met-sere den gront vandenselven patroen getrocken heeft*).[36] The agreement for Willem Hessels to make an altarpiece for the kloveniers' guild of Leuven stipulates that the retable should be "according to the content and appearance of the *patroon*" (*nar inhoudt ende vuytwysen des patroens*);[37] and the Gembloers contract with Moreau uses the same term in French, saying that "all [should be] following the *patroon* . . . exhibited here and signed by my notary" (*en tout ensuyvant le patron . . . icy exhibé et signé de moy notaire*).[38] Another term for a design-drawing used in the documents is "bewerp," which is used synonymously with "patroon" in a document of 1506 between the joiners' guild of Leuven and Hendrik van Tongerlo, requesting an altarpiece "after the appearance of the *bewerp* and *patroon*" (*nae vutwysen vanden beworpe ende patronen*);[39] the term "bewerp" also appears in the 1447 commission for an altarpiece from Cornelis Boene for the Church of the Nazareth of Ghent, which

---

[33] Crab, *Beeldsnijcentrum Leuven* (as in note 8), 324. I am indebted to Hans Nieuwdorp for help in translating this document.

[34] A number of scholars have emphasized that artists were in general relatively free to make their own choices regarding the specifics of iconographic presentation (see note 59 below), and it is quite likely that artists also had a good degree of freedom in the area of design as well.

[35] Prims, "Altaarstudien" (as in note 10), 283.

[36] Crab, *Beeldsnijcentrum Leuven* (as in note 8), 324.

[37] Ibid., 333.

[38] Donnet, "Robert Moreau" (as in note 11), 50.

[39] Crab, *Beeldsnijcentrum Leuven* (as in note 8), 331.

requests a retable with scenes of the five feasts of Our Lady "after the manner of the *bewerp*" (*naer de maniere van den bewerpe*).[40]

In one documented case there was a change in the *patroon* in the middle of a project. The controversy between the masters of St. Anne and the two artists Jan van Kessele and Jan Petercels about the late delivery of an altarpiece (discussed above in section II) was partly due to the fact that the St. Anne masters had changed the *patroon*, as recorded in a document of April 9, 1504.[41] Here the masters acknowledge that, although the parties had originally agreed on a "*patroon* made here in Leuven" (*patroon alhier te Loevene gemaict*), they now "had made another *patroon* in Antwerp" (*hebben doen maken eene andren patroon tot Antwerpen*). One year later, in accounting for the delay in production, the artists claimed that the second *patroon* was more difficult than the first.[42] In another unusual case, the *patroon* was part of an exhibit required as part of the commission. The church masters of St. Quentin of Leuven requested that Joris Asselyns, in the course of preparing their altarpiece, should stage an exhibition in the church displaying one of the six carved scenes of St. Quentin's life (to be included in the final altarpiece) together with "a *patroon* of the whole altarpiece" (*eene patroen van geheelden tafelen*).[43]

The surviving documentation, however, suggests that the *patroon* was less commonly used than written contracts describing the planned retable, and called a *chyrograph*, *celle*, or *cedulle*.[44] These terms appear in documents far more often than the term "patroon." Thus, the St. Nicholas guild of Goes commissioned an altarpiece from Gillis van der Sluys to be made according to certain conditions stipulated in a *chyrograph*.[45] The term "celle" appears in the 1518 commission for Jan Genoots' Munstermaifeld altarpiece, which is to be made "following the *celle* which henceforth shall be made" (*navolgende der celen die daer af gemaect sal wor.dden*).[46] Similarly, in a document of 1470, Bertelmeeus van Raephorst agrees to make an altarpiece "after the contents of 2 *cedullen*, of which both sides have [a copy]" (*na inhout van 2 cedullen die zij te beyden zijden daeraf hebben*).[47] Some of the surviving documentation is ac-

---

[40] C. Diericx, *Mémoires sur la ville de Gand* (Ghent, 1814), vol. 1, 339.

[41] Crab, *Beeldsnijcentrum Leuven* (as in note 8), 326.

[42] Ibid., 327.

[43] Ibid., 338.

[44] On the *chyrograph* (or *celle*, or *cedulle*), see L. Helmus, "Drie contracten met zilversmeden," in *Kunst uit de Bourgondische tijd te 's-Hertogenbosch. De cultuur van late middeleeuwen en renaissance* (The Hague, 1990), 474–475; I am indebted to J. M. Montias for this reference. Normally the *chyrograph* was a one-page document wherein the agreement was written out in two or three copies, which were then cut apart, with one copy given to each of the parties; the third copy, when used, became part of city records at the finalization of the contract.

[45] Prims, "Altaarstudien" (as in note 10), 282.

[46] C. Dumortier, "Jan Genoots, sculpteur anversois du XVIᵉ siècle," *Bulletin des Musées Royaux d'Art et d'Histoire* 57 (1986), 38.

[47] G. Asaert, "Documenten voor de geschiedenis van de beeldhouwkunst te Antwerpen in de XVe eeuw," *Jaarboek van het Koninklijk Museum voor Schone Kunsten Antwerpen* (1972), 55.

tually specified as being the *cedulle* itself: the early sixteenth-century French contract for the altarpiece of Fetinne states that the altarpiece should be made according to the "conditions and specifications specified in a *cedulle* on paper, which will be inserted at the end of this letter" (*conditions et devises specifyees en unne cedulle de pappier, qui serat en fin de ces presentes inserree*).[48] The *cedulle* that follows states the patron's specific requirements regarding dimensions, iconography, gilding, delivery, and ornament (as discussed above in this section); however, the payment arrangements are stipulated only in the initial, more summary document, rather than in the *cedulle* itself. From this it is evident that commissions could often involve more than one document, a fairly general agreement (the type more commonly preserved), and a more detailed written description, the *cedulle*, which was often cited in the general agreement. Of course, there could simply be one document containing all of the specifications, as appears to be the case for the Averbode Holy Sacrament Altarpiece. Alternatively, there could be both a *cedulle* and a *patroon*: the 1550 agreement between the church officials of Diest and the sculptor Joris van Schutteputte the Younger for an altarpiece with a tabernacle—in this case in stone rather than in wood—included the contents of the *cedulle* itself, which states that the retable should be made "entirely following the appearance of the *patroon*" (*geheel vervolgende nae duytwysen des patroons*).[49] Here the patrons chose to limit the *cedulle* primarily to financial issues and convey or confirm their requirements about design features through a visual record.

## IV. Iconography

Iconographic content, while considered in some detail in the Averbode document, is the subject of even fuller discussion in other examples. A very early contract, of July 1448, between the abbess of Flines and a sculptor from Valenciennes named Ricquart includes particularly elaborate specifications for each scene, including this description of the Annunciation scene (on the right of the altarpiece):

> [Show] Our Lady on her knees in front of an altar, her book in front of her, on a seat . . . covered with a cloth of gold . . . having the appearance of countenance fitting to the salutation of the angel Gabriel, who will be depicted on his knees in front of the above-mentioned image [of Mary] having the appearance of greeting her with the hail [Mary] full of grace, and above this angel will be depicted the appearance of God the Father, coming out from the sky, throwing out rays of sun

[48] Helbig, "Contrat" (as in note 32), 405.

[49] Crab, *Beeldsnijcentrum Leuven* (as in note 8), 341. In addition, a 1552 document for a grave monument commissioned from Roeland Hermans by Lodewijk van Schore refers to both a *cedulle* and a *patroon*: see Crab, *Beeldsnijcentrum Leuven*, 342–343.

which will spread right up to the head of the image of Our Lady, and [the retable] will depict the appearance of the Holy Spirit, coming down on the Virgin Mary, and in the middle of the image of that angel [will be depicted] the [flower] pot and the lily. . . .

Nostre-Dame a genoux pardevant ung autel, son livre devant luy, sur ung fau-dosteul . . . couvert d'un drap d'or . . . faisant maniere de contenance appartenant a la salutacion de l'ange Gabriel, qui sera fourméz a genoux devant lad. ymaige faisant maniere de le saluer de ave gratia plena, et par deseure led. ange sera four-méz la maniere de Dieu le pere, yssant du chiel gettans des rays de soleil, lesquelz seront espars jusques assez prés du chief de l'imaige Nostre Dame, et sera fourméz la maniere de Saint Esprit, descendant en la Vierge Marie, et au milieu de l'imaige dud. ange, le pot et fleur de lys. . . .[50]

Another document marked by great specificity in its iconographic description is the 1538 contract between Joris Asselyns and the St. Quentin masters of Leu-ven; the contract specifies each of the events in the life of St. Quentin to be depicted, stating, for example, that "on the right side shall be the scene wherein St. Quentin is pulled asunder on the rack. And the third scene of the left side shall be [the scene] wherein St. Quentin is hanged between two branches with burning lamps under his armpits" (*opde rechte syde sal syn het point dat Sinte Quinten op een pynbanck wordt uyteengebonden. Ende het derde point ter lincker syden sal syn dair dat Sinte Quinten gehangen wordt tusschen twee vorcken met berrende lampen onder syn oxele*).[51] In some cases the icono-graphic specifications require that the patron be depicted in the work; thus, the 1537 contract between Moreau and the abbey of Gembloers states that the altarpiece should depict ten scenes of the lives of Peter and Paul and include a portrait of the abbot himself, "clothed pontifically with the cross in his hand and the miter on his *prie-dieu* in front of him" (*accoustré en pontifical avecq la croche en sa main et le mitre sur son oratoire devant luy*).[52]

Not all contracts needed to provide written specifications about iconography, since the *patroon* could accomplish this by visual means. Thus, for example, when the 1525 contract between Willem Hessels and the kloveniers' guild of Leuven states that the work should follow "the content and appearance of the *patroon*" (*nar inhoudt ende vuytwysen des patroens*), the term "appearance" (*vuytwysen*) probably refers to issues of design (and perhaps even style), while

50 R. Hanke, "Art religieux et création artistique au XVe siècle: Les retables sculptés de l'abbaye cister-cienne de Flines," *Amis de Douai. Revue du syndicat d'initiative de Douai et de l'arrondissement* 9 (1984), 109; I am indebted to Andrea Pearson for this reference. The Flines contract is an unusually detailed docu-ment vis-à-vis iconography, which may be due in part to the fact that some of the iconographic requirements —though not those concerning the depiction of the Annunciation—are somewhat nontraditional.

51 Crab, *Beeldsnijcentrum Leuven* (as in note 8), 338.

52 Donnet, "Robert Moreau" (as in note 11), 50.

"content" (*inhoudt*) seems to refer to iconography.[53] The 1510 contract between the Holy Sacrament brotherhood of Turnhout and Jan Petercels states that Jan is to make a *patroon* "in order to see how pleasing to us the figures and mysteries [will be]" (*om te beseyen hoe ons genoegen die personagien ende die misterien*)—a specification which seems to allude to both the stylistic and the iconographic elements indicated by the *patroon*.[54] Iconographic specifications may sometimes have been left to oral rather than written or visual delineations. This may have been the case with the second retable which the abbey of Averbode commissioned from Jan de Molder, the now-lost All Saints Altarpiece: the 1518 document states that "he [De Molder] shall fill the compartments with figures serving for that purpose, just like the information [which] was given to him about it; and still more [information] will be given to him by lord Adriaen, his brother-in-law" (*de percken sal hij vullen met personagien daer toe dienende, alsoe hem daer af informatie gegeven is, ende hem bij heer Adriaen, zijnen zwager, noch breeder gegeven sal worden*).[55] This example indicates that sometimes the complexity of the iconographic programs of carved retables caused the patrons to reserve the right to make decisions about iconography as the project evolved, rather than specifying all the scenes at the time of the initial contract. This approach is also used in the 1432 contract for Jan van Molenbeke to polychrome an altarpiece for the Cloister of 's-Hertogendal: for the outside of the shutters, the contract requests "an image such as shall please my lady [the abbess of 's-Hertogendal], and she shall let him [Jan van Molenbeke] know in good time" (*een beelt, alsulc alst mijne vrouwen sal genuegen, ende hem in goets tyts sal laten weten*).[56]

Since decisions about iconography could be delayed or given orally or via drawings, one cannot assume that documents which do not fully specify thematic content were granting the artist control over iconographic choices. Indeed, aside from the Averbode contract—which explicitly allows the artist to select some typological scenes—no other documents known to me provide clear indications that the artist was given free choice in the selection of subject matter.[57] Instead, patrons tended to specify all of the subjects, even in very

[53] Crab, *Beeldsnijcentrum Leuven* (as in note 8), 333.

[54] Ibid., 326.

[55] Lefèvre, "Documents" (as in note 4), 109–110.

[56] Crab, *Beeldsnijcentrum Leuven* (as in note 8), 320.

[57] Two documents could be considered as suggesting some element of choice for the artist. The first is a 1446 document for the polychromy and wings of the retable of St. Pierre of Antoing-lez-Tournai, which states that the scenes of the outer wings are to be selected "au los dou consel." A. Louant, "Un retable en polychromie et plate peinture de Nicaise Barat," *Revue belge d'archéologie et d'histoire de l'art* 9 (1939), 11, interprets this to mean "according to the artist's own inspiration" although the phrase could be understood to mean "according to the specifications of the council of church wardens." Hence the import of this document is unclear. The second document is the 1510 contract between the Holy Sacrament confraternity of Turnhout

peripheral areas of the work; thus, the 1432 's-Hertogendal contract for poly-
chromy and wing-painting states that "in the two small wings above at the
top"—the least important painted sections of an altarpiece—"[there] shall be
our Lord sitting in one [wing], and in the other Our Lady in the manner of a
coronation" (*in twee cleyn dueren boven int hoeft sal staen in deene onze heere
sittende ende in dandere onse vrouwe op de maniere vander coronacien*).[58] To
be sure, as other scholars have noted, the iconographic specifications of the
patron were often limited simply to naming the themes to be shown, rather
than spelling out the specifics of iconographic content and/or symbolism, and
hence the artist was not, in fact, highly constrained in the area of iconogra-
phy.[59] Nevertheless, the basic iconographic program of the altarpiece does
seem to have been largely under the control of the patron.

## V. Quality and Price

In the documentation, concerns about quality and price appear to be of primary
importance to the patrons. This is evident first from the attention devoted to
quality of materials in nearly every contract. The request for "good and dry
woods" in the Averbode document is an especially common one, since patrons
knew that a work made with poor or improperly treated wood would rapidly
deteriorate; thus, for example, the commission from the abbey of Flines re-
quests that "all of this work be made of good clean wood, without knotholes
and without sapwood, all of the heart[wood] of oak or of walnut" (*tout
l'ouvraige dessusd. faire de bon net bos, sans neulx et sans aulbun, tout de cuer
de quaesne ou de gauquier*).[60] The abbey of Gembloers even required Moreau
to use "good and dry wood of Denmark, of the best that he can find" (*bon et

---

and Jan Petercels, which states that "at the top [of the retable] . . . he [Petercels] shall make seven small scenes
which we shall [have] him make, which represent the Old Testament or miracles" (*inde cruyene . . . sal hy
maken zeven cleyn personagien die men hem doen sal, het zy figueren van den ouden testamente oft mir-
akelen*). Undoubtedly this document refers to the small figurative consoles included in most sixteenth-century
retables, among the least important sculptured elements in a retable; and the reference to scenes of the "Old
Testament or miracles" suggests the possibility that the artist could make his own choices in these small
scenes. However, the language "which we shall [have] him make" (*die men hem doen sal*) could be intended
to indicate that the patrons planned to specify the particular scenes at a later date; see Crab, *Beeldsnijcentrum
Leuven* (as in note 8), 325.

[58] Crab, *Beeldsnijcentrum Leuven* (as in note 8), 320.

[59] The fact that patrons probably specified only the basic theme to be shown, rather than dictating the
specifics of iconographic content and/or symbolism, is emphasized by C. Gilbert, "A Statement of the Aes-
thetic Attitude around 1230," *Hebrew University Studies in Literature and the Arts* 13 (1985), 134ff.; and
M. Kemp, "Introduction: The Altarpiece in the Renaissance. A Taxonomic Approach," in *The Altarpiece in
the Renaissance* (Cambridge, 1990), 17–18.

[60] Hanke, "Art religieux" (as in note 50), 110.

*secq bois de denemarche du meilleur quil pourra trouver).*[61] While the Averbode document for the Holy Sacrament Altarpiece is fairly sketchy when discussing the quality of the polychromy, requesting simply that the *caisse* should be well gilded and polychromed, other documents devote more attention to the quality of the polychromy. Thus the contract between the abbey of Averbode and Jan de Molder for a second work, the All Saints Altarpiece, specifies that "he shall gild the altarpiece thickly with fine gold and the gold [will be] pure and securely laid on [the altarpiece] to a master's level of excellence" (*hij sal de tafel wel dick vegulden met fijnen goude, ende tgout reijnlijc ende vast daer op leggen, tot meester prijse).*[62] The contracts specifically for polychroming naturally provide more specifications about the polychromy. The 1432 contract with the painter Jan van Molenbeke for the polychromy of the retable for 's-Hertogendal specifies the use of both "fine burnished gold" (*fynen gebruneerden goude*) and "matte gold" (*matten goude*), as well as specifying the use of "azurite" (*lazuere*) and silver.[63] Concern with quality is particularly evident in the 1460 contract for the polychromy of an altarpiece in the church of Asper, which specifies that the work should be gilded "with good, fine, sound, burnished gold beaten to the price of 4 schillings groat per hundred, thus good, honest gold" (*met goeden finen duechdelicke ghebruneerde goude ghesleghen vp den prijs van IIIJ schellinghen grooten thondert also goet loyalic gaud).*[64]

Along with specifications about the quality of the materials, many documents make general comments requesting good quality workmanship. As mentioned above, the Averbode document requests scenes with "exalted and skillfully formed images." Similarly, the abbey of Flines requests that each scene be "well and properly cut with good and pretty architectural decoration, well and cleanly worked" (*bien et proprement taillyes de bonne et jolye machonnerie, bien et nettement ouvrees);*[65] and the masters of the St. Quentin guild request that their altarpiece should have "commendable and excellent work" (*loffelyck en exellent wercken).*[66] In a more direct attempt to ensure good workmanship, some patrons issued specifications about who could work on an altarpiece. The abbey of Averbode stipulated that no apprentices could work on their All Saints Altarpiece, commissioned from Jan de Molder in 1518.[67] In their 1507 con-

---

[61] Donnet, "Robert Moreau" (as in note 11), 50. It remains an open question whether this document specifically requests wood from Denmark or whether Denmark is being invoked simply to specify a good quality wood; little is currently known about the origins of the wood used in carved retables.

[62] Lefèvre, "Documents" (as in note 4), 110.

[63] Crab, *Beeldsnijcentrum Leuven* (as in note 8), 320.

[64] E. Vandamme, *De polychromie van gotische houtsculptuur in de Zuidelijke Nederlanden: Materialen en technieken* (Brussels, 1982), 203.

[65] Hanke, "Art religieux" (as in note 50), 110.

[66] Crab, *Beeldsnijcentrum Leuven* (as in note 8), 338.

[67] Lefèvre, "Documents" (as in note 4), 110.

tract with the Leuven joiner Jan Petercels, the St. Arnold's confraternity and brewers' guild of Leuven specified that the figures included in the altarpiece should be "by the hand of Master Jan Borman, living in Brussels" (*vander hant meester Jans Borreman, wonende te Bruessel*).[68] So, too, a contract of 1510 between Petercels and the Holy Sacrament confraternity of Turnhout requested that the figures be cut by Jan Borman or by his son Pasquier.[69] Hence, when these two patrons contracted with Petercels, they clearly wanted to ensure that they would receive altarpieces carved at the level of quality of the famous Borman shop of Brussels, rather than the level of their local joiner's shop.[70]

Another approach to ensure good quality workmanship was the demand for a warranty on the finished product. Thus, for example, the church of Middelgem in 1437 required that the artist Denijs den Roeden be responsible for any defects in the work occurring within the year.[71] And in a legal controversy of 1506 over payment, the church masters of Emmelen wanted the carver Jan Meerenbroeck to provide a guarantee "in case within two years something in the above-mentioned altarpiece is broken as regards the painting or the polychromy, as it was agreed in the *chyrograph*" (*of aan de voorschreven tafel binnen de twee jaren iets gebrake aangaande de schildering of het stoffeersel, gelijk dit in hun chyrograaf verstaan was*).[72] The abbey of Flines required the artist to repair any defects occurring within one year: according to the contract, the agreement is "on the condition that, within one year after the above-mentioned altarpiece is delivered, [if] any of the sculptures or other works as well as the tabernacles . . . deteriorate or fall apart or if there is found wood, which has sapwood or with unsightly knotholes, or if there is any lack of workmanship, the worker and maker who did it will be held responsible to restore [the work]" (*par telle condicion que se dedens ung an aprés lad. table livree aucuns desd. ymaiges ou autres ouvraiges, tant es tabernacles . . . se decrevoit ou desmentesist, ou qu'il fust trouvé de bos ayant aubun ou a vilains neulx, ou quil y eust aucune deffaulte d'ouvraige, l'ouvrier et facteur qui ce fera sera tenus de l'amender*).[73]

---

[68] Crab, *Beeldsnijcentrum Leuven* (as in note 8), 324.

[69] Ibid., 325.

[70] Another attempt to control the subcontracting of work in the interest of quality is evident in a 1476 contract for a tabernacle between the priest of Zyberund and the carver Jan Vorspoel, which specifies that the tabernacle must be made completely in the city of Antwerp; see Prims, "Altaarstudien" (as in note 10), 281. On subcontracting in painting and related quality concerns, see Campbell, "Art Market" (as in note 3), 193–194.

[71] Prims, "Altaarstudien" (as in note 10), 280.

[72] Ibid., 282.

[73] Hanke, "Art religieux" (as in note 50), 110. Some other contracts with provisions for repair include the contract between the kloveniers' guild of Leuven and Willem Hessels of 1525, which has the proviso that Hessels will stop any splitting of the wood of the altarpiece at his own cost (Crab, *Beeldsnijcentrum Leuven* [as in note 8], 334); the contract between the church of Wachtebeke and the Ghent painter Cleerbout van

In order to assess the quality of materials and workmanship, and thereby establish the value of the work, many contracts called for an appraisal of the completed work. The Averbode document refers to such an appraisal in the Latin coda to the Flemish version, which states that the appraisal is required to determine if the retable is indeed worth 16 pounds. A document of 1506 records how the representatives of the Antwerp St. Luke's guild went to the house of the sculptor Peeter Pauw to appraise an altarpiece of the legend of St. Nicholas, which the townsmen of Duinkerken had commissioned from this sculptor; the document records that the value was placed at 115 Flemish groat pounds (without the tabernacle).[74] Similarly, the deacons of the Antwerp St. Luke's guild are recorded as visiting and appraising the All Saints Altarpiece commissioned in 1518 by the Averbode Abbey from Jan de Molder at a value of 29½ Flemish pounds: the document states that the deacons inspected the wood, the gold, and the polychromy, and "found no defect or fraud in the altarpiece" (*egeen gebreck oft fraude aen de tafel en vijnden*), a legal formula frequently used in this context.[75]

The appraisal was often the time when final decisions were made about the price an artist would be paid, since many contracts allowed the patrons to adjust their payment based on the results of the appraisal. Some patrons drove a hard bargain, as did the abbey of Averbode in the Holy Sacrament contract, requiring an appraisal to assess whether the abbey should pay the full 16 pounds, but stating that it would not pay more if the work were appraised at a higher value. So, too, the English merchant Thomas Leich agreed to pay Jan van der Heere the sum of 33 Flemish pounds with the proviso that "in the case that the altarpiece was not made to the value of the above-mentioned sum, according to [what] those who are good judges of it [i.e., the appraisers] say, then shall master Thomas be able to pay less, and in the case that they say that the altarpiece is worth more, Thomas shall not be obliged to pay more" (*of het geviel dat de tafel niet ware gewrocht tot de waarde der vernoemde somme,*

---

Witevelde, in which the artist guaranteed his retouching of the retable for a full twenty years (Campbell, "Art Market" [as in note 3], 193, esp. n. 56); and the 1464 contract between the magistrate of Strasbourg and Nicholas van Leyden, in which the artist also furnishes a twenty-year guarantee (R. Recht, *Nicolas de Leyde et la sculpture à Strasbourg [1460–1525]* [Strasbourg, 1987], 84–85).

[74] F. Prims, "Antwerpse altaartafels," *Antwerpiensia* 19 (1948), 52.

[75] Lefèvre, "Documents" (as in note 4), 110. It should be noted that in most cases the artists had no say in selecting the appraisers of their work: thus the Averbode Holy Sacrament Altarpiece commission states that the appraising masters will be "chosen by us [i.e., the abbey]" (*per nos assumendi*); ibid., 109. In some instances the artists could select some of the appraisers; for example, in a 1563 commission for the polychromy of an altarpiece in the St. Barbara Chapel of Leuven, the painter Charles de Cuypere was allowed to select two of the four appraisers (with the patron selecting the other two); see E. van Even, "Monographie de l'ancienne école de peinture de Louvain," *Messager des sciences historiques, ou archives des arts et de la bibliographie de Belgique* (1869), 318–319.

*naar zeggen van mannen zich des verstaande, zoo zal meester Thomas minder
mogen betalen, en in geval zij wijzen dat de tafel meer waard is, zal dezelfde niet
gehouden zijn meer to betalen).*[76] Other contracts were more favorable for the
artist: the 1538 contract with Joris Asselyns for the St. Quentin's altar states
that "in the case that the same above-mentioned work is made very praise-
worthily and artistically, as is fitting, according to the opinion of the good men,
then we shall give Joris himself still more for his work and wine, as much as two
Flemish pounds" (*ingevalle dat dit selve voirscreven werck alsoe loffelyck en
werckelijk gewracht es alst behoirt, nae goetdunken vanden goeden mannen,
dan sal men den selven Jorys noch geven voere syn const ende wijn twee pont
vleemsch eens).*[77] Similarly, a fifteenth-century document records that the St.
Nicholas guild of Goes paid Gillis van der Sluys 6 pounds more than the 26
pounds agreed upon, because the appraiser said that the sculptor had made the
altarpiece much better than had been stipulated in the *chyrograph*.[78]

Quite often, patrons tried to make their concerns about quality and value
more concrete by requesting that the work to be made for them be similar to
existing works of art. Indeed, in a sample of 75 published documents (dealing
with both painting and sculpture) compiled by J. Dijkstra, some 35 percent of
the fifteenth-century commissions and 52 percent of the sixteenth-century ones
included references to a preexisting work that the patrons wanted the artist to
follow in some way.[79] One such request is found in the Averbode Holy Sacra-
ment contract, which states that the retable should have a round shape, like
that of the retable on the high altar. Similarly, the Tournai sculptor Martin
Daret was commissioned in 1503 "to make an altarpiece, which will be like and
similar to another altarpiece that he showed them [i.e., the church masters of
Cobrieux]" (*pour faire une table d'ostel, laquelle seroit telle et semblable que
une autre table d'ostel qu'il leur a monstrée).*[80] Such specifications may have

---

[76] Prims, "Altaarstudien" (as in note 10), 283. Also see the contract for the stone altarpiece of Joris van
Schutteputte for Diest (Crab, *Beeldsnijcentrum Leuven* [as in note 8], 341) in which the patrons state that
they are not obligated to pay more if the work is better than the *patroon*.

[77] Crab, *Beeldsnijcentrum Leuven* (as in note 8), 338–339.

[78] Prims, "Altaarstudien" (as in note 10), 282.

[79] J. Dijkstra, *Origineel en kopie: Een onderzoek naar de navolging van de Meester van Flémalle en
Rogier van der Weyden* (Amsterdam, 1990), 13. Dijkstra's sample indicates that this type of request is found
in commissions for both painted and sculpted works; some examples of similar contracts in painting include
the document cited in E. de Busscher, *Recherches sur les peintres gantois des XIVᵉ et XVᵉ siècles* (Ghent,
1859), 72, which records a contract for a painted altarpiece, wherein another work was to serve as a model
for the frame. The contract between the church of Warchin and the painter Philippe Truffin for a painted
retable is especially specific about which features of the existing model are to be followed and what excep-
tions are to be made; see Campbell, "Art Market" (as in note 3), 193. Indeed, the practice of modeling
commissions on existing works within the Netherlandish art market overall was so common that, before
placing a commission, patrons would sometimes travel to see other works to help shape their plans; see
Dijkstra, 25.

[80] A. de la Grange and L. Cloquet, "Etudes sur l'art à Tournai et sur les anciens artistes de cette ville,"
*Mémoires de la société historique et littéraire de Tournai* 20–21 (1887–88), 219.

been intended in part to provide an actual model to serve in place of a detailed *cedulle* or *patroon*.

But in many documents that refer to an existing work of art, the model is cited not only in terms of form and iconography, but also in terms of quality and value. Thus, for example, the church of St. Vincent of Fetinne requested that the altarpiece for their St. Nicholas altar be "all gilded above, except the hands and faces of the figures, as good and as sufficient as is that on the high altar of the above-mentioned church of Fetinne [i.e., the church of St. Vincent], and it should be made as well gilded on the whole" (*tout sus doree, excepteit les mains et visaiges des personaige, dossy bonne or et ossy suffisant, comme est celle de grant aulteit en ladicte engliese de Fettinne, et le doit faire ossy puissamment doreir le tout*);[81] here it is clear that the altarpiece on the high altar of St. Vincent's of Fetinne is being invoked as an example of the level of quality required for the altarpiece on a side altar in the same church. This is true as well for a saint box—a *caisse* with a statue of a saint—commissioned by the Infirmary of Klapdorp from Bertelmeeus van Raephorst in 1471: the document requested that the image of the Magdalen be "cut and gilded in the same manner and with the same colors as the image of St. Mary Magdalen in the church of Our Lady is cut and polychromed, not worse but better" (*gesneden ende gestoffeert in der selver manieren ende met alsulker verwen als d'beelde van Sente Marie Magdalenen dat in Onser Vrouwenkerke staet gesneden ende gestoffeert is, niet arger maer beter*).[82] In this instance, the existing statue provided a model for the colors and "manner" (presumably referring to elements of style or design), as well as a standard of quality that the new work is required to surpass. Another document, concerning the 1532 commission for an altarpiece by the sculptor Rogier de Smet for the church of Avelgem, indicates both that the work should be "on the model of the altarpiece in Waermaerde" (*upden patroon vander tafle staende te Waermaerde*)—showing that the preexistent work is to serve as a general model—and that the altarpiece should be "gilded likewise at the price of the altarpiece of Waermaerde" (*ten pryse also de tafle te Waermaerde ghegolden heeft*)—thereby linking the use of the model more specifically to the issues of price and quality.[83]

---

[81] Helbig, "Contrat" (as in note 32), 406.

[82] Asaert, "Documenten" (as in note 47), 55. The full phrase here reads "Bertelmeeus aengenomen ende gelooft heeft voirs. kerken te makene een beelt van Sinte Marien Magdalenen, lanc wezende 3½ voeten, met eenre cassen, gesneden ende gestoffeert in der selver manieren ende met alzulker verwen als d'beelde van Sente Marie Magdalenen dat in Onser Vrouwenkerke staet gesneden ende gestoffeert is, niet arger maer beter, na den heisch van der groetten van denselven beelde." Given the syntax, it is possible that the phrase "not worse but better" could apply to the following phrase, "concerning the question of the size of this same statue," rather than to the preceding discussion of the carving and polychromy, as I have suggested. But, given that the size is indicated by specific dimensions, I believe that it makes more sense to see the specification "not worse but better" as relating to the quality of the carving and polychromy, rather than to the size of the work.

[83] P. Debrabandere, *Geschiedenis van de beeldhouwkunst te Kortrijk* (Kortrijk, 1968), 156. Another

The importance of the preexisting model as a means of assessing the value of the commissioned work is particularly evident in two other examples. The first is a 1506 document recording a controversy that arose in the commissioning of an altarpiece from the sculptor Jan Meerenbroeck for the church of Emmelen. The document records that the church masters were withholding payment after completion of the work because the artist had been commissioned to make a work after the form and manner of the altarpiece of Cluyse in Lier, but had made it less good, and hence the altarpiece was worth 9 Rhine guilders less than had been agreed.[84] This document indicates that a definite monetary value was at issue when a commissioned work was to be based on another one. Indeed, such monetary concerns are clearly spelled out in a 1534 document, in which the church of Neerlinter commissioned Joris van Schutteputte to make a rood loft—a contract that, although it concerns another art form, is highly relevant for an understanding of carved retable commissions. The document states that Schutteputte was commissioned to make a work "in the manner of the rood loft of Oplinter" (*inder manieren alsoe docsale van Oplynthere*), but two feet higher and "fifty Carolus guilders better than the rood loft of Oplinter" (*vyftich karolusgulden beeter dan docsale van Oplynthere*); the artist is warned that, if the work is not 50 guilders better, he will receive a lower payment.[85] Thus, by citing another work in a contract, the patron could establish very specifically the level of quality and value that he required in his work, setting levels higher and more specific than those established by guild regulations. Such desire for a high level of specificity, not only in terms of quality, but also in date of completion, dimensions and design, and iconography, predominates throughout the documents concerning commissioned retables.

## VI. The Interrelation between Commissioned and Market Sales

The documents thus reveal that a number of carved retables were produced under the traditional patronage model that allowed the patron to exert considerable control over production—a model that stands in marked contrast to that of a buyer purchasing on the open market. Such commissioned retables, however, probably represent only a small percentage of retable production overall. To be sure, the relative frequency of commissioned sales compared to market sales is difficult to establish based on documents, since commissioned sales nec-

---

example demonstrating some of the same concerns is the 1550 contract between Joris van Schutteputte and the church of Diest, in which the altarpiece, in this case a stone work, is requested to be "as well, finely, and freely done as the work in St. Michael's church in Leuven" (*alsoe goet cleyn ende fraey gedaen als twerck staende inde Sinte Machiels kercke tot Loeven*); see Crab, *Beeldsnijcentrum Leuven* (as in note 8), 341.

[84] Prims, "Altaarstudien" (as in note 10), 282.

[85] Crab, *Beeldsnijcentrum Leuven* (as in note 8), 330.

essarily entailed more documentation than market transactions; and most pay-
ment documents—probably the primary records of market sales—usually do
not specify whether the payment is for a commissioned or non-commissioned
work. Still, one piece of written evidence, a dispute between the Brussels
painters' and sculptors' guilds over rights to sell polychromed altarpieces, re-
corded in documents of 1453 and 1454, provides some evidence that the mar-
ket formed the main source of sales revenue. The 1454 document reveals that
the painters' guild—which in 1453 had received exclusive rights to sell carved
altarpieces—was willing to allow the sculptors to sell on commission, but con-
tinued for the most part to retain control over market sales.[86] The new agree-
ment indicates that market sales were of greater importance to the painters than
commissioned sales, suggesting that the market was the more important source
of revenue.[87] Furthermore, two significant features of retable production,
stamping and export, also suggest a predominance of market sales. The practice
of stamping retables with guarantees of quality—a procedure required by the
guilds of both Brussels and Antwerp—reveals a special concern with market
buyers, who were not able to specify requirements of quality in a commission
*cedulle*;[88] and since foreign clients had less opportunity to commission art

[86] For a fuller discussion of these documents, see Jacobs, "Marketing and Standardization" (as in note 1),
210–211. As noted here, the painters' control over market sales was limited to polychromed works, with the
sculptors allowed to sell unpolychromed retables on the market; however, since unpolychromed works were
unfinished works (given that nearly all Netherlandish retables were polychromed), this regulation seems to
have effectively given the painters control over the bulk of the market sales of carved retables.

[87] One could argue that this documentation can be interpreted to show that commissioned sales, not
market sales, were the dominant mode of sales. On this interpretation (which would, of course, directly
contradict my arguments here) the parity between the painters and sculptors for commissioned sales could be
seen as evidence that the sculptors' guild was powerful enough to fight off a disadvantageous arrangement for
the dominant mode of sale (commissioned sales), but was willing to give the painters an advantage in the less
important area (market sales). It is also possible that the guild conflicts provide more evidence about the
dynamics of the power struggles between the guilds than they do about the relative importance of the differ-
ent sources of revenue. Perhaps the focus on rights to the market in this and other guild disputes arose simply
because it was easier to control this outlet than to limit another artisan's rights to take on commissions; see
D. Wolfthal, *The Beginnings of Netherlandish Canvas Painting: 1400–1530* (Cambridge, 1989), 6–7, for a
discussion of a similar dispute over market access within the Bruges painters' guild. But while they do admit
of different interpretation, I nevertheless believe that the Brussels guild documents of 1453–54, taken to-
gether with other evidence—including foreign sales, stamping, and standardization—are more convincingly
interpreted as an indication of the dominance of market sales.

[88] On the stamping of carved retables, see H. Nieuwdorp, "De oorspronkelijke betekenis en interpretatie
van de keurmerken op brabantse retabels en beeldsnijwerk (15de–begin 16de eeuw)," in *Archivum artis
lovaniense: Bijdragen tot de geschiedenis van de kunst der Nederlanden opgedragen aan Prof. Em. Dr. J.K.
Steppe* (Leuven, 1981), 85–98; M. Schuster-Gawłowska, "Marques de corporations, poinçons d'ateliers et
autres marques apposées sur les supports de bois des tableaux et des retables sculptés flamands. Essai de
documentation à partir des collections polonaises," *Jaarboek van het Koninklijk Museum voor Schone
Kunsten Antwerpen* (1989), 211–261; J. van der Stock, "Antwerps beeldhouwwerk: over de praktijk van het
merktekenen," in *Merken opmerken. Merk- en meestertekens op kunstwerken in de Zuidelijke Nederlanden
en het Prinsbisdom Luik, typologie en methode* (Leuven, 1990), 127–144; H. J. de Smedt, "Merktekens op
enkele Antwerpse retabels," in ibid., 145–183.

works than local buyers, the bulk of the enormous export production (which may represent well over half of all retable production), must have been sold ready-made.[89]

Indeed, few of the surviving retables appear to have been commissioned works. Of course, in the absence of confirming documentation it is difficult to distinguish a commissioned work from an uncommissioned piece, given, on the one hand, that donor portraits and other individualizing features could be added to market works, and, on the other, that patrons could commission works without significant individualizing features. But, of the surviving works known to me (and I am considering only those that are largely intact and on a monumental scale, rather than fragments or domestic retables), it appears that only about 28 percent at most provide any visual evidence of individualization that could mark them as commissioned products.[90] Such a figure is, however, rather unreliable, not only because of the difficulty of identifying a work's commissioned or uncommissioned status, but also because large numbers of carved retables have been lost.[91] Still, this data does suggest that commissioned production was a fairly small element within carved retable manufacturing overall.

While commissioned works most likely formed only a small percentage of the total output, they should not be seen as an isolated strand within retable production, since commissioned sales were an integral part of the ateliers' overall marketing strategy: they allowed the ateliers to include in their client-base buyers with highly individualized needs. Furthermore, while in theory the commissioned and uncommissioned patronage models represent separate modes of production, in practice the two forms could easily overlap. As we have seen, commissioned works were often based on preexistent models; and, while I have argued above (in section V) that such a practice was often intended primarily to

[89] For fuller discussion of these issues, see Jacobs, "Marketing and Standardization" (as in note 1), 213–214. Indeed, the very fact that about 75 percent of the surviving carved retables are found outside the South Netherlands indicates that exports—while not necessarily constituting 75 percent of all sales (since retables are sometimes preserved outside their original location)—must surely have formed the majority of all sales.

[90] In making this count I included every altarpiece with any evidence of commissioned patronage in either the center or the wings of the retable; this evidence included dedication to specific saints, unusual iconography, unusual design, and donor portraits or coats of arms. Since some of these features could have been added to ready-made works, I have probably significantly over-counted the number of commissioned works—unless, of course, large numbers of unindividualized works were commissioned, a possibility that cannot be ruled out completely, although it seems rather unlikely. It should be noted that the percentage of commissioned works may well have been higher in smaller centers of production than in the major centers of Brussels and Antwerp, as noted in *Het laatgotisch beeldsnijcentrum Leuven*, exhib. cat., Leuven, Stedelijk Museum (Leuven, 1979), 15.

[91] Given that one would expect the survival rate of commissioned pieces to be higher than that of market works (since, as discussed below in this section, they were more expensive and hence more likely to be stored and repaired), the losses of retables may have actually skewed the percentages in favor of commissioned products. The 28 percent commission rate is hence more likely to be too high, rather than too low, if questions of survival rate are taken into account. I will consider the additional question of whether the percentage of commissioned works changed over the course of retable production in a future study.

set standards of quality and did not necessarily limit the patron's options, this practice in effect linked the commissioned product to the ready-made work. Thus, for example, in 1546 the abbot of Vauclair (in northeastern France) commissioned from Pierre Quintin an altarpiece which was to have "the wings all painted in flat painting and gilded, painted and gilded in the manner of another altarpiece [that] Jehan Ribaucourt, Guillaume Lenfant, and Jehan Wouters saw and visited in the *pand* in Antwerp this day, and of as good quality [as the other work] regarding the polychromy as well as the painting and the gold" (*les huys tout paincts en platte paincture et dore ainsy painct et doree co[mm]e Jeh[an] ribaucourt guillaume lenfant et Jeh[an] wouters ont veu et visite une aultre tableau au pand en anvers ce jourdhuy et de sy bonne sorte quant a lestoffe tant de la paincture et dor*).[92] In the same document the client specified a number of requirements for the commissioned work—in particular, that it measure 16 feet high by 10 to 11 feet wide and depict the Passion with the life of the Virgin in the predella—but the market work served as a model for the commissioned purchase, certainly in terms of quality, but also in terms of basic format and materials. So, too, a 1503 contract between the Tournai sculptor Martin Daret and the church of Cobrieux requests an altarpiece, which (as discussed above in section V) is to be like another retable "which he [Daret] showed them in his house" (*qu'il leur a monstrée en sa maison*);[93] in this case, the work providing the model was not in the *pand*, but a ready-made work that the artist had in stock in his house, which (as was typical at the time) must also have served as his studio and salesroom. Most likely, then, the retable ateliers displayed ready-made works in the *pand* or in their shops in the hopes not only of obtaining direct sales income, but also of promoting commissioned sales.[94]

The overlap between market and commissioned sales is further evidenced by the fact that market works sometimes involved input from the buyer, which was similar to, if more limited than, that offered by the commissioning patron. Thus when, in 1524, the abbey of Averbode "bought from Laureys Keldermans . . . an altarpiece . . . which was in Antwerp in the Our Lady *pand*" (*tegen Laureys Keldermans . . . gecocht een outaer tafel . . . die tot Antwerpen in Onser Vrouwen pandt stond*), they included a number of conditions that mirror the kinds of concerns and language found in commission contracts.[95] The delivery

---

[92] This document is found in the Antwerp Stadsarchief, Notaris 's-Hertogen, act of September 9, 1546 (N 2073, fols. 115v–116). Prims, "Altaarstudien" (as in note 10), 284, cites portions of this document.

[93] De la Grange and Cloquet, "Art à Tournai" (as in note 80), 219.

[94] On the other hand, the ateliers may have viewed high profile commissions as opportunities to create works of such distinction that they would attract additional market sales; see C. Périer- d'Ieteren, "Le marché d'exportation et l'organisation du travail dans les ateliers brabançons aux XVe et XVIe siècles," in *Artistes, artisans et production artistique au moyen âge*, vol. 3 (Paris, 1990), 640–642, 644, on how double-winged carved retables could serve as publicity.

[95] Lefèvre, "Textes" (as in note 8), 53.

arrangements for this (apparently no longer surviving) work parallel those found in commission *cedulles*: they state that payment is made "on the condition that Laureys shall pack and deliver the above-mentioned altarpiece into the ship and when it is in Averbode, he shall install it at his cost, but he shall have the costs of food and lodging while he is working at Averbode" (*met voir-wairden dat Laureys de voirscreve tafel sal packen ende leveren int scep, ende als die tot Everbode is, zal hy die stellen op zijnen cost, mer hy sal den montcost ende logys hebben als hy tot Everbode werct*). Thus we see that works bought on the market involved more interaction between the artist and the buyer than a mere exchange of money for goods. Most significantly, the document goes on to specify that Keldermans "shall deliver [the altarpiece with] the *looveren, pyleernen,* and *capiteelen* [referring here to parts of the architectural ornament] gilded and [with] a statue on top 2½ feet tall, gilded in accordance with the standard of the rest of the work" (*hy sal leveren de looveren, de pyleernen, capiteelen overgult ende een beelt daer op van 2½ vote, vergult nae den eysch vanden anderen werck*).[96] This statement indicates that the work sold by Keldermans at the *pand* was incomplete, since it lacked the normal gilding of the architectural decoration; the sale of incomplete works—though in this case perhaps designed as a means to avoid the full capital outlay for gold leaf until sale was assured[97] —nevertheless provided the market buyer with an opportunity to make some specifications; here the abbey was able not only to require that the architectural decoration be gilded, but also that a statue be added to the top of the retable. This document, then, provides key evidence that retable ateliers could customize ready-made products by adding personalized elements, for example, a statue, as at Averbode, or special wings depicting the donors or patron saints in other examples.[98] Thus, rather than forming two distinctly

[96] On the meaning of the term "looveren," see note 8 above; and of "capiteelen," see note 7. The term "eysch," which I have translated here as "standard," often appears in contracts to refer to the desires or requirements of the patrons; in some cases it can mean "rich," and the connotation of matching the richness of the rest of the gilding may be an element of the meaning here; see Verdam, *Handwoordenboek* (as in note 8), 162.

[97] There is evidence showing that the cost of gold used for gilding a retable indeed represented a substantial outlay of money relative to the overall price of the work: the documents concerning the St. Barbara altarpiece—commissioned by the St. Barbara guild of St. Maartensdijk from the Antwerp carver Aerd van der Cleyen (alias Van Linthout) in 1463—indicate that the artist owed 4.12 Brabant pounds for the gold used in the altarpiece. Since he received 12 Flemish pounds for the work, the price of the gold constituted 22 percent of his earnings; see Asaert, "Documenten" (as in note 47), 50 (doc. 11) and 52 (doc. 15). The fact that the gold leaf used in retables was deemed a very costly component is also evident from the fact that many testaments provided money for the purchase of gold for the gilding of art works; see De la Grange, "Testaments tournaisiens" (as in note 12), esp. nos. 615, 912, 998, 1020.

[98] Retables that were entirely devoted to the lives of particular saints must certainly have been commissioned products, since there would not have been a broad enough market for the ateliers to risk production of specific saints' retables without commission. But works that honored particular saints in more peripheral ways could easily have been produced by adding customized features to ready-made retables.

separate poles, commissioned and uncommissioned production merely represent two sides of a continuum.

Indeed, commissioned and uncommissioned retables appear to have attracted the same kinds of buyers. In a survey of some 70 documents on carved retables, Kim Woods identified 30 bought by a church bodies, 21 by confraternities or guilds within a parish church, 9 by religious houses, 7 by private individuals, 2 by hospitals, and 1 by a municipal body;[99] this survey, though not differentiating commissioned from market sales, helps establish an overall sense of what kinds of clients bought carved retables, and the relative importance of the different buyer categories. However, buyers of all types may well have chosen freely between market and commissioned products, depending on their particular needs. Thus, for example, the abbey of Averbode obtained the numerous retables needed for refurnishing their church after a fire from both commission and market sources. As we have seen, the abbey obtained the Holy Sacrament Retable of Jan de Molder, as well as De Molder's All Saints Retable, on a commissioned basis; but they also obtained the 1524 retable of Laureys Keldermans from the Antwerp *pand*. Moreover, they purchased three retables from Jacob de Cothem that most likely were also market works. The first two retables acquired from De Cothem—one for the Holy Martyrs altar and one for the Holy Virgin's altar—were purchased within a span of less than one month: the first on October 24 of 1513, the second on November 20 of that same year;[100] since commissioned works took many months to produce, the abbey probably would only have been able to obtain ready-made works in such short order. The absence of any allusions to commission contract within the payment documents further supports this assumption. So, too, the documentation suggests that the third De Cothem retable purchased for Averbode—a work traditionally identified as the Lamentation Retable now in the Vleeshuis Museum in Antwerp (Fig. 2)—was also an uncommissioned work.[101] The document states that this work (for the Holy Confessors altar) "was purchased" (*empta [est]*) by Wilhelm Crupers, the abbey's agent, on July 24, 1514; the date of October 17, less than three months later, when Wilhelm was reimbursed for costs of packing and

[99] K. Woods, "Netherlandish Carved Wooden Altarpieces of the Fifteenth and Early Sixteenth Centuries in Britain" (Ph.D. diss., Courtauld Institute of Art, University of London, 1988), 49; Woods notes that some of the private commissions in her sample were in fact intended to be placed in a church or monastery. I am very grateful to Dr. Woods for giving me permission to read her dissertation.

[100] Lefèvre, "Textes" (as in note 8), 51.

[101] Lefèvre (ibid., 51–52) published this document and identified the retable as the Vleeshuis work. It should be noted, however, as Hans Nieuwdorp suggested to me, that there is no evidence that links the document (which does not specify the subject matter or the dimensions of the work) specifically to the Vleeshuis altarpiece. While the document does note that the work was paid for by the profits of the beekeeper Nicolaas, who is depicted on the predella of the Vleeshuis Lamentation (along with the coat of arms of the abbey), the fact that the predella may not be original to the work (see note 104 below) makes a firm identification impossible.

confirmation of sale (the so-called *lijfcoop* and *denario dei*)[102] probably marks the date when the work was ready for delivery. The retable was presumably installed at the abbey by December 4, the date when De Cothem received his full or final payment. As Marijnissen has argued, few commissioned works could have been contracted in late July and installed by early December.[103] More likely, the four-month time span allowed for only some finishing touches on a ready-made work rather than production from scratch.[104] Thus, by purchasing ready-made works from Jacob de Cothem, the abbey was able to acquire three retables in two years, a far speedier rate than the two retables over five years which they received on a commissioned basis from Jan de Molder.[105]

To some degree price may have been a factor in the decision to purchase a commissioned or a market work, since the typical market work was often less expensive than commissioned pieces. Of the eleven known documents dating between 1455 and 1524 that record payments for market retables, the costs for carved retables range between 9 and 15 Flemish pounds.[106] Similarly, the prices noted in ten purchases of works whose commissioned status is indeterminate but are probably primarily market examples, fall mostly in the 9- to 15-pound range, with a few works priced significantly lower, at 4 to 6 pounds, and a few significantly higher, at around 25 pounds. On the other hand, some 35 payments for commissioned sales include a good number of works well above the 15-pound and even 25-pound level: among these are the work costing 33 pounds bought by Thomas Leich,[107] one costing 32 pounds purchased by the

---

[102] On these costs, see Helmus, "Drie contracten" (as in note 44), 474.

[103] R. Marijnissen, "Het Retabel van Averbode uit de verzamelingen van het Museum Vleeshuis," *Antwerpen* 7 (1961), 7. It should be noted, however, that it was not impossible to produce a commissioned work within four months; the commission for De Molder's Holy Sacrament Altarpiece, as we have seen, specified delivery in only six months (although there is no confirmation that the work was actually completed within this time frame).

[104] In that case, the predella, which depicts the arms of the abbey along with the patron, the abbey beekeeper Nicolaas Huybs, could perhaps have been added at this time. However, Marijnissen, "Retabel van Averbode" (as in note 103), 11, argues that the predella is not original to the work because it is technically different from the wings. It therefore appears unlikely that the predella was a customized addition by the De Cothem atelier; nevertheless, it is still possible that the shop could have subcontracted the predella (made after purchase) to painters other than those who made the wings of the ready-made product.

[105] Indeed, the fact that De Cothem was able to supply three retables to the abbey so quickly has caused Marijnissen, "Retabel van Averbode" (as in note 103), 7, to speculate that De Cothem may have been a dealer rather than a craftsman. However, F. Smekens, "Le retable d'Averbode: Histoire et restauration d'un chef-d'oeuvre du Musée Vleeshuis à Anvers," *Bulletin des musées de Belgique* 7 (1961), 135–136, discovered that De Cothem is called "beeldsnydere" in a document of 1505, proving his status as a carver; the works that he sold to the abbey of Averbode, then, were most likely his own productions.

[106] Those amounts represent about two to three years' salary for an Antwerp laborer; Vroom notes that the average salary of an unskilled worker in Antwerp in the later fifteenth and early sixteenth centuries was around 7 Brabantine pounds or 4⅔ Flemish pounds; see W. H. Vroom, *De Onze-Lieve-Vrouwekerk te Antwerpen: De financiering van de bouw tot de beeldenstorm* (Antwerp and Amsterdam, 1983), 10.

[107] Prims, "Altaarstudien" (as in note 10), 283.

St. Nicholas guild of Goes,[108] and one costing 90, which the mercers' guild of London was struggling to finance.[109] One of the most expensive documented commissioned works was purchased by the abbey of Gembloers from Moreau in 1537 for 800 gold Carolus florens, which, at 6 florens a pound, converts to over 133 Flemish pounds.[110] Out of my sample of 35 documented commissioned works, nearly 70 percent sold at over 15 pounds, the upper limit for most market works.[111]

Nevertheless, works could be commissioned for low prices. The St. Barbara's guild of St. Maartensdijk purchased a retable in 1463 from Aerd van der Cleyen for 12 pounds,[112] and in 1470 the Dominican cloister of Antwerp obtained a retable for their high altar from Berthelmeeus van Raephorst for 25 Brabantine pounds, which equals about 16⅔ Flemish pounds.[113] The records of the abbey of Averbode provide further evidence that there could be little price differential between market and commissioned works. To be sure, the two De Molder retables, which were commissioned works, sold for 16 pounds and 29½ pounds— significantly higher prices than those paid for the three presumably market retables of De Cothem, which sold for around 9, 10, and 6 pounds;[114] however, the retable by Keldermans, which was purchased from the *pand*, cost 14½ pounds, only a pound and a half lower than the first commissioned De Molder work, the Holy Sacrament Retable. Of course, price determinations would have been based on many factors besides the commissioned or uncommissioned status of a work, such as the reputation of the artist and the complexity and size of the work, as well as the cost of the materials. And even when two retables of the same size, about 7 × 9 each,[115] were commissioned by the same patron, the abbey of Averbode, from the same artist, Jan de Molder, around the same time, 1513 and

[108] Ibid., 281–282; here the patrons paid six pounds more than the initial contract amount since the artist had done more than had been stipulated in the *chyrograph*.

[109] O. de Smedt, *De Engelse natie te Antwerpen in de 16e eeuw (1496–1582)* (Antwerp, 1954), 410.

[110] Donnet, "Robert Moreau" (as in note 11), 51. Other expensive retables include the retable of Duin-kerk, which cost 115 pounds, not including the tabernacle (Prims, "Antwerpse Altaartafels" [as in note 74], 52); and the retable of Flines, which cost 60 pounds for the painting and 73 for the sculpture (Hanke, "Art religieux" [as in note 50], 110).

[111] It should be noted that in some of the commissioned examples the amounts listed could be partial payments, rather than the full compensation, and the actual number of commissioned works exceeding the fifteen-pound level could thus be even higher.

[112] Asaert, "Documenten" (as in note 47), 50–51.

[113] Ibid., 55.

[114] The payment for the third De Cothem retable is given as "37 flor. ren.," presumably indicating payment in Rhenish guilders; I have converted the Rhine guilder to Flemish pounds at the rate of 40 Flemish groats per Rhine guilder, based on the currency equivalencies given in W. Prevenier and W. Blockmans, *The Burgundian Netherlands* (Cambridge, 1986), 394.

[115] For the All Saints Retable the document states that the altar is 6 feet and 2 "duijmen" (around an inch) wide, and that the altarpiece should have a one-half-foot overhang at each side; so this retable should have been 7 feet and 2 "duijmen" wide.

1518, the prices could differ significantly, in this case by 13½ pounds. But regardless of the specific factors affecting each particular case, late Gothic buyers in certain cases were able to obtain commissioned works for prices similar to market ones.

The fact that market and commissioned works could sell for similar prices indicates that there was not necessarily a difference in quality between retables purchased in these two ways. Works of very low quality have typically been identified as market works; the Passion and Infancy Retable in the museum at Leuven, for example (Fig. 3), with its crude carving and polychromy has always been presumed to be a market work.[116] No doubt the Leuven retable, along with many other low-quality works, was indeed produced hurriedly for cheap sale on the market. But clearly not all commissioned works were of higher quality than market ones, since the commissioned works that sold at market prices must have been of no more than average quality; and some market works may very well have been expensive and high-quality products. One such example may be the retable that the abbey of Averbode purchased from Laureys Keldermans in 1511. This work—which has been incorrectly identified as the Passion retable of Opitter—sold for the high price of 46½ Flemish pounds,[117] much above the 14½ pounds that the abbey paid for the other Keldermans retable, purchased at the *pand* in 1524. But while it is tempting to attribute the price differential here to the difference between a commissioned and a market work, the 1511 purchase document gives no evidence that the work was commissioned. The document states that the abbey "bought" (*emit*) the retable from Keldermans, language which parallels the Flemish "heeft gecocht" describing the 1524 purchase in the *pand*; and the same term "bought" (*emit*) is used to describe the three purchases from De Cothem, which, as we have seen, were probably also ready-made purchases. This language differs markedly from that used for the abbey's commissioned purchases, such as the payment record for the All Saints Retable, which states that De Molder "had undertaken to make the above-mentioned retable after the conditions written in the *Rapiarius antiquus*" (*heeft aengenomen te maken de voirscreve tafel, nae de voirwaerden in Rapiario antiquo . . . gescreven*), referring to the full commission contract for the retable, which was preserved in other abbey records.[118] The 1511 docu-

---

[116] *Het laatgotisch beeldsnijcentrum Leuven* (as in note 90), 433–436. The general view that market works are lower in quality (and, conversely, that commissioned works are higher quality) is expressed in Périer-d'Ieteren, "Marché d'exportation" (as in note 94), 639–640.

[117] The document of the 1511 purchase is published in Lefèvre, "Textes" (as in note 8), 51. It was Lefèvre, ibid., 51 n. 2, who first identified the work with the retable of Opitter; however, since stylistic considerations indicate that Opitter must date ca. 1540 (see *Antwerpse retabels, 15de–16de eeuw*, exhib. cat., Antwerp Cathedral [Antwerp, 1993], 113–114), it cannot be identified with this 1511 Keldermans work.

[118] The contract for the All Saints Retable found in the *Rapiarius antiquus* is that published by Lefèvre, "Documents" (as in note 4), 109–110, whereas the document published in Lefèvre, "Textes" (as in note 8), 52, records only the payment for this same retable, with this brief allusion to the full contract record.

ment, then, strongly indicates that, despite its high price, high quality, and prominent position on the high altar of Averbode, the Keldermans Passion retable was most likely purchased not by commission, but on the open market.

Thus while commissioned and market works reflect a different relationship between artist and buyer, the retables that were produced under the two patronage models do not fall into a neat dichotomy wherein all commissioned works were high priced, high quality, and strongly individualized, and all market works were low priced, low quality, and completely standardized. Commissioned works could be cheaply priced, lower quality pieces, produced after the same design patterns used for market products, and conversely, market works could be expensive, high-quality products outfitted with customized wings and predellas. As a result, commissioned and market works could appeal to the very same buyers. But the fact that uncommissioned retables could satisfy many of the same needs as commissioned ones gave those ready-made works the ultimate marketing edge, since uncommissioned production overall was more time and cost efficient than commissioned production. In this age of expanding art markets, such advantages allowed uncommissioned production to relegate commissioned production to a small sliver of the market pie.

<div align="right">

THE UNIVERSITY OF ARKANSAS
FAYETTEVILLE

</div>

1. Jan de Molder, Holy Sacrament Altarpiece. Paris, Musée de Cluny (photo: ©Photo R.M.N., Paris)

2. Jacob de Cothem, Lamentation Altarpiece. Antwerp, Museum Vleeshuis (photo: ©A.C.L., Brussels)

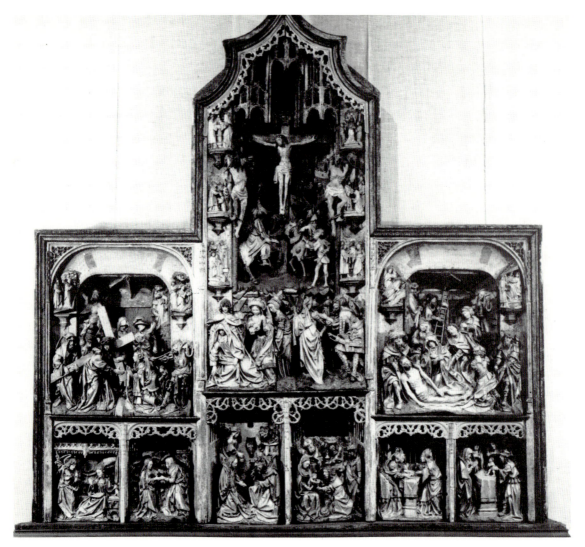

3. Passion and Infancy Altarpiece. Leuven, Stedelijk Museum (photo: ©A.C.L., Brussels)

# Protestant Madonnas Revisited: Iconographic Duality in Works by Jan Sadeler and Joos van Winghe*

## DOROTHY LIMOUZE

⚜

ONE KEY CONCERN in the study of Northern Renaissance art is that of analyzing unorthodox elements that appear in the orthodox context of Catholic art. This has been a focus of recent exhibitions, monographs, and articles dealing with the impact of the Reformation and iconoclasm on artists in the northern Netherlands.[1] These studies both richly contextualize the complex imagery of the mid- to late sixteenth century and suggest alternate modes of interpreting it. The scrutiny that artists in the Netherlands have received would also profit another, closely related group: contemporaries who, instead of moving north from Flanders, emigrated to Italy and the Holy Roman Empire between the 1550s and 1580s. Escaping Spanish-occupied Flanders for environments that

* This paper developed out of research that I had initially planned to include in my Ph.D. dissertation, "Aegidius Sadeler (c. 1570–1629): Drawings, Prints, and Art Theory," Princeton University, 1990. I was most pleased that Professor Koch was able to serve on my committee during the year preceding his retirement, and I thank him and my advisor, Thomas DaCosta Kaufmann, for their thoughtful comments while that research was underway. Financial support for further research was graciously provided by Associate Dean Betsy Rezelman of St. Lawrence University. Finally, I thank Lynette Bosch of Brandeis University for her helpful advice at the beginning of this project, and Keith P. F. Moxey of Barnard College and Columbia University for his comments on a draft of this article.

1 For example, David Freedberg, *Iconoclasts and Their Motives* (Maarsen, 1985); Keith P. F. Moxey, "Pieter Aertsen, Joachim Beuckelaer and the Rise of Secular Painting in the Context of the Reformation" (Ph.D. diss., University of Chicago, 1974), published by Garland (New York, 1977); and the subsequent Pieter Aertsen studies by Moxey and others which appeared in *Nederlands kunsthistorisch jaarboek* 40 (1989). Of special note were the Dutch exhibitions organized in 1986 around the theme, *De eeuw van de beeldstorm* (Amsterdam, Rijksmuseum, and other locations), and related studies in the *Nederlands kunsthistorisch jaarboek* 37 (1986), *Bulletin van het Rijksmuseum* 35 (1987), and *Oud Holland* 102, no. 2 (1988). In the field of prints, important works have been published by Ilja Veldman, e.g., the catalogue *Leerijke reeksen* from the above-mentioned exhibition, and *De wereld tussen Goed en Kwaad. Late prenten van Coornhert* (The Hague, 1990). Also noteworthy is the study by Christine Megan Armstrong, *The Moralizing Prints of Cornelis Anthonisz* (Princeton, 1990).

afforded sanctuary and prosperity, these emigres produced imagery analogous to that from the northern provinces. In both contexts one finds sharp critiques of the times and more subtly designed images meant for both Catholic and Protestant audiences.

If the volatile politics of the time is reflected in the emigres' art, it is seen even more clearly in their careers. The engraver Jan Sadeler, for example, seems to have spent much of his working life adapting to adverse conditions. Descended from a family of weapons engravers in Brussels, Sadeler (1550–1600) moved to Antwerp around 1570 to start a new career in printmaking. He was an untiring worker, as indicated by written accounts and by his more than 600 prints, and he founded a family enterprise in which relatives served variously as engravers, publishers, and art dealers.[2] Various motivations—the need for sanctuary, the financial survival of his publishing firm, and ambitions for himself and the family—may lie behind Sadeler's migrations to the northern Netherlands, Germany, and Italy. While one may only speculate about these migrations, evidence on Sadeler's political and religious stance may be culled from certain prints and written documents.

Having begun as an engraver for the Plantin press, Jan Sadeler was publishing his own prints by 1576.[3] He maintained professional and social contacts with Christophe Plantin and with other northern European intellectuals such as Abraham Ortelius and Jean de Seur. These first patrons were not only prominent figures of their time; some had belonged to the covert spiritualist group known as the Family of Love (*Familia Charitatis*), whose founders were expelled as heretics in the 1560s.[4]

Jan Sadeler's first departure from Antwerp took place in the year following the devastating sack of the city of 1576. Prints by Jan and his brother Raphael dated between 1577 and 1582 indicate that they had settled in Cologne to reestablish

---

[2] On Jan Sadeler, see the biography in Joachim von Sandrart, *L'academia todesca della architectura, scultura e pittura . . .* (Nuremberg, 1675), vol. 1, 354–355. See also Isabelle de Ramaix, "Les Sadeler: De damasquineur à graveur et marchand d'estampes. Quelques documents inédits," *Le livre et l'estampe* 35 (1989), 7–46; Philippe Sénéchal, "Les graveurs des écoles du nord à Venise (1528–1620). Les Sadeler: Entremise et entreprise," Thèse de doctorat de III cycle, Paris, Université de Paris-Sorbonne, 1987, 3 vols.; and Dorothy Limouze, "Aegidius Sadeler (c. 1570–1629): Drawings, Prints, and Art Theory" (Ph.D. diss., Princeton University, 1990). A nearly complete selection of the Sadeler's prints is catalogued in *Hollstein's Dutch and Flemish Engravings, Etchings, and Woodcuts*, vol. 21, ed. Dieuwke de Hoop-Scheffer (Amsterdam, 1980); vol. 22, ed. K. G. Boon (Amsterdam, 1980).

[3] This date is given on the basis of information gleaned from Sadeler's prints (changes in format, as well as the addition of his address as publisher).

[4] Their correspondence is recorded in *Correspondance de Christophe Plantin*, ed. J. Denucé, vols. 7–9 (Antwerp, 1908–1909); *Abrahami Ortelii Epistulae*, ed. J. H. Hessels (Cambridge, 1888), 578; also cited in Limouze, "Aegidius Sadeler" (as in note 2), 421–423. A print inserted by Sadeler in the *Album Amicorum* of Jean de Seur is in the Rijksmuseum, Amsterdam (illus. Hollstein 619). On the Family of Love and its impact upon Pieter Bruegel the Elder and other figures, see note 38 below.

themselves in that publishing center. In 1578, Jan also traveled to Campen, a center for books and popular woodcuts in the northern Netherlands.[5]

Sadeler's visit to Campen yielded one popular woodcut, representing the portentous birth in the Netherlands on New Year's Day, 1578, of a seven-headed, seven-eyed, seven-armed baby with the haunches and cloven hooves of an animal (Fig. 2).[6] Only a German copy after this print is known. Its text metaphorizes the multiple heads, eyes, and limbs as signs of a schism between spiritual and worldly realms—the viewer might further link the numbers of these parts to the Seven Deadly Sins, or the seals of the Apocalypse. The text goes on to relate the one-eyed heads to the cyclopes (*Menschenfresser*) who go about devouring other humans. The centaurlike haunches and hooves reflect the bestial nature of humanity, if not also tacitly the devil, who could in this context signify heresy. The text continues that such a baby was born in Constantinople in 596, one year before the supposed birth of Mohammed, who, as the text relates, caused the "blasphemous Turkish superstition . . . that divided the beloved church and tore apart the entire Roman empire. . . ." The text then mentions a similar prodigy, born during the lifetime of the "heretic Arius," in the late third to early fourth century.

The print therefore alludes to both schisms and agents of violence. Its text hides behind these allusions, not naming the centaurs and cyclopes; yet one assumes that they signify both the rioting Protestant sects and the Spanish forces.

The concept behind this print is most interesting. Images of prodigies, with their claims to historical precedents and threats of catastrophe, belong to a much older tradition. One immediately notices its connection with Sebastian Brandt's *Sow of Landseer*, as well as with such broadsheets as *Seven-Headed Luther* and the *Seven-Headed Pope*, all widely circulated vehicles of Reformation polemic.[7] A similar revival of this imagery is found in D. V. Coornhert's engraving of *Sedition*, showing a divided figure warring against itself, from the

---

[5] On Campen, see the studies of the publisher Warnersen in *Het boek in Nederland in de 16de eeuw*, exhib. cat., The Hague, Rijksmuseum Meermanno-Westreenianum (The Hague, 1986), 81–82; and Armstrong, *Moralizing Prints* (as in note 1), 58, 157 n. 27, with further citations.

[6] The print is illustrated in Walter L. Strauss, *The German Single-Leaf Woodcut 1550–1600: A Pictorial Catalogue* (New York, 1979), 892.

[7] The images of prodigies were first explored by Aby Warburg, *Heidnisch-antike Weissagung in Wort und Bild zu Luthers Zeiten*, Sitzungsberichte der Heidelberger Akademie der Wissenschaften, Abhandlung 26 (Heidelberg, 1920); reprinted in *A. M. Warburg, Ausgewählte Schriften und Würdigungen*, ed. Dieter Wuttke (Baden-Baden, 1979), 199–304. The vague references to the monsters in this print may relate to the fact that they go back to the older concept of Saturn as devourer of gods, which Warburg traces through this body of material. For discussion of the other Lutheran and anti-Lutheran broadsheets, see Christiane Andersson, "Polemical Prints in Reformation Nuremberg," in *New Perspectives on the Art of Renaissance Nuremberg: Five Essays*, ed. J. C. Smith (Austin, 1985), 40–62.

series after drawings by Adriaen de Weert.[8] Two very similar seven-headed infants appear in German and Italian engravings, which locate the monstrous birth in the regions around Novara and Milan in the year 1578.[9]

In this print Sadeler moved from the production of technically demanding engravings to a crude, woodblock image. As was the case with many other sixteenth-century printmakers, he worked on both elite and popular levels. Recent studies have indeed challenged the hierarchical distinctions that art historians previously imposed on these genres.[10]

The other prints from this period come from Sadeler's sojourn in Cologne, which was then a haven for religious refugees from the Netherlands, and, from December, 1577, the seat of Archbishop Gebhard Truchsess von Waldburg, a liberal Catholic with connections to the Netherlandish reformers. Jan Sadeler made a portrait of Truchsess in which he addressed the archbishop in a eulogistic dedication.[11] Other works from this period include a print after Adriaen de Weert's design of *Christ as Victor over Sin and Death*, which Julius Held and David Freedberg have connected with Lutheran sources,[12] and, more strikingly, a portrait of Martin Luther (Fig. 1). The profile portrait commemorates Luther, who "put down the cults and restored the faith." The inscription at the top, "in quietness and trust shall be your strength" (Isaiah 30:15), is also seen in a frontal portrait of Luther by the workshop of Lukas Cranach the Elder, from 1528.[13] If this passage takes on a significance within Lutheranism, it had an even wider currency because of the neo-stoic orientation of the period. The

[8] This print and the series to which it belongs are analyzed by Veldman, *De wereld tussen Goed en Kwaad* (as in note 1), 82–85.

[9] Zentralbibliothek Zürich, Graphische Sammlung, PAS II 15/9 and PAS II 16/5. My thanks to Dr. Bruno Weber for this information.

[10] On the need to abandon aesthetic criteria and judge these works as cultural constructs, see Keith Moxey, *Peasants, Warriors, and Wives. Popular Imagery in the Reformation* (Chicago, 1989), 1–9. Moxey, "The Beham Brothers and the Death of the Artist," *Register of the Spencer Museum of Art* 6, no. 6 (1989), 25–29, argues further for reading woodcut images as carriers of social meaning, as opposed to assertions of artistic identity. In the same issue of that journal, however, Peter Parshall explores sixteenth-century uses of the woodcut as a vehicle for concepts of artistic virtuosity: "Reading the Renaissance Woodcut: The Odd Case of the Master N.H. and Hans Lützelburger," 30–43.

[11] *Hollstein's Dutch and Flemish Engravings* (as in note 2), vol. 21, no. 618. On Truchsess, see Günther von Lojewsky, *Bayerns Weg nach Köln*, Bonner historische Forschung 21 (Bonn, 1962).

[12] Julius S. Held, "A Protestant Source for a Rubens Subject," in *Liber Amicorum Karel G. Boon* (Amsterdam, 1974), 79–95; reprinted in *Rubens and His Circle*, ed. Anne W. Lowenthal et al. (Princeton, 1982), 138–148; David Freedberg, "Rubens As a Painter of Epitaphs," *Gentse bijdragen tot de kunstgeschiedenis* 24 (1976–78), 51–71; idem, *Rubens. The Life of Christ after the Passion*, Corpus Rubenianum Ludwig Burchard, vol. 7 (Oxford, 1989), 59–69. On the author of the composition, Adriaen de Weert, see Nicole Dacos, "Autour de Pellegrino Tibaldi. Adriaen de Weerdt en Italie," in *Scritti in onore di Giulio Briganti*, ed. Marco Bona Castellotti et al. (Milan, 1990), 109–122. Also see note 8 above.

[13] The print is Hollstein 604. I note that the address of Caspar Ruts, the publisher, indicates that it was published in Cologne, a proof of Sadeler's presence in the city in that year. The Cranach workshop portrait is illustrated in *Kunst der Reformationszeit*, exhib. cat., Altes Museum, Berlin (West Berlin, 1983), 319, no. E 35.

same text was used by Jan's cousin, Aegidius Sadeler, for the engraved book-plate of the humanist nobleman Peter Vok von Rosenberg.[14]

Truchsess's reign over Cologne was of brief duration. The Catholic powers within the empire, angered first at Truchsess's libertine behavior and later at his attempt to bring the Reformation to Cologne, expelled him and drove out or imprisoned all the French and Netherlandish Protestants who had settled there. He was replaced by a Catholic cousin, Ernst von Wittelsbach.[15]

During his sojourn in Cologne, Jan Sadeler revealed his ability to play both sides of the skirmish. In 1580, he applied to the Holy Roman Emperor Rudolf II for a permit to work within the empire as well as for a *privilegium*. A set of prints dedicated to the Bohemian Count Otto Heinrich von Schwarzenberg secured a recommendation at court on his behalf. Schwarzenberg described Sadeler as an "honorable, pious, and Catholic man, well above the common rabble of artists."[16]

When the Sadelers returned to Antwerp in 1582, the number of Calvinists and other Protestants exceeded that of Catholics in spite of the Spanish oppression.[17] The city endured an attack by the French in that year. In July of 1584, Spanish troops led by Alessandro Farnese, Duke of Parma, imposed a siege that dragged on for fourteen months until mid-August of 1585.

Here again, Sadeler shifted his allegiance to adapt to the new circumstances with the design of a print series on the *Seven Planets* dedicated to Alessandro Farnese, victor of the siege of Antwerp.[18] The title page is dated August, 1585, the month of Antwerp's capitulation. Sadeler may have hoped for an appointment from Farnese, who patronized artists at his court at Malines.

It is more significant that Sadeler seems to have had a role in designing Farnese's triumphal entry into the city, which took place on September 7. There is a previously unnoted correspondence between the print series and seven of the triumphal arches built for that festivity. Michael Eytzinger's chronicle, *De leone belgica*, describes the Stadholder's progress past arches representing his native Italy and Antwerp, to a series of arches representing celestial bodies and the aspects that they govern on earth. His description of the arches of Jupiter, Sat-

---

[14] Discussed by Limouze, "Aegidius Sadeler" (as in note 2), 184–185.

[15] Von Lojewski, *Bayerns Weg nach Köln* (as in note 11), 350–361.

[16] In the original, "ain ehrlicher frommer und chatolischer mann, und von gemainer dergleichen Kuenstlerschwurmerei alienus." First published by Hans Voltellini in *Jahrbuch der Kunsthistorischen Samm-lungen des allerhöchsten Kaiserhauses* (1894), lxxx–lxxxi; cited by Limouze, "Aegidius Sadeler" (as in note 2), 414.

[17] See, for example, the numbers cited by H. Soly, "The Betrayal of the Sixteenth-Century Bourgeoisie: A Myth?" *Acta Historiae Neerlandicae* 8 (1975), 31–49.

[18] Hollstein 517–524.

urn, Mars, the sun, the moon, Venus, and Mercury corresponds to the images in the print series.[19]

If the above particulars reveal Sadeler's readiness to change sides, his subsequent activities reflect an altered view of the circumstances. Letters of Christophe Plantin from 1585 and 1586 document Sadeler's intentions of moving to Mainz and Frankfurt,[20] and engravings and documents indicate his departure in the next year.[21] The cities to which the Sadelers moved were both publishing centers; even more importantly, Frankfurt was a trading capital and supported a biannual international fair for the sale of art and other commodities.

In Frankfurt, Sadeler began to engrave after designs by Joos van Winghe, a painter who emigrated from Flanders in 1584; innovative products of their collaboration will be discussed below. In 1589, Sadeler was called to Munich, to serve as court engraver to Duke Wilhelm V of Bavaria. Here again, Sadeler passed the test of Catholic orthodoxy: individuals who could not do so did not stay long at this court.[22] Unfortunately, the poor financial state of the court at Wilhelm's abdication in 1595 led to the dismissal of Sadeler and several other artists.[23] In that year, Sadeler traveled with his family to Italy and set up a successful printing firm in Venice, which was continued by his son, Justus Sadeler.[24] Still seeking court patronage, he made a trip to Rome in 1600 to attract the interest of Pope Clement VIII by means of gifts of prints. Discouraged by the Pope's reward, which was an assortment of relics rather than a more substantial remuneration, Sadeler returned to Venice. Having caught a fever en route, he died in Venice on August 26, 1600.[25] In his will he made a final gesture of his Catholic orthodoxy by disinheriting his wife because of her "heresies."[26]

[19] Michaele Aitsingero Austriaco, *De Leone Belgica, Eiusq. Topographica atqu. Historica Descriptione Liber* (Cologne, 1588), 388. I note that the date on that page is erroneously given as 1586, while the previous and succeeding pages are dated 1585.

[20] *Correspondance de Christophe Plantin* (as in note 4), vol. 7, no. 1044; vol. 8, no. 1161,R.

[21] The print, Hollstein 181, is signed "Mainz, 1587." On documents relating to Sadeler's stay in Frankfurt, see Walter Karl Zülch, *Frankfurter Künstler, 1223–1700* (Frankfurt a.M., 1935), 397–399, 400–401, 416–417.

[22] See the account of the religious *Sanierung* of the court in Thea Vignau-Wilberg, "Joris Hoefnagel's Tätigkeit in München," *Jahrbuch der Kunsthistorischen Sammlungen in Wien*, n.s., 45 (1988), 150–151. Also cited by Limouze, "Aegidius Sadeler" (as in note 2), 29, 60 n. 38.

[23] See Heinz Dollinger, *Studien zur Finanzreform Herzog Maximilians I. in den Jahren 1598–1618. Ein Beitrag zur Geschichte des Frühabsolutismus* (Göttingen, 1968).

[24] This is the focus of Sénéchal, "Les graveurs des écoles du nord à Venise" (as in note 2), and of his more recent article, "Justus Sadeler. Print Publisher and Art Dealer in Early Seicento Venice," *Print Quarterly* 7 (1990), 21–35.

[25] See Sandrart's account in *L'academia todesca* (as in note 2), 355.

[26] Documents relating to Sadeler's death were brought together by Rodolfo Gallo, "Gli incisori Sadeler a Venezia," *Rivista della città di Venezia* 9, no. 1 (Jan., 1930), 35–56. Also cited by Sénéchal, "Les graveurs des écoles du nord à Venise" (as in note 2), vol. 1, 34; and Limouze, "Aegidius Sadeler" (as in note 2), 31. Sénéchal notes, however, that Sadeler's son and heir was buried in the Protestant cemetery in Leiden.

Fluctuations in Sadeler's political and religious views run through his prints. His work was also directed at diverse levels of reception, ranging from popular audiences to the courts of the Holy Roman Empire and of Rome. The aesthetic level of the prints did not always correspond to their contexts. What might be regarded as Sadeler's most aesthetically elevated prints were made in Frankfurt in collaboration with Joos van Winghe. Only the more prosaic of these images were dedicated to patrons, whereas the more novel prints bear no dedications.

Joos van Winghe[27] was a gifted artist whose career was hampered by circumstances. Showing early talent, Winghe (ca. 1544–11 December, 1603) was supported by a cardinal in Rome for four years. He returned to work in Brussels in 1568 and became painter to the court at Malines following Alessandro Farnese's appointment as Stadholder in 1578. Winghe emigrated to Frankfurt in 1584, during the time of Farnese's military reconquest of the southern Netherlands.

According to Karel van Mander, Winghe attacked the Spanish rule of Flanders in two allegories painted in Frankfurt. The now-lost painting of *Horrified Belgium* represented Belgium tied like Andromeda to a rock and threatened by a dragon representing Spain. Time flies to her rescue, while Religion is pinned to the ground by Tyranny. Another painting was said to have represented *Justice Shielding Ignorance from Tyranny*.[28]

Evidence in the biographies of Sadeler and Winghe opens up possibilities of interpretation of a group of prints created by their collaboration. The themes of the prints are not openly polemical, but rather open to different readings. Such is the case with Jan Sadeler's print after Winghe of *Christ Blessing the Children* of 1588 (Fig. 3).[29] Seen against the backdrop of quasi-antique architecture, the figures, who include the protesting apostles, women, and children, form a circle around Christ, who carries the smallest infant. That child is in the attitude of praying to heaven, thereby becoming a trope for the infant Christ. The biblical text (Matthew 19:14, Mark 10:14, and Luke 18:15–17) is given in Latin: "Suffer the little children to come unto me, for theirs is the kingdom of Heaven."

The subject was introduced to altarpieces by Lukas Cranach the Elder and became a popular theme of later Reformation art.[30] According to Gottfried See-

---

[27] Publications on this artist include Georg Poensgen, "Das Werk des Jodocus a Winghe," *Pantheon* 28 (1970), 504–515; idem, "Zu den Zeichnungen des Jodocus a Winghe," *Pantheon* 30 (1972), 36–47; J. Richard Judson, "A New Joos van Winghe Drawing," *Nederlands kunsthistorisch jaarboek* 23 (1972), 37–40; Konrad Renger, "Joos van Winghes 'Nachtbancket met een Mascarade' und verwandte Darstellungen," *Jahrbuch der Berliner Museen* 14 (1972), 161–193; and William W. Robinson, "Two Drawings by Joos van Winghe," *Master Drawings* 27 (1989), 314–321.

[28] Karel van Mander, *Het Schilder-Boeck* (Haarlem, 1604; reprint Utrecht, 1969), 264–264v.

[29] Hollstein 196.

[30] See Gottfried Seebass's remarks on the painting exhibited in Nuremberg, Germanisches Nationalmuseum, *Martin Luther und die Reformation in Deutschland*, exhib. cat. (Frankfurt, 1983), 269–270. Also see Carl Christensen, *Art and the Reformation in Germany* (Athens, Georgia, 1989).

bass, Lukas Cranach's painting of around 1540 reflects the conflict between Lutherans and Anabaptists over the latter group's adoption of adult baptisms. Here the focus is entirely upon newborn infants. The disciples, who protest Christ's insistence on touching the infants, glare at them angrily from the left. Between 1575 and 1576, Marten de Vos picked up this theme in an altarpiece for the chapel of the palace at Celle of Duke Wilhelm the Younger of Braunschweig-Lüneberg.[31] By this time the debate over baptism had slipped into the background. De Vos represented the theme in a civic space, which, like that of the print, is composed partly of fantastic architecture. There, children of various ages are led to Christ, amid a group of disciples who offer little resistance. The inscription above is from Deuteronomy 6:6: "And these words which I command you this day shall be upon your heart; and you shall teach them diligently to your children." The altarpiece for the court chapel has thus moved away from a polemical stance to an eirenic one by means of its imagery and typological source given by its inscription for the bringing of children into the faith.

The Sadeler print after Winghe, from 1588, shows a similar distancing from the Lutheran polemic of a generation earlier. Furthermore, it bears a Latin inscription, rather than a German one. The language of the inscription—that of the Vulgate rather than the Lutheran Bible—serves to disguise its original artistic context. Thus the image is made palatable to a Catholic audience through its Latin text, even though its subject is a product of Lutheran art.

More reflections on the experiences of these emigres and supposed heretics might be seen in another print from the group, this one representing *St. Paul in Exile at Corinth* (Fig. 4).[32] While the image is unusual in concept, it may be understood by reference to narrative treatments of the life of St. Paul within Jan Sadeler's oeuvre. Cycles of the life of Paul were engraved by Jan Sadeler after designs by Frans Pourbus and Marten de Vos, in 1580 and 1581, respectively.[33] Both of these print cycles therefore date from Sadeler's period of association with Truchsess in Cologne. The series after Pourbus, which represents the *Conversion of Saul* (Acts 9:1–9), and the *Beheading of the Saint*, was dedicated to Otto Heinrich von Schwarzenberg, the Catholic official from whom Sadeler secured a recommendation to the imperial court. The focus on the two key manifestations of faith on the part of the saint—his conversion and martyrdom —correspond to Counterreformatory trends in Catholic art. In contrast, the series after De Vos focuses on other events: Paul's imprisonment at Philippi (Acts 16:19–24), his vision of Christ in the army barracks (Acts 23:11), his sojourn on Malta (Acts 27:41–28:6), and his liberation from prison with Silas at Philippi (Acts 16:35–40).

---

[31] Armin Zweite, *Marten de Vos als Maler* (Berlin, 1980), cat. no. 38, 85–155.
[32] Hollstein 336.
[33] Hollstein 334–335, and 330–333.

This emphasis on persecution, exile, and the loneliness of a holy life is also reflected in the choice of subject of Van Winghe's composition. Leaving the hostile crowds of Athens, Paul went to Corinth and was sheltered by a Jewish couple, Aquila and Prisca, who, like him, were tent makers. The text beneath (cropped in the present impression) gives in Latin the passage from Acts 18:1–3, which narrates this visit. However, the imagery may reflect other themes that concerned Paul in the letters written at Corinth. Paul in fact sits at the left foreground with pen in hand, writing one of the final sentences of the first letter to the Corinthians, in which he mentions that Aquila and Prisca send their greetings (1 Cor. 19). Aquila's wife Prisca and their children move across the composition in a dancelike sequence of forward, sideways, and backward poses—a stylistic device that connects Van Winghe with influences from the School of Fontainebleau.[34] Here, as in other compositions by Van Winghe, the organization of figures and objects is observably deliberate and calculated. This manner of isolating motifs invites one to look at them for multiple meanings.

One obvious source for this print's iconography is the letters of the apostle Paul. In the print, a mirror is placed prominently on the table beside Paul, possibly in reference to the famous passage, "For now we see through a glass darkly, but then face to face" (1 Cor. 13:12). Below this, the figure of Prisca at her spinning wheel, her young daughter, and the others may signal the moral issues of marriage, the family, and the care for worldly concerns that Paul addresses at length in that first letter to the Corinthians, which he is indeed seen writing. In the background Aquila looks toward a nearby stranger and gestures hospitably to a serving bowl with three spoons that is placed on his loom. Two looms for weaving tent cloth dominate the middle ground: could these reflect the passage about tents in the second letter: "For we know that if the earthly tent we live in is destroyed, we have a building from God, a house not made with hands, eternal in the heavens" (2 Cor. 5:1)? The implications of this passage are powerful, given the frequent use of the tent in the Bible as a metaphor for the houses of man and of God, and for the exiled peoples of Israel. Is this perhaps also a veiled reference to the situation of the Flemish emigres? In the background, figures with bundles on their backs walk up and down the stairs. They could well be guests at a sixteenth-century inn, such as that at which Sadeler was known to have lived in Frankfurt. Winghe most certainly lodged in such places, too, as they were common shelters for the refugees.[35]

Further, this image reflects more canonical themes, and thereby borrows their religious and moral implications. The entire scene resembles traditional

[34] Also suggested by Judson, "A New Joos van Winghe Drawing" (as in note 27), 37. I am investigating connections between Fontainebleau and Northern Mannerism in a further project.

[35] Sadeler is described as working in a hostel in Frankfurt by Sandrart, *L'academia todesca* (as in note 2), vol. 1, 354. Also see the unpublished notes taken from old documents on Sadeler in the Trautmann Nachlass, Munich Stadtarchiv, Schachtel 38, 112, 114.

Netherlandish images of the holy family in a domestic setting.[36] In effect, one is made to look backward from Paul to that earlier group of refugees, Christ and his parents. Could not a typological linkage be implied, that, in turn, refers forward to the Flemish emigres? The prominent spinning wheel suggests another, disparate reference: the well-known theme of the "visit to the spinner," which was a metaphor for visiting a prostitute.[37] The context in which Van Winghe presents this motif—that of a virtuous family—and the beauty and grace of the representation fashion it into a moral antithesis to the theme of debauchery. The virtues reflected by the figures and their setting—diligence, domesticity, grace, hospitality, prudence (embodied in the mirror's symbolism) —are in fact held up to the viewer as a model for living.

This print may indeed be the touchstone for the entire group of prints produced by Jan and Raphael Sadeler after Joos van Winghe. The various prints, *Christ Blessing the Children*, *Lot and His Daughters*, *Evening Banquet with Mascarade* (also called a *House of Ill Fame*), and *The Power of Women over Men*, all sermonize about one or another moral issue. The engraving *Paul at Corinth* may perhaps provide the key to interpreting these works, as a moral and didactic project undertaken by the refugee artists in emulation of Paul.

Viewed in their entirety, the compositions of Joos van Winghe and the Sadelers reflect changing attitudes and allegiances. Such inconsistencies may be resolved by reference to the turmoil in Flanders in the 1570s and 1580s. The enlightened members of Plantin's circle developed ways of coping with political and religious strife through acts of simulation and conciliation. The Family of Love, a popular religious sect which advocated such conduct, was founded in the 1530s. At least some of its original adherents, e.g., Christophe Plantin and Abraham Ortelius, were friends of Jan Sadeler. Furthermore, since the prominent members of the sect were driven to Cologne in the 1560s and 1570s, they were present in that city during Jan Sadeler's sojourn there.[38] The interpretation of these works by emigre artists might therefore be approached in a way

---

[36] I thank Keith Moxey for drawing my attention to this affinity with the preexisting type.

[37] See the discussion of Israhel van Meckenem's engraving of this theme in H. Diane Russell, *Eva/Ave. Woman in Renaissance and Baroque Prints*, exhib. cat., National Gallery of Art (Washington, D.C., 1990), 184–185.

[38] For more on the Family of Love, see Alastair Hamilton, *The Family of Love* (Cambridge, 1981); B. Rekers, *Benito Arias Montano (1527–1598)* (London, 1972); J. van Dorsten, *The Radical Arts: First Decade of an Elizabethan Renaissance* (Leiden and London, 1973); Nicolette Mout, *Bohemen en de Nederlanden in de zestiende eeuw* (Leiden, 1975); and eadem, "Political and Religious Ideas of Netherlanders at the Court in Prague," *Acta Historiae Neerlandicae* 9 (1976), 1–29. Mout actually proposes that Sadeler was a member, although no definitive proof can be found for this idea. C. G. Stridbeck found kindred anti-clericalist sentiments in a Bruegel painting: "'Combat between Carnival and Lent' by Pieter Bruegel the Elder. An Allegorical Picture of the Sixteenth Century," *Journal of the Warburg and Courtauld Institutes* 19, nos. 1–2 (Jan.–June, 1956), 96–108.

similar to that employed with familist texts: with sensitivity toward their dis-simulating and diacritical content.[39]

Confusing times gave rise to a confusing variety of artistic themes, some subtle enough to offer dual readings to Catholic and reformed viewers.[40] To the former group, these artists would have offered orthodox treatments of pious subjects. To the latter, their images and texts would have evoked ideas about religion, persecution, and exile—all topical concerns in the period of religious strife in northern Europe.

<div align="right">

St. Lawrence University
Canton, New York

</div>

---

[39] Summarily discussed by Janet E. Halley, "Identity and Censored Language: The Case of the Familists," in *Persons in Groups*, ed. Richard Trexler (Binghamton, 1985), 221–229. See also Carlo Ginzburg, *Il nicodemismo. Simulazione e dissimulazione religiosa nell'Europa dal '500* (Turin, 1970); and the observations about contemporary eirenic impulses reflected in a poem by Georg Hoefnagel, in Thomas DaCosta Kaufmann, "The Nature of Imitation: Hoefnagel on Dürer," *Jahrbuch der Kunsthistorischen Sammlungen in Wien* 82/83 (1986/87), 163–177; reprinted in idem, *The Mastery of Nature: Aspects of Art, Science, and Humanism in the Renaissance* (Princeton, 1993), 79–99.

[40] Barbara Haeger has proposed that a print series by Cornelisz Anthonisz presented levels of meaning apparent only to those previously exposed to Protestant beliefs: "Cornelis Anthonisz's Representation of the Parable of the Prodigal Son: A Protestant Interpretation of a Biblical Text," *Nederlands kunsthistorisch jaarboek* 37 (1986), 133–150.

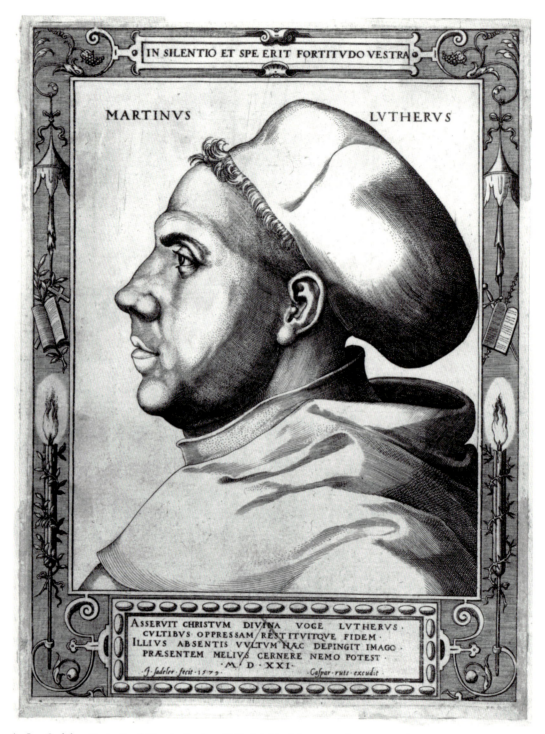

IN SILENTIO ET SPE ERIT FORTITVDO VESTRA

MARTINVS                    LVTHERVS

ASSERVIT CHRISTVM DIVINA VOCE LVTHERVS
CVLTIBVS OPPRESSAM RESTITVITQVE FIDEM·
ILLIVS ABSENTIS VVLTVM HAC DEPINGIT IMAGO
PRÆSENTEM MELIVS CERNERE NEMO POTEST·
·M·D·XXI·
J. Sadeler fecit 1579        Caspar ruts excudit

1. Jan Sadeler, *Portrait of Martin Luther*. Philadelphia Museum of Art, Muriel and Philip Berman Gift
(photo: museum)

# Warhafftige Contrafactur einer erschrecklichen Wundergeburt

eines Knebleins/welches recht am newen Jarstage dieses jetzlauffenden 1578. Jars

von einer alten Frawen in Eurigo Terra, del noua, rese, ist geboren worden.

IM anfang die-
ses jtzlauffenden 1578.
Jars / recht am newen
Jars Tage / ist dieses
grewliche vnd schreckli-
che Monstrum / von ei-
ner Frawen im Nider-
land geboren worden. Ist seines ge-
schlechts ein Kneblein gewesen / mit sie-
ben Heuptern/welche jedes nur ein Au-
ge gehabt/desgleichen mit sieben Armen
vnd zu vey Füssen/gleich eines wilden
Thiers oder Bestien Füssen.

In diesem Monstro mahlet vns
one zweiffel Gott vnsere Sündliche na-
tur / vnd Epicurisch / Cyclopisch vnd
Viehisches leben abe / weil die Cyclopes
vnd Menschenfresser einenaig beschrie-
ben / vnd daher auch Cyclopes geheissen
werden. Welcher jtzt die gantze Welt
voll ist / vnd schier einer den andern für
geitz vnd bosheit Frist vnd auffreibet.
So zeigen die Centaurischen vnd Vie-
hischen Füsse / vnserer Centauren viehi-
sches vnd Vnmenschliches leben vnd
wandel an / darin die Leute mehr den
Centauris/Satyris vnd wilden Leuten/
ja mehr den wilden Thieren vnd Besti-
en / denn den Menschen gleich sehen/
stehen vnd wandeln / wie leider am tage
ist.

Es bedeuten auch die viel zerthei-
te vnd mannigfeltige Heupter vnd Ar-
me one zweiffel künfftige zerrüttung vnd
spaltung im Geistlichen vnd Weltli-
chen Regiment. Denn es bewerens die
Historien / vnd gibts die erfarung / das
wenn Monstra mit mehr als einem
Heupte geboren werden/gemeinlich tren-
nung vnd spaltung darauff erfolgen.

Im Jar Christi 596. ist zu Con-
stantinopel ein Kind mit zwey Heuptern
vnd vier Füssen jung worden/ Bald fol-
gends Jars darauff ist in Arabia geborn
Machumetes ein vrsach des Türckischen
Gotteslesterlichen aberglaubens vnd al-
les vnglücks / dadurch die liebe Kirche
getrennet / vnd das gantze Römische
Reich von den Mahomcisten vnd Tür-
cken noch heutiges Tages zerrissen vnd
verheeret wird.

Kurtz zuvor ehe der Ketzer Arrius/
der die Gottheit Christi geleugnet/auff-
gestanden / ist ein Kindt jung worden/
welches zwey Meuler/vier Augen vnd
zwene Zeene gehabt/ vnd sind Cometen
vnd Erdbiben zugleich mit vorher gan-
gen/ welche alle die grewliche zerrüttung
vnd trennung der Kirchen/so durch Ar-
rium geschehen/bedeutet haben.

Der barmhertzige Gott verleihe
das wir diese Zeichen vnd warnungen/
zu Hertzen nemen/vns bessern vnd Bus-
se thun/ vnd ablenung oder ja linderung
vorstehender straffe bey jm erlangen mö-
gen / vmb seines geliebten Sons Jhesu
Christi willen/Amen.
Erstlich durch Johan Sadeler excusum
zu Campen/vnd jtzt newlich aus
Niderlendischer sprach ins
Deudsche gebracht.

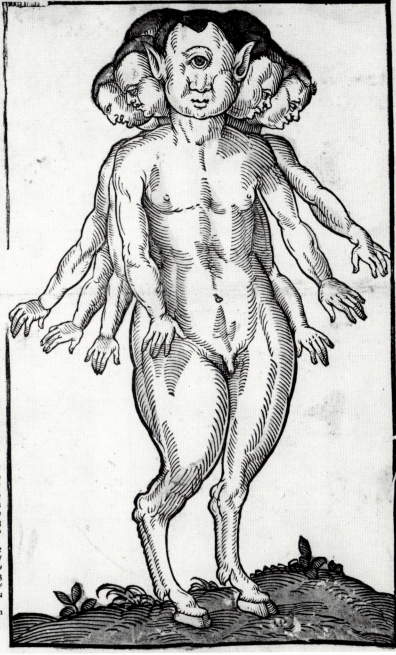

2. Jan Sadeler, *Seven-Headed Baby*, 1578. Zurich, Zentralbibliothek, no. PAS II 15/37
(photo: Zentralbibliothek, Zurich)

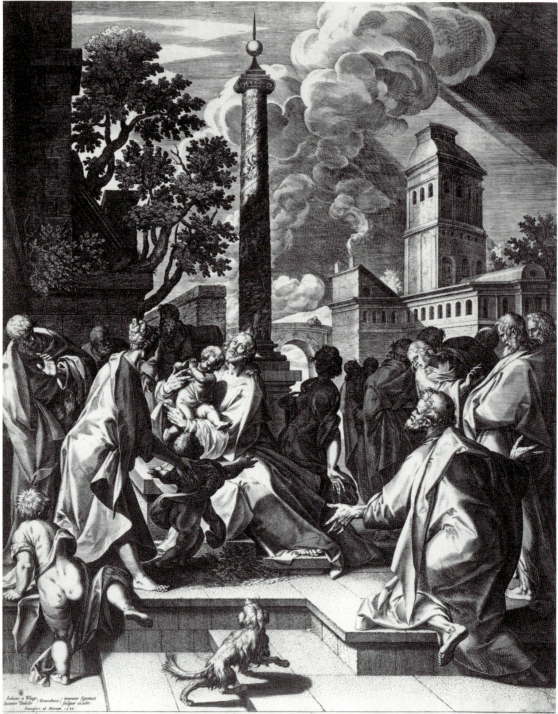

SINITE PVEROS, ET NE PROHIBEATIS EOS AD ME VENIRE: TALIVM EST ENT REGNVM CŒLORVM.

3. Jan Sadeler, *Christ Blessing the Children*, after Joos van Winghe, 1588. Amsterdam, Rijksmuseum
(photo: ©Rijksmuseum-Stichting)

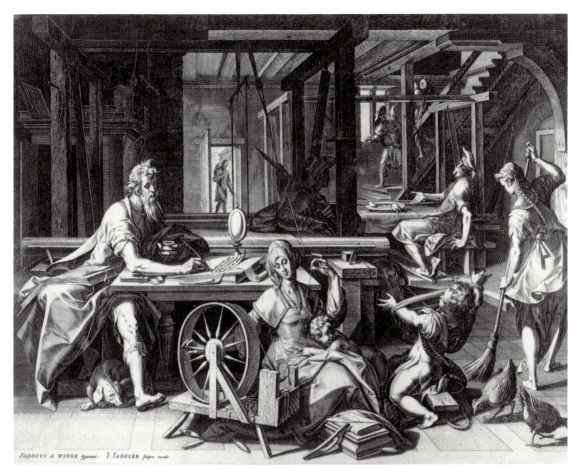

4. Jan Sadeler, *St. Paul in Exile at Corinth*. Philadelphia Museum of Art, Muriel and Philip Berman Gift
(photo: museum)

# The Meaning of the Baerze-Broederlam Altarpiece*

## CHARLES MINOTT

❧

IN THE YEAR 1390, Philip the Bold, duke of Burgundy, ordered two carved wooden altarpieces from one of his *varlets de chambre*, the Flemish wood sculptor Jacques de Baerze of Termonde (Figs. 1–3).[1] They were shipped to Dijon in August of 1391. In 1393 the two retables were forwarded for painting and gilding to the painter Melchior Broederlam of Ypres. Broederlam was also in the service of Duke Philip.

Broederlam added panel paintings to the outer surfaces of the wings of the more elaborate work, the Crucifixion Altarpiece (Fig. 4). He may also have painted panels for the outer wings of the other retable, known as the Saints and Martyrs Altarpiece, but if so they have been lost. When his work was completed, the painter accompanied the finished pieces to Dijon, where he supervised their placement in the abbey church of the Chartreuse de Champmol,

* This paper has been modified and expanded from the form in which it was presented to a session on Netherlandish patrons and patronage at the 1986 College Art Association Meeting in New York. That session was chaired by Barbara Lane; Bob Koch and the late dear friend of all of us, James Snyder, acted as respondents to the papers. I am pleased to be able to present it here in thanks for Bob's kind words then and his continuous good will.

[1] C. Monget, *La Chartreuse de Dijon d'après les documents des archives de Bourgogne* (Montreuil-sur-Mer, 1898), vol. 1, 201; D. Roggen, "De twee retabels van de Baerze te Dijon," *Gentsche Bijdragen* 1 (1934), 91–107; E. Panofsky, *Early Netherlandish Painting* (Cambridge, 1953), vol. 1, 86–89; vol. 2, figs. 104, 105, 164; L. F. Jacobs, "Aspects of Netherlandish Carved Altarpieces: 1380–1530" (Ph.D. diss., Institute of Fine Arts, New York University, 1986), chap. 1, "Patronage and Mass Production." I am grateful to Lynn Jacobs for the reference to her work and the Pitts and Hinkey references that follow. Jacobs has discussed the altarpiece as a ducal commission, and the ordering of its iconography to suit the duke's needs. She refers to two studies: F. Pitts, "The Crucifixion Altarpiece by Jacques de Baerze" (M.A. thesis, U.C.L.A.); and D. Hinkey, "The Dijon Altarpiece by Melchior Broederlam and Jacques de Baerze: A Study of Its Iconographic Integrity" (Ph.D. diss., U.C.L.A., 1976), both unpublished. Neither of these has been available to me. For the most recent and thorough study of the Crucifixion Altarpiece, see M. Comblen-Sonkes and N. Veronee-Verhaegen, *Le Musée des Beaux-Arts de Dijon*, Les Primitifs Flamands, ser. no. 18 (Brussels, 1986), vol. 1, 70–158; vol. 2, pls. XXXVI–CXIX, with extensive bibliography.

Philip's monastic foundation on the outskirts of town. The installation took place in 1399.

The gilt woodcarvings on the center face of the more complex of these two altarpieces include three narrative scenes: the *Adoration of the Magi*, the *Crucifixion*, and the *Entombment of Christ*. When the polygonal wings are closed, these carvings are covered and Broederlam's paintings are visible. The paintings depict the *Annunciation to the Virgin and the Visitation of Mary and Elizabeth* on the left wing, and the *Presentation of the Christ Child in the Temple and Flight of the Holy Family into Egypt* on the right wing.

The records of these transactions are remarkably complete and the two retables survive in the Salle du Garde of the Burgundian Ducal Palace, now the Musée des Beaux-Arts in Dijon. They were moved to the palace in the early nineteenth century; the Crucifixion Altarpiece in 1818 or 1819, followed by the Saints and Martyrs Altarpiece in 1827.

According to contemporary documents, Philip the Bold ordered the two retables and specified that they replicate earlier works carved by the sculptor Jacques de Baerze. Philip had seen these in Termonde (Dendermonde) and in the abbey at Biloque (Byloke) near Ghent. There is no mention of paintings in these earlier altarpieces, nor do they survive. Thus, as far as we know, the paintings added by Melchior Broederlam to the Crucifixion Altarpiece at the Chartreuse de Champmol were an innovation, not to say an afterthought. They were executed after the carving was done. Over the centuries, however, the innate charm and brilliance of Broederlam's bright, colorful work in these paintings have attracted more attention than has the carving by Jacques de Baerze.

It is not too surprising, then, that the Baerze-Broederlam Altarpiece has been given little serious consideration for its programmatic unity.[2] As seems to be the case with the great Ghent Altarpiece, made a little later by the Van Eyck brothers, the work is a product of a two-stage collaboration. In each instance the second man has been given more importance and is considered to have been impeded by the first artist's composition, which was not fully rationalized. There is no doubt or argument, however, as to the identity of the artists in the Baerze-Broederlam work.

The objective of this paper is to show that the work done on this altarpiece for Philip the Bold represents an action and a reaction. The painter's reaction bears directly upon the meaning of the sculptures, changing their context within the whole. These added paintings may thus have some further parallel

---

[2] The dissertation by D. Hinkey (as in note 1), with a complex theory of iconographic interpretation, is summarized in Comblen-Sonkes and Veronee-Verhaegen, *Musée des Beaux-Arts de Dijon* (as in note 1), 100–101.

with the predicament in sorting out the program of the Van Eyck brothers' retable. This will be discussed below.

THE FIRST STUMBLING BLOCK in all attempts to interpret the program of the Baerze-Broederlam Altarpiece to date has been the chronological imbalance of the historical scenes, particularly those carved by Jacques de Baerze. As we noted, the sculptor chose the Epiphany, Crucifixion, and Entombment of Christ for the main face of the altarpiece. Read from left to right, this combination of a single subject from the infancy of Christ with two closely linked scenes of Christ's Passion seems at first to be arbitrary and pointlessly random. Moreover, no clarification comes from the sculptures on the flanking pair of wings. On their inner faces, seen when the carvings are displayed, are rows of saints in niches surrounded by the same elaborate architectural decor that overarches the scenes of the central panel.

All of the saints that can be identified are popular and virtually universal presences in saintly groups of the period. Whether they all have special meaning to Philip the Bold and Margaret of Flanders seems doubtful at best. On the left wing they include, from left to right, St. George, St. Mary Magdalene, St. John the Evangelist, St. Catherine of Alexandria, and St. Christopher. On the right wing are St. Anthony, St. Margaret, a royal saint (Louis and Wenzel have been suggested), St. Barbara, and a bearded saint holding a chalice (St. Justus, in one opinion).[3]

The figures, all a little over 15 inches (about 40 centimeters) high, are carved separately and can be removed from their niches. There is no certainty that they now stand in their original places. Under the circumstances, it is probably no small miracle that all are still present.[4] I would like to suggest that the two unidentified saints are Charlemagne and St. Philip. The latter figure holds a chalice, possibly a replacement for his usual attribute, a cross-staff. These identifications would place the founder of the royal house of France, along with both Philip and Margaret's name-saints, in the lineup.

---

[3] Kathleen Morand, *Claus Sluter: Artist at the Court of Burgundy* (Austin, 1991), 86–87, 322, 325, notes that fragments of a statue, identified as St. George and attributed to Claus Sluter, resemble details of Jacques de Baerze's St. George on the left retable wing. She asserts that the latter has a similar sense of monumentality to the *pleurant* figures on Philip's tomb carved by Sluter and that Jacques de Baerze's St. George is unlike the remaining saints on the wings of the triptych. He is "too dynamic and too profoundly three-dimensional to be accommodated into the shallow niche provided for him." Jacques's St. George is meticulously carved with armor, helmet, and chain-mail neck guard. His hands are raised in combat with the dragon at his feet. Thus he is visibly more active and individually clad than his robed and generally quiescent companions. It is difficult for this writer to see him as "monumental" or to compare him, as such, to Sluter's *pleurant* figures.

[4] The figure of Christ from the central *Crucifixion* has long since resided in the Art Institute of Chicago. It was purloined long ago from the retable. The carving of St. George in the left wing has been detached and exhibited alone, as at Vienna in the 1962 exhibition of International Gothic art sponsored by the Council of Europe; *Europäische Kunst um 1400* (Vienna, 1962), cat. no. 375, pl. 58.

Except for St. George, as noted, and St. Philip(?), who is curiously under-dressed, most of the saints are heavily draped. They stand in frontal, inactive poses on pedestals. For this reason they at first seem larger in scale than the figures in the historical scenes they flank. In fact they are approximately the same size. Conversely, the central *Crucifixion*, with more than twice the number of figures of either the *Epiphany* or the *Entombment*, is peopled with figures half the size of its neighbors'.

To understand the choice of narrative subjects in the main body of this altar-piece it is necessary to consider the three carved scenes as constituents of a triangle rather than a linear progression of historical scenes. Thus the *Crucifixion* is the center and focus of the work. Christ appears high above the groups of the mourning women and St. John, soldiers gambling for Christ's robe, riders, and the spear and sponge bearers. The two thieves, also elevated and isolated above the figures below, flank the central cross. Above them an angel and a devil bear their respective souls away.

More than an historical event, the Crucifixion of Christ depicts the pivotal moment for all Christianity. The cross is the Christian symbol above all others. It is at once the tragic instrument of Christ's death and the means to redemption for all humankind. In keeping with tradition, the positive elements in this composition, St. John, the mourning women, and the good thief, are placed to Christ's right, while the bad thief, gambling soldiers, and tormentors and doubters are predominantly to his left.

The adjacent scene on Christ's right, or the side of virtue to the viewer's left, is the *Adoration of the Magi*. Its historical moment, at a great remove from the Crucifixion, casts doubt on the idea that chronological placement alone is responsible for the choice or position of the scene. In fact, the juxtaposition of Epiphany and Crucifixion scenes is not uncommon. The small contemporary diptych of the *Adoration of the Kings* and *Crucifixion* in the Bargello in Florence is a good example (Figs. 5a and 5b).[5] The presence of a crucifix on a spandrel of the shed in the Epiphany in Rogier van der Weyden's St. Columba Altarpiece also establishes that the association has continuity and meaning.[6]

There are two logical reasons for combining the Adoration of the Kings with the Crucifixion. First, the *Golden Legend*, the ever popular and widely read account of the major feasts and lives of the saints written by Jacobus da Voragine around 1267, relates that the cross was revealed to the Magi in the star that led them to Bethlehem.[7] Some painters, among them Taddeo Gaddi in his

---

[5] J. Snyder, *Northern Renaissance Art* (New York, 1985), color plate 5 and fig. 32, p. 46.

[6] Ibid., color plate 22.

[7] G. Ryan and H. Ripperger, *The Golden Legend of Jacobus de Voragine* (New York, 1969), 85–86: "Now in the night of Christ's birth a star appeared to them, which had the shape of a wondrous child, with a fiery cross upon his head. . . . " See also the *Speculum humanae salvationis*; A. Henry, *The Mirour of Mans Saluacioun* (Philadelphia, 1987), 75: "Thre kinges se in the Est a sterne of fulle grete leeme, / In whilke newe sterne thai see a knave childe faire and hulde; / Aboven his heved apiered a bright crosse of fyne gulde."

frescoes in the Baroncelli Chapel in Santa Croce in Florence, made the cross quite visible. The two scenes are also linked in what has been called the "structuring of devotion."[8] In some books of hours, such as the Hours of Jeanne d'Evreux in the Cloisters Collection, the infancy scenes of the Little Office of the Virgin are combined with scenes of Christ's Passion, bringing the Crucifixion and Epiphany together (Fig. 6).

In her article on the Epiphany and the Eucharist published in the *Art Bulletin*, Ursula Nilgen pointed out that the manger in the center of Jacques de Baerze's *Epiphany* also represents an altar.[9] This had become a traditional association in Magi plays of the twelfth to fourteenth century and in a wide array of works of art. From this we can readily note an intentional parallel in the Baerze-Broederlam Altarpiece between the manger and the sarcophagus of the *Entombment of Christ* which flanks the *Crucifixion* on the other side. Each is centered and bears the same pattern of decorative tracery on its front side. Christ's tomb also represents an altar in the *Entombment*. The eucharistic implication of the body of Christ laid out atop it needs little further elaboration.

Thus the triad of carved and gilded scenes made for this altarpiece by Jacques de Baerze is clearly harmonious in an iconographic sense. By no means can the selection have been random. An additional thread of meaning that unites all three scenes is established by the choice of the Epiphany. Each of the carvings portrays the effective realization of the meaning expressed in one of the gifts of the Magi. This must have appealed to the royal consciousness of Philip the Bold. Again, the *Golden Legend* is one likely source.[10]

The gift of gold is tribute to Christ's royalty, shown in the Epiphany itself. Frankincense is offered for sacrifice to his divinity, revealed by the Crucifixion, and myrrh is the ointment for the anointing of Christ's body at the Entombment, representing his human nature. The idea is also well expressed in the *Speculum humanae salvationis*, here in the fifteenth-century English version:

> Golde is a real gift for his grete nobletee,
> Be whilk thai shewed the child a king verray to be.
> Encense is oblacioune, ye wote, is sacerdotale,
> And this child was a prest that neuer hadde his egale.
> In auncien tyme with mirre dede bodies biried were:
> Crist, kin and prest, for manne wald in this world dye here.
> Than aght us offre to Crist golde of dileccioune,
> Sithen he for us bare payne of bitterest passioune,

[8] J. M. Hoffeld, "An Image of St. Louis and the Structuring of Devotion," *Metropolitan Museum of Art Bulletin* (February, 1971), 261–266.

[9] U. Nilgen, "The Epiphany and the Eucharist: On the Interpretation of Eucharistic Motifs in Medieval Epiphany Scenes," *Art Bulletin* 49 (1967), 311–316.

[10] Ryan and Ripperger, *Golden Legend* (as in note 7), 87.

Encense of devoute laude and of graces thanking,
And mirre of compassioune of his deth recoreding.[11]

WHEN THE WINGS of the retable were delivered to Melchior Broederlam, Duke
Philip's painter resident at Ypres, the basic program of the altarpiece had been
set.[12] In addition to painting and gilding the carvings, Broederlam painted the
outer sides of the two wings. We do not know the circumstances of this deci-
sion, nor can we determine whether the four scenes he painted were his own
choice or if they were imposed upon him. As observed already, there is no
evidence of wings or paintings associated with either of the earlier altarpieces
that Jacques de Baerze was commissioned to replicate for the Chartreuse de
Champmol. To Panofsky, Broederlam was simply "completing the Infancy cy-
cle, merely adumbrated in Jacques de Baerze's carved 'Adoration of the
Magi.'"[13]

Not all of the evidence, however, is neutral. We must still consider the wings
with their colorful episodic scenes. Why were four scenes from Christ's infancy
chosen? Why these particular scenes? Would not the Nativity have been a more
logical and compelling choice than any of these except the Annunciation?
Working with the remaining visual evidence and what is known from other
sources, can we at least form a rational idea of the way in which these paintings
respond to the sculptures they were designed to cover when the altarpiece was
closed? If considered alone, the four Broederlam paintings are incomplete. The
Nativity is even more conspicuously absent.[14]

In any case, Melchior Broederlam's paintings changed the program. By add-
ing two prenatal scenes, the Annunciation and the Visitation, the painter placed
added emphasis on the Virgin Mary. She becomes the only person to appear in
all of the painted and carved narrative scenes. Moreover, Broederlam's bright,
colorful style brings an immediacy to the work that invites closer examination
and a more intimate study of details, anticipating the works of future genera-
tions of Flemish painters.

At this point we should note that, as a collaboration, the altarpiece looks
forward and back. Broederlam, having the wings in his shop, used the scale of
the figures on the inner sides for that of his figures. Elements of the Interna-
tional Gothic and the trecento appear in the paintings. Yet he invests them with
detailed observation that anticipates the great age of early Netherlandish paint-

[11] Henry, *Mirour* (as in note 7), 77, lines 1193–1203.
[12] Comblen-Sonkes and Veronee-Verhaegen, *Musée des Beaux-Arts de Dijon* (as in note 1), 138–139.
[13] Panofsky, *Early Netherlandish Painting* (as in note 1), vol. 1, 86.
[14] There might be some connection between the absence of this scene and the splendid *Nativity* by Robert
Campin, also preserved in the Dijon Museum. It was almost certainly painted for the Chartreuse de
Champmol.

ing. Jacques de Baerze, in the carved panels and in the decorative architectural framework above the scenes, utilized a widely varied scale following established and typical late Gothic tradition. The same variation survives in the Ghent Altarpiece, Rogier van der Weyden's Last Judgment Altarpiece in Beaune, and continues to appear in the great carved and painted altarpieces of Germany and Austria through the fifteenth and into the sixteenth century.

Of the painter Melchior Broederlam little is known. He is said to have come from Ypres and to have worked for Philip the Bold from 1383, mostly at the ducal residence in Hesdin. By February of 1393 he had returned to his residence in Ypres to work on the retables. Technical examination and stylistic analysis of his work have suggested a wide variety of influences on his paintings. Unfortunately, no other works by Broederlam's hand are preserved.

The most important of Broederlam's depictions on the retable is the Annunciation. It is the opening scene of the entire complex and iconographically the most intricate. This new emphasis, however, is an enhancement rather than a reversal of Jacques de Baerze's original intentions. It directs the worshipful viewer to consider the Incarnation of Christ, a very logical extension of the sculptor's program, as we shall see.

A fascinating feature of the Annunciation by Broederlam is its nearly exact parallel with the composition of the Annunciation miniature in the *Liber viaticus* of John of Středa, made in Prague about 1460 (Fig. 7).[15] The ell of added architectural detail behind the archangel in the manuscript illumination corresponds closely in shape and form to Broederlam's detailed setting. Other comparisons have been made between Broederlam's work and Bohemian art of the period of Charles IV and Wenzel IV, Charles's son, including both technical and stylistic elements.[16] In the realm of rapidly transmitted stylistic elements of the International Gothic, these similarities hardly place Broederlam in Prague at any point. At the same time, it seems astonishing that artwork as accomplished as Broederlam's for these wings is all that survives from the hand of this artist.

The Incarnation is celebrated symbolically by the addition of a particular detail to the Annunciation. Mary holds a tiny candle in the form of a ball of wax-impregnated flaxen twine in her left hand. Once designated a "skein of purple wool" by Erwin Panofsky, this little device reveals its true identity by the fact that one end of the wick is turned upward and is brightly aflame.[17] Two meanings, closely intertwined, are invoked by this candle. In Italian trecento art the virtue of Humility is represented by a woman holding a candle; such an

---

[15] Prague, National Library, ms. XIII.A.12, fol. 69r.

[16] Comblen-Sonkes and Veronee-Verhaegen, *Musée des Beaux-Arts de Dijon* (as in note 1), 111–112, 122.

[17] Panofsky, *Early Netherlandish Painting* (as in note 1), vol. 1, 131; Comblen-Sonkes and Veronee-Verhaegen, *Musée des Beaux-Arts de Dijon* (as in note 1), 79, 83–84.

image appears in Andrea Pisano's bronze doors of the Baptistery in Florence (Fig. 8).[18] Even more cogently, Taddeo Gaddi placed the same personification of Humility, an image of a woman holding a candle, adjacent to the Annunciation in his famed fresco cycle in the Baroncelli Chapel of Santa Croce in the same city.[19]

A candle, further, is a symbol of Christ, as Durandus of Mende and others have asserted.[20] The wax represents Christ's body, the wick, his soul, and the flame, his divinity. As an extension of the same image, Mary is likened to a candleholder in the text of the *Speculum humanae salvationis*, the famed typological account of Christ's life:

> This Ladie is verray candelabre and Cristis bright lanterne,
> The laumpe brynnyng in fire of light souerayne superne . . .
> Jhesu Crist, Marie son, is this candel brynning,
> Be threfald matiers þat ere founden in swilke a thyng:
> For in the candel is fire, weke and wax, this thre—
> In Crist warre flesshe and sawle and verray divinitee.[21]

In Broederlam's work the tiny light of the candle is contrasted with the generous outpouring of golden light that streams from the Lord through a Gothic window above and onto Mary's head, bearing the dove of the Holy Spirit along in its powerful current. Within this simple composition are a number of complex and profound meanings for the viewer to contemplate. Confirmation of their presence and meaning comes from repeated occurrences in earlier and later examples of the Annunciation.

The contrasted lights reveal the two natures of Christ. The frail candle represents Christ in his human form, while the great light stream from God asserts his divinity.[22] The two styles of architecture create a further contrast.[23] Mary's little reading room is Gothic, unlike the domed chamber behind it, which has essentially Romanesque elements. Artists from Giotto and Pietro Lorenzetti to Robert Campin and Jan van Eyck chose to contrast historical architectural styles as a representation of the advent of the new Christian faith in place of the old order. The light that streams from God to the Virgin passes through the

---

[18] I. Toesca, *Andrea e Nino Pisano* (Florence, 1950), fig. 57. Humility is the fourth—after Hope, Faith, and Charity—of the eight virtues on Andrea's doors.

[19] See J. Gardner, "The Decoration of the Baroncelli Chapel in Santa Croce," *Zeitschrift für Kunstgeschichte* 34 (1971), 89–114, diagram p. 102, no. 29. Humility appears a second time in the Baroncelli frescoes, as a winged female offering a lamb at the top of the side vault; see A. Ladis, *Taddeo Gaddi* (Columbia, Missouri, 1982), 105, fig. 4d-1 and 4d-2, the latter mislabelled *Faith*.

[20] Snyder, *Northern Renaissance Art* (as in note 5), 121.

[21] Henry, *Mirour* (as in note 7), 81.

[22] See the *Nativity* in Dijon by Robert Campin, illustrated, e.g., by Snyder, *Northern Renaissance Art* (as in note 5), 123, fig. 118. The lights contrasted there are the rising sun and the candle held by St. Joseph.

[23] Panofsky, *Early Netherlandish Painting* (as in note 1), vol. 1, 131–132.

glass window of her reading room. This passage of light is a metaphor for Mary's virginity, well established in the poetry, hymnology, and homilies of the period.[24]

While they, too, are charming and colorful, none of the other Broederlam paintings is as intricate as the Annunciation. The selection of scenes was, nonetheless, important. The scenes on the left wing, Annunciation and Visitation, are the first two Joys of the Virgin. They enhance the triumphal theme of the Epiphany as heralding the victory that is the positive side of Christ's sacrifice at the Crucifixion.

Each scene on the left wing is prophetic. The angel announces the forthcoming birth of Christ. St. John announces the coming of the Messiah through the vocalization of his mother, St. Elizabeth, in the Visitation (Luke 1:42ff.). Perhaps another tie to the Epiphany can be seen here: John baptized Christ on the day of Epiphany, twenty-nine years after the event.[25]

Broederlam's *Presentation of Christ and Flight into Egypt* on the right wing are the first two Sorrows of the Virgin. The *Entombment*, covered by these paintings when the wings are shut, is the last Sorrow. The *Entombment* is also linked to the *Flight into Egypt* by the same combination of infancy and Passion scenes that tie the Epiphany and Crucifixion together in books of hours. Thus, inexorably, the paintings on the right wing affirm and prophecy the tragedy of the Passion. Diagrammatically:

CRUCIFIXION

/ \

ADORATION OF THE MAGI : ENTOMBMENT OF CHRIST

/ \

ANNUNCIATION + VISITATION : PRESENTATION + FLIGHT INTO EGYPT

Far from being a random, accidental, or casual collection of scenes, then, the Baerze-Broederlam Altarpiece was put together with sophistication and forethought. Once considered, this fact is not so surprising. It presages ideas that will characterize later polyptychs: the thematic interweaving of meaning and expression. There is no strict formula by which the subjects are determined, and the concept is based on principles that emerged in earlier mosaic and fresco

[24] See M. Meiss, "Light as Form and Symbol in Some Fifteenth-Century Paintings," *Art Bulletin* 27 (1945), 175ff.

[25] I. Ragusa and R. Green, *Meditations on the Life of Christ* (Princeton, 1971), 47–48. Both the *Meditations* and the *Golden Legend* affirm that this was also the same day as the day of the Miracle at Cana and the Feeding of the Multitude. These represent affirmation of the Trinity (Baptism) and the sacraments (the wine and bread of the two miracles) on the day of Epiphany.

programs, sculpted portals of churches, and altarpieces. Thus it is no longer possible to look at this altarpiece as merely a foreshadowing of the great age of early Netherlandish painting. Rather, it represents a critical link to well-established traditions vitally alive in the art and familiar literature of the late Gothic world.

The choices made by Broederlam also explain the significant omission of the Nativity from the complex. His scenes are the first two of Mary's Joys and Sorrows. These were individually governed by the triad of Jacques de Baerze's carved scenes.

## Excursus

No such clear pattern of finished program has been worked out for the Ghent Altarpiece, a complex that still seems in all likelihood to have been created in two stages. Erwin Panofsky long ago opined that Hubert van Eyck, the first artist of record, had intended to create an "All-Saints Altarpiece" incorporating at least the Adoration of the Lamb in the lower half of the open, central section of the work.[26]

Panofsky rightly warned that an attempt to separate the hands of Hubert van Eyck and his brother Jan van Eyck, who finished the work after the death of Hubert, would be futile. As it is, each of the panels has been attributed by one scholar or another to each artist. The analysis of the panels in scientific laboratories has yielded virtually no assured answers to these questions of attribution.[27]

Most scholars seem to agree, however, that the outer panels of the Ghent Altarpiece wings are the work of Jan van Eyck. Moreover, their form is partially conditioned by the panels on the reverse, causing, among other things, the rather awkward four-paneled scene of the Annunciation.[28] There is also a continuity of meaning between the individual panels of the outer wings and the scenes they cover. The donors join the supplicants approaching the altar with the lamb of God. The two St. Johns hold a lamb and chalice respectively. Directly behind them is the image of the lamb of God, whose wounded breast pours sacred blood into a chalice.

Above the donors and saints, the Annunciation is a prefiguration of the apocalyptic appearance of the Deisis and Adoration of the Lamb, inferring, as it does, the Incarnation as prophecy of Christ's second coming. The prophets and sibyls above this scene belong by extension to the same prophetic mode.

---

26 Panofsky, *Early Netherlandish Painting* (as in note 1), 217–230.
27 P. Coremans, *L'Agneau Mystique au laboratoire*, Les Primitifs Flamands, III, 2 (Antwerp, 1953).
28 Panofsky, *Early Netherlandish Painting* (as in note 1), 208–209.

Jan van Eyck thus tied the elements of the Ghent Altarpiece together as a programmatic unit, probably more complex and elaborate than the intentions first established for it by Hubert. The process was conditioned by Hubert's work, and the result contains anomalies reminiscent of those in the retable from the Chartreuse de Champmol.

THE UNIVERSITY OF PENNSYLVANIA
PHILADELPHIA

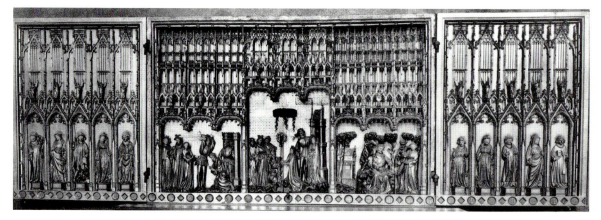

1. Jacques de Baerze, Saints and Martyrs Altarpiece, 1390–1399. Dijon, Musée des Beaux-Arts
(after M. Aubert, *La Bourgogne, la sculpture* [Paris, 1930], vol. 3, pl. 145)

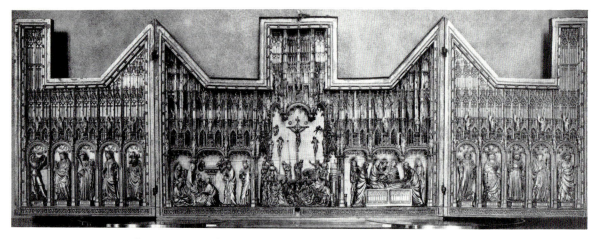

2. Jacques de Baerze, Crucifixion Altarpiece, 1390–1399. Dijon, Musée des Beaux-Arts
(after M. Aubert, *La Bourgogne, la sculpture* [Paris, 1930], vol. 3, pl. 145)

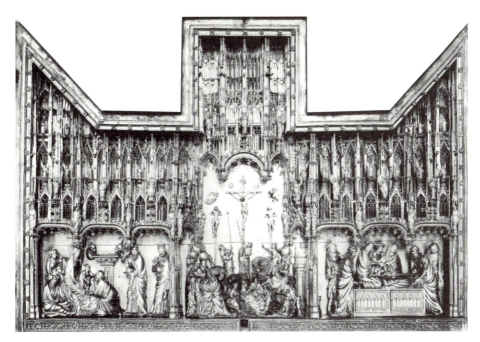

3. Jacques de Baerze, Crucifixion Altarpiece, detail. Dijon, Musée des Beaux-Arts
(photo: museum)

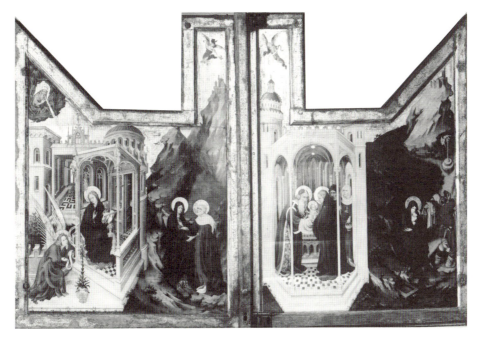

4. Melchior Broederlam, Crucifixion Altarpiece (closed), *Annunciation and Visitation*
and *Presentation of Christ and Flight into Egypt*. Dijon, Musée des Beaux-Arts
(photo: museum)

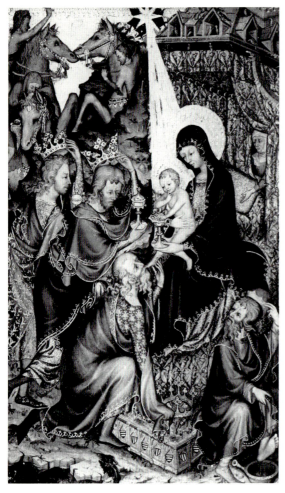

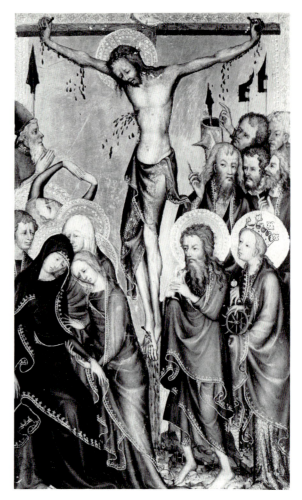

5a. Anonymous French, *Adoration of the Kings.*
Florence, Bargello (photo: Alinari/Art Resource, N.Y.)

5b. Anonymous French, *Crucifixion.*
Florence, Bargello (photo: Alinari/Art Resource, N.Y.)

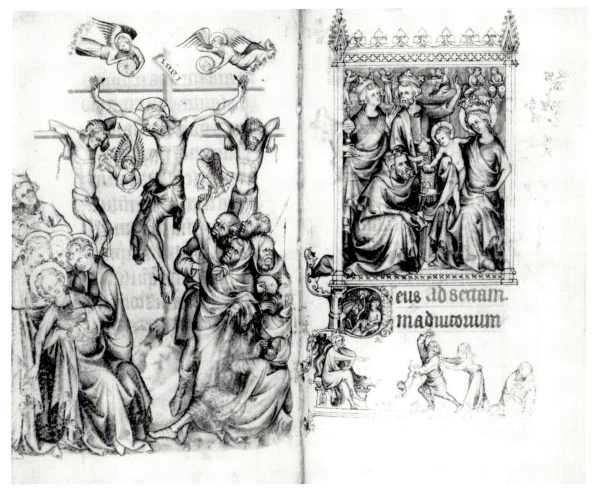

6. Jean Pucelle, *Adoration of the Kings* and *Crucifixion*, Hours of Jeanne d'Evreux, fols. xx verso, xxi recto. New York, The Metropolitan Museum of Art, The Cloisters Collection (photo: museum)

7. Anonymous Bohemian miniaturist, *Annunciation*, *Liber viaticus* of John of Středa, fol. 69r. Prague, National Library XIII.A.12 (after *Czechoslovakia. Romanesque and Gothic Illuminated Manuscripts* [Greenwich, Conn., 1959], pl. 30)

8. Andrea Pisano, *Humility*, panel in south door of the Baptistery, Florence (photo: Alinari/Art Resource, N.Y.)

# Burgundian *Gloire* vs. *Vaine Gloire*: Patterns of Neochivalric *Psychomachia*

## BURR WALLEN[*]

❦

THE FIELD OF MORAL PHILOSOPHY is all too often treated in isolation from other areas of historical research, despite the fact that changing ethical values can provide worthwhile explanations for many perplexing cultural developments, especially in the transitional stage between the Middle Ages and the Renaissance, when the emergence of secular and humanistic ideals seriously challenged and influenced traditional Christian ideologies of the virtues and vices. Scholarly investigations of these evolving patterns of ethical thought, however, are complicated by our modern biases, which can easily hinder an objective understanding of the critical cultural and social dynamics at work during a particular stage of history.

All students of the magnificent flowering of art, literature, and neochivalric court ceremonies under the Burgundian dukes are indebted to Johan Huizinga's classic study, *The Waning of the Middle Ages* (*Herfsttij der Middeleeuwen*, 1919), though it remains necessary to deal with the Dutch scholar's moralizing conclusions about "the decay of overripe forms of civilization," as Huizinga phrased it in the preface to the first English edition of 1924. In this article I intend to explore a neglected area of transformative values which preoccupied the Burgundian epoch and which may serve as a touchstone for a fuller understanding of the complex mechanics underlying the rich intellectual, artistic, and socio-political expressions of this fertile age. My focus on moral allegories and related ethical texts treating chivalric virtues and vices is designed to clarify seemingly outlandish literary personifications and related iconographical tropes, as well as to place in more balanced perspective the aspects of Burgundian culture that for Huizinga signaled social decadence.

---

[*] The manuscript of this paper was prepared for publication by Jody Hoppe following the author's untimely death in 1991.

*The Waning of the Middle Ages* still dominates our conceptions of the pervasive revival of chivalry under the Valois dukes of Burgundy, despite numerous scholarly efforts to refine and redefine Huizinga's conclusions concerning neo-chivalric knightly codes and conduct.[1] As the Dutch author so memorably demonstrated, the Burgundians wholeheartedly revived romantic chivalric customs and codes of honor of an earlier age, reasserting the knight's value to a mercantile society.[2] The tournament formed the most popular spectator sport of this magnificent chivalric renaissance, combining displays of physical prowess and skill at arms, courtly gallantry, and proud shows of heraldry.[3] For Huizinga, nonetheless, an ineluctable divorce had taken place between the heroic ethos underlying Christian knighthood and all the external manifestations of medieval chivalry which were emulated so splendidly by the later age. The elaborate tournaments and feasts, knightly vows and posturing, heraldic displays and codes of honor were carried to such exaggerated gestural and aesthetic extremes that they lost touch with the fundamental ethical and military ideals they were once meant to express.

"Like all romantic forms that are worn out as an instrument of passion, this apparatus of chivalry and of courtesy affects us at first sight as a silly and ridiculous thing. . . . Only a stray glimmer now reminds us of the passionate significance of these cultural forms."[4] Playacting and artifice dominated chivalric fictions such as the passage of arms (*pas d'armes*), a stylized individual joust popular in the late fourteenth and fifteenth centuries, inspired by knightly adventures of the Arthurian romances.[5] The celebrated Vows of the Pheasant (*Voeux du Faisan*) staged by Philip the Good at Lille in 1454 to stimulate a new Burgundian-led crusade particularly attracted the Dutch author's scorn: "It is like the last manifestation of dying usage, which has become a fantastic ornament, after having been a very serious element of earlier civilization."[6] Tremen-

---

[1] I cite the English translation of Huizinga by F. Hopman, *The Waning of the Middle Ages* (Harmondsworth, 1976), which unfortunately omits the reference notes of the original Dutch edition.

[2] Ibid., 65ff.

[3] A good picture of Burgundian jousts and tourneys can be garnered from studies of English contests based on the continental model: A. B. Ferguson, *The Indian Summer of English Chivalry* (Durham, North Carolina, 1960), esp. 13–15; S. Anglo, "Anglo-Burgundian Feats of Arms at Smithfield: June 1467," *Guildhall Miscellany*, 2, no. 7 (1965); idem, *The Great Tournament Roll of Westminster* (Oxford, 1968); and A. Young, *Tudor and Jacobean Tournaments* (London, 1987). Cf. also O. Cartellieri, *The Court of Burgundy* (London, 1929).

[4] Huizinga, *Waning* (as in note 1), 78–79.

[5] Ibid., 81. In the *pas d'armes*, a knight (the *dedans*, or *tenans*) would stake out a certain territory, whether real or imagined, and defend it against all challenges from fellow chevaliers (the *venans*). Customarily adopting romantic literary locales such as the fountain of tears employed in Jacques de Lalaing's famous *pas d'armes* held in 1449–50, the victorious defender was typically rewarded by the favors of a lady, similar to Yvain in Chrétien de Troyes. Cf. A. W. Annunziata, "The *Pas d'Armes* and Its Occurrences in Malory," in *Chivalric Literature. Essays on Relations between Literature and Life in the Later Middle Ages*, ed. L. D. Benson and J. Leyerle (Kalamazoo, 1980), 39–48.

[6] Huizinga, *Waning* (as in note 1), 89. For the Feast of the Pheasant of 1454, see also A. Lafortune-Martel, *Fête noble en Bourgogne au XVᵉ siècle, Le Banquet du Faisan (1454)* (Montreal, 1984).

dously influential, *The Waning of the Middle Ages* structured the attitudes of a whole generation of scholars. In a study published in 1937, R. L. Kilgour painted essentially the same picture of outworn gestural rituals that had lost touch with the inner truths and hard realities of knighthood, citing numerous contemporary late medieval critics such as Eustache Deschamps, Alain Chartier, and Honoré Bonet.[7]

It certainly cannot be denied that the decorative trappings of chivalry loomed large during the Burgundian era—an age when lavish display was enhanced by sophisticated artistic illusionism and funded generously by ducal tax revenues. Yet Huizinga's central thesis that the cult of chivalry experienced a drastic decline in the fifteenth century from an earlier period of martial vigor and heroic idealism buttressed by authentic moral/spiritual values has not held up. In a thoughtful article published in *Medievalia et Humanistica* in 1977, Maurice Keen rightly pointed out that rebukes of knightly decadence were not peculiar to the late medieval poets cited by Kilgour. From its very origins, the cult of chivalry had aroused similar laments about how the knight-errantry of the day had lost their former martial vigor and become prone to ostentatious trappings and effete showmanship.[8] For Keen, such criticisms of decadent chivalry formed a literary convention simply reiterated by later generations of authors, which may not have had serious bearing upon the moral concerns of the fourteenth and fifteenth centuries:

> The criticisms of early medieval knighthood are indeed sometimes so similar to those levelled by later generations as to make one wonder how seriously the latter should be taken. Though it is clear that in the later period there was genuine and widely felt disquiet about the degree to which contemporary chivalry fell short of ideal standards, the contrast between the degeneracy of modern knighthood and its antique vigor came to be repeated so often as to suggest that it had become a *topos*—a theme for elegant literacy or poetical exercise which did not necessarily reflect real unease about contemporary mores.[9]

Keen and other scholars have also observed that the theatrical ostentation characterizing late medieval chivalry in fact served a very real propaganda function: it gave military and political power a conspicuous, tangible presence for an age that placed great value upon aristocratic displays of wealth and grandeur. The dazzling Burgundian banquets, tourneys, and *pas d'armes* buttressed ducal reputation for flamboyant magnificence and helped to shore up their rather fragile dynastic and territorial claims to towering authority in northern

---

[7] R. L. Kilgour, *The Decline of Chivalry* (Cambridge, Mass., 1937). For a good summary of Kilgour's thesis, see M. Keen, "Huizinga, Kilgour and the Decline of Chivalry," *Medievalia et Humanistica* 8 (1977), 1–20, esp. 4–5.

[8] Keen, "Huizinga, Kilgour and the Decline" (as in note 7), 5–6.

[9] Ibid., 6.

Europe. Pre-announced by heralds dispatched far and wide with invitations and challenges, these splendid events were afterwards reported upon by heralds visiting from foreign courts, and subsequently recorded for posterity by ducal chroniclers like Chastellain or Molinet in their historical narratives.[10] The highly illusionistic propaganda campaigns generated by the Burgundians were so effective that they were avidly emulated by other European courts, especially the English, and became fundamental underpinnings to sixteenth-century royal power.

While scholarly rebuttals of Huizinga's pejorative views about neochivalric decadence have shifted the picture somewhat, enabling us to perceive the showy excesses of the age in a more balanced manner, they have failed to shed much light upon the contemporary issues of moral philosophy involved. It has become increasingly clear that contrary ethical stances were held concerning the potentials of terrestrial glory, and these provide a valuable framework for understanding the seemingly flawed, paradoxical nature of the chivalric revival. The lavish display and showmanship that marked the Burgundian era were fundamental means of promoting glory—helping to bring the honor, praise, and acclaim that, from the very beginnings of the cult of knighthood, were regarded as proper rewards for worthy chivalric endeavor. Yet widely divergent views about the moral validity of this pursuit gave the topic a highly ambivalent, disputative flavor. A positivistic ethos of heroic military glory promulgated by Arthurian romances and panegyrical biographies of famed chevaliers ran directly counter to ingrained Christian sensitivities about the dire perils of improper self-exaltation and boastfulness. Such external manifestations of the root sin pride (*superbia*) were signs of knighthood's besetting vice: vainglory (*vana gloria*, or *inanis gloria*), which the great medieval moral theologians John Cassian, Gregory the Great, and Thomas Aquinas all viewed as the foremost moral trespass in the hierarchy of capital sins descending from pride.[11]

The highly influential doctrine of the "triple temptations" linking Genesis 3:5, 1 John 2:16, and Matthew 4 insured mainstream theological attention to the vice, for vainglory was almost always included among the tripartite division, mostly as the "pride of life" but also sometimes as the "lust of the eyes."[12] Although vainglory was subsumed under pride in the popular SALIGIA listing of seven sins taught at schools,[13] it was listed separately as the eighth deadly sin

[10] R. F. Green, *Poets and Princepleasers, Literature and the English Court in the Late Middle Ages* (Toronto, 1980), 168–174.

[11] For the patristic evolution of vainglory, see my study, *Bosch and Vainglory*, to be published by Princeton University Press. Cf. also F. Joukovsky-Micha, "La notion de 'Vaine Gloire' de Simund de Freine à Martin le Franc," *Romania* 89 (1968), 1–30; and the valuable entries in *Dictionnaire de théologie catholique*, vol. 6, cols. 1429–1432; and *Dictionnaire de spiritualité ascétique et mystique*, vol. 6, cols. 494–505.

[12] See the fundamental study by D. R. Howard, *The Three Temptations* (Princeton, 1966), 44ff.

[13] SALIGIA = *superbia, avaritia, luxuria, ira, gula, invidia, accidia*. For the development of medieval thinking about the sins, see M. W. Bloomfield, *The Seven Deadly Sins* (East Lansing, 1952).

in both the Gregorian and Cassianic schemes. These authoritative lists contin-
ued to be repeated and explicated in late medieval and Renaissance theology.[14]
Even when the SALIGIA format was employed, vainglory was examined as a
separate aspect of pride with its own intrinsic pathology and appurtenances.
Orthodox theologians always cited Thomas Aquinas's qualification that, al-
though pride and vainglory are apparently identical, they are actually distinct
sins: "Pride is a cause of, but is not identical with vainglory. For pride inor-
dinately craves for excellence, but vainglory for its display."[15]

Pride, in other words, is the inner appetite for "excellentiae" ("distinctions,"
"eminence"), while vainglory forms the outward manifestation of proud desire,
designed to attract admiration from other men. Aquinas's widely-held under-
standing of the central difference between the two vices encouraged the associa-
tion of various forms of grandiose outward display with vainglory, not the least
being the ambitious, boastful *miles gloriosus*. For medieval moralists, the chiv-
alric pursuit of military glory and high honors often boiled down to the eighth
deadly sin. Pierre Bersuire illustrated his examination of vainglory of bodily
strength in his comprehensive *Dictionarium morale* with the typical example of
knights glorying in their prowess at arms.[16] Bernard of Clairvaux regarded
worldly glory as a primary motivation behind incessant knightly thirst for war-
fare. "What else is the cause of wars and root of disputes among you," Bernard
shouted at the chevaliers in his *De laude novae militiae* (*In Praise of the New
Knighthood*), "except unreasonable flashes of anger, the thirst for empty glory,
or the hankering after some earthly possessions?"[17] The chivalric passion for
tournaments was especially singled out as a manifestation of the eighth deadly

[14] Of the two lists, the Gregorian was the most influential, preserved in numerous works of moral theol-
ogy as well as in the popular iconographical tree of vices. Gregory separated pride as the root of the seven
capital sins, which are led by vainglory (S—VIIAAGL = *superbia—vana gloria, invidia, ira, avaritia, accidia,
gula, luxuria*).

[15] "Ad secundum dicendum quod superbia non est idem inani gloriae, sed causa ejus. Nam superbia
inordinate excellentiam appetit; sed inanis gloria appetit excellentiae manifestationem." Thomas Aquinas,
*Summa theologiae*, 2a2ae, 162, 8, trans. and ed. T. Gilby (New York, 1964), XLIV, 146–147. This distinc-
tion was accepted by all orthodox theologians, e.g., Jean Gerson, *De consolatione theologie*, "De septem
vitiis capitalibus in speciali," in *Opera* (Strasbourg, Johann Prüss, October 9, 1488), II, xxviii; idem, *Com-
pendium theologiae*, "Septem vitia capitalia," in *Opera omnia* (Antwerp, 1706), I, iii, col. 327; Johannes
Nider, *Praeceptorium divinae legis, sive espositio decalogi* (Ulm, 1480), i, 13; St. Antonino, *Summa theo-
logica* (Verona, 1740; reprint Graz, 1959), II, iv, 1, col. 555; Arnold Geilhoven, *Gnotosolitos, sive speculum
conscientiae* (Brussels, Brethren of the Common Life, 1476), i, 1.

[16] Pierre Bersuire (Petrus Berchorius), *Dictionarium morale*, in *Opera omnia* (Mainz, 1609), III, 691.

[17] *In Praise of the New Knighthood*, trans. C. Greenia, in *Treatises III, The Works of Bernard of Clair-
vaux* (Kalamazoo, 1977), vii, 2, p. 133; *De laude novae militiae*, PL 182, cols. 923, 926. See S. Painter,
*French Chivalry, Chivalric Ideas and Practices in Mediaeval France* (Baltimore, 1940), 153. John Gower
condemned the vainglory of knights in his *Mirour de l'omme* (11.23,893ff.) and *Vox clamantis* (v, 5). Cf.
P. Boitani, *Chaucer and the Imaginary World of Fame* (Cambridge, 1984), 154–155. A perceptive study of
Arthurian romances by L. S. Topsfield has revealed important thematic oppositions of vainglory and charity
in these popular chivalric epics: *Chrétien de Troyes, A Study of the Arthurian Romances* (Cambridge, 1981),
111, 157, 216–219, 225–237, 302.

sin by Jacques de Vitry, Caesarius of Heisterbach, Rutebeuf, and others.[18]

Elizabeth Siberry has recently demonstrated that critics of crusaders' motivations not infrequently ascribed their shortcomings to the vice.[19] In a vision of the netherworld recounted by Vincent of Beauvais, a monk of Eynsham witnessed a crusader who was being punished in Purgatory since he had taken up the cross out of vainglory rather than sincere devotion.[20] The ostentatious regalia and flamboyant demeanor of knights of the cross often cast doubts upon their inward intentions. Following the disastrous defeat at Hattin in Galilee in 1187, a shocked Pope Gregory VIII issued a bull (*Audita tremendi*) urging surviving knights to act as if they were performing penance rather than pursuing *vana gloria*. Exhortations concerning the vice were addressed to monks who wished to join the crusading campaigns. Bernard of Clairvaux rebuked fellow Cistercian brothers who expressed the desire to go on the Second Crusade, querying them, mockingly, "Why do you seek the glory of the world?"[21]

Medieval treatises on chivalry insisted that aspiring knights take pains to avoid the eighth deadly sin, which was felt to be totally antithetic to chivalric ideals. In Ramon Lull's popular *Libre del ordre de cavayleria*, written sometime after the author's conversion in 1263, the squire was warned that vainglory "is the vice that destroys and brings to nothing the merits and guerdons of the benefice of chivalry."[22] An extensive discussion of the chivalric ethical obligation not to seek praise and glory in the goods of fortune and nature is found in another important treatise of this type, *Le livre de chevalerie*, composed by Geoffrey de Charny (d. 1356).[23] Charny cited typical models of vainglorying in strength (Samson), good looks (Absalom), and wisdom (Solomon), and he ad-

[18] Painter, *French Chivalry* (as in note 17), 153–154; M. H. Keen, *Chivalry* (New Haven, 1984), 94–95; J. Le Goff, "Réalités sociales et codes idéologiques au début du XIIIᵉ siècle: Un exemplum de Jacques de Vitry sur les tournois," in idem, *L'imaginaire médiéval* (Paris, 1985), 248–261, esp. 253–255 (Engl. trans. by A. Goldhammer, in J. Le Goff, *The Medieval Imagination* [Chicago, 1985], 181–192). Vainglory supplemented avarice as the prominent sin associated with tournaments around the time that chivalric romances disseminated the notion that the chief goal of these honorific displays of knightly prowess was glory rather than financial gain. For the romances' impact on developing perceptions of the sport, see L. D. Benson, "The Tournament in the Romances of Chrétien de Troyes and *L'histoire de Guillaume le Maréchal*," in *Chivalric Literature* (as in note 5), 1–24.

[19] E. Siberry, *Criticism of Crusading, 1095–1274* (Oxford, 1985). Cf. *Chronicles of Matthew Paris, Monastic Life in the Thirteenth Century*, trans. and ed. R. Vaughan (Gloucester, 1984), 239, on Robert, count of Artois. See also C. Tyerman, *England and the Crusades, 1095–1588* (Chicago, 1988), 261.

[20] Siberry, *Criticism of Crusading* (as in note 19), 48–49.

[21] Ibid., 42.

[22] Translation modernized from the English version by Caxton. *The Book of the Ordre of Chyvalry*, ed. A. T. P. Byles (London, 1926), 64. Caxton followed the French translation of Lull's treatise, which was well known in northern Europe and went through three editions in the early sixteenth century. *Livre de l'Ordre de Chevalerie*, ed. V. Minervini (Bari, 1972), 134. Cf. Keen, *Chivalry* (as in note 18), 8–11.

[23] Geoffrey de Charny, *Le livre de chevalerie*, in *Oeuvres de Froissart*, ed. J. Kervyn de Lettenhove, vol. 1, iii (Brussels, 1873), 463–533, esp. 494, 509. For more on the flimsy and transient terrestrial goods of glory, see my *Bosch and Vainglory* (as in note 11), passim.

vised the knight to emulate instead the virtuous Old Testament leader Judas Maccabeus, who always thanked God for all the goods and honors accorded him.[24]

Vainglory received special attention in a fascinating thirteenth-century French work composed by an anonymous author in the Low Countries and published in the nineteenth century by Jules Petit. Entitled the *Traité des différentes sortes d'amour et d'amitié* (or *Li ars d'amour, de vertu et de boneurté*), the tract fashions an elaborate code of courtly ethics concerning love and friendship, treating standard chivalric virtues at some length. The author discusses vainglory as the crucial sin opposite *vraieté* (truthfulness), a position acknowledging traditional links between the vice and boastful deceit and hypocrisy.[25] At the close of the treatise, he argues that true happiness (*boneurtés*) is not to be found in transient temporal glory and honors, but in contemplation and understanding of spiritual wisdom.[26]

Vainglory was more often opposed to magnanimity in late medieval thinking about the virtues and vices. Thomas Aquinas took pains to distinguish between the moderate desire for glory which is a valid part of the virtue of magnanimity, and the inordinate appetite for vainglory: "But as regards what he thinks of himself, the vainglorious man is opposed to the magnanimous by excess, because he considers as important the glory which he seeks, and strives for it beyond his real worth."[27] The Aquinan distinction between magnanimity and vainglory was accepted as authority in later treatments of chivalric virtue. Probably the most influential source for this moral dualism among the French nobility was the popular encyclopedic treatise written in French around 1270 by Brunetto Latini, *Le livres dou tresor*, which was copied in numerous manuscripts during the late thirteenth, fourteenth, and fifteenth centuries, many of them illuminated.[28] This particular *psychomachia* bears special relevance to

[24] Charny, *Chevalerie* (as in note 23), 508. Fifteenth-century heraldic compilations also frequently included an imaginary debate among Hannibal, Alexander, and Scipio Africanus, in which Scipio came out on top, mainly due to his avoidance of chivalry's besetting sin. Entitled *Le debat de trois chevalereux princes*, this work has been identified as a translation by Jean Miélot of Dialogue XII of the *Mortuorum dialogi* by the ancient Greek satirist Lucian, following Aurispa's Latin translation. Cf. Keen, *Chivalry* (as in note 18), 235; and C.-A. Mayer, *Lucien de Samosate et la renaissance française* (Geneva, 1984), 127.

[25] *Li ars d'amour, de vertu et de boneurté*, ed. J. Petit (Brussels, 1867–69), vol. 1, ii, 3, 55, pp. 490–496.

[26] Ibid., II, iii, 1, 10, pp. 275–276; and 22, pp. 315–319. On the basis of an anagram inserted at the end of the text, Petit identified the anonymous author as Jan van Arckel (1314–78), erudite bishop of Utrecht and Liège who composed a number of lost works; ibid., II, pp. i–xliii. This hypothesis is discounted by the style of the miniatures in the surviving manuscripts (Brussels, BR MSS. 9543 and 9548), which date to the end of the thirteenth century. M. Debae, *La librairie de Marguerite d'Autriche*, exhib. cat., Bibliothèque Royale Albert Iᵉʳ (Brussels, 1987), 102–105, no. 30.

[27] Aquinas, *Summa theologiae* (as in note 15), 2a2ae, 132, 2, XLII, pp. 146–151.

[28] See the critical edition of Latini's *Li livres dou tresor* by F. J. Carmody (Berkeley, 1948), xlvi–lviii. A fine illuminated manuscript of the treatise from ca. 1300 figured among the treasures assembled by Margaret

our subject, since, as we shall see, magnanimity played an essential role in the positivistic moral strategy adopted at the Burgundian court, which defined a wholesome sort of terrestrial glory embodied in the virtuous knight.

Originally regarded as an aspect of the cardinal virtue fortitude, magnanimity attained prominence as a chivalric virtue in its own right during the later Middle Ages. Magnanimity contained a much broader meaning than it does nowadays. In essence, it meant the courageous performance of great deeds worthy of garnering supreme honors.[29] Only noble-minded men blessed with grandeur of soul and exceptional gifts of fortune and grace were deemed capable: magnanimity was thus a special virtue shared by the noble elite of Christendom, eminently suited to the heroic idealism and crusader spirit of chivalry.

Magnanimity was also equated with magnificence—according to Aristotle, the liberal expenditure of wealth to accomplish great deeds.[30] Magnificence provided essential ethical justification for the lavish display characterizing court life of the late Middle Ages, especially under the French king Charles V (d. 1380), who was frequently lauded for his royal splendor and sumptuous artistic and architectural donations by Christine de Pisan and other authors.[31] As Brunetto Latini's *Li livres dou tresor*, following Aristotle's *Ethics*, advised the French nobility, "Magnificense est une vertus ki oevre par richece grans despenses et grans meisons; et l'ome ki est magnifiques est ententis par sa nature que ses afferes soient fet a grant honor, et a grant despenses plus volenters que a petis." But, just as magnificent endeavor could be despoiled by greed, the magnanimous individual's lofty actions were constantly imperiled by the eighth deadly sin: "Magnanimes est celui ki est atornés a grandismes afferes et s'esleece et s'esjoïst a fere les haute choses. Mais celui ki s'entremet, s'il n'est atornés a ce fere, il est apelés vanaglorieus."[32]

---

[29] R.-A. Gauthier, *Magnanimité, l'idéal de la grandeur dans la philosophie païenne et dans la théologie chrétienne* (Paris, 1951); M. B. McNamee, *Honor and the Epic Hero* (New York, 1960); F. Marty, "Magnanimité," in *Dictionnaire de spiritualité ascétique et mystique*, vol. 10, pt. 1, cols. 92–97; A. Murray, *Reason and Society in the Middle Ages* (Oxford, 1978), 355–362.

[30] This commonplace definition derives from Aristotle's *Ethics* and *Rhetoric*. Cf. R. Tuve, *Allegorical Imagery* (Princeton, 1966), 58–59. The traditional theological identification of magnanimity and magnificence was found in Thomas Aquinas and important later treatments of the virtues such as those by Peraldus and pseudo-Vincent of Beauvais. G. Kipling, *The Triumph of Honour: Burgundian Origins of the Elizabethan Renaissance* (The Hague, 1977), 28; and W. O. Harris, *Skelton's Magnyfycence and the Cardinal Virtue Tradition* (Chapel Hill, 1965), 58–69.

[31] Christine de Pisan, *Le livre des fais et bonnes meurs de sage Roy Charles V*, esp. II.iii.22, ed. S. Solente (Paris, 1936–40), 86–89. Cf. D. M. Bell, *L'idéal ethique de la royauté en France au Moyen Age* (Geneva, 1962), 124–129; and J. Krynen, *Idéal du prince et pouvoir royale en France á la fin du Moyen Age (1380–1440)* (Paris, 1981), 133–136. For the rich artistic patrimony surviving from his reign, see *Les fastes du Gothique, le siècle de Charles V*, exhib. cat., Grand Palais (Paris, 1981).

[32] Latini, *Livres dou tresor*, ed. Carmody (as in note 28), ii, 22–23, p. 193. Cf. ii, 23, p. 194: "Et celui ki en ces choses se desmesure est vaneglorieus et beubanciers, et celui ki s'entremet des grans afferes et des

Along with other aspects of the cardinal virtue fortitude, such as liberality, loyalty, steadfastness, courage, perseverance, etc., magnanimity and magnificence became mainstays of a positivistic ethos of neochivalric glory founded on Christian virtue: the "good fame" (*bonne renommée*) which was widely promulgated during the Burgundian era. *Rhétoriqueurs* attached to the Burgundian court, especially under the enlightened Duchess Isabella of Portugal in the mid-fifteenth century, produced a spate of works defining newly reinstated chivalric values. Adopting Petrarch's affirmative assimilation of virtue to glory in their laudatory estimations of Burgundian ducal *gloire*,[33] court *rhétoriqueurs* aggressively groomed traditional chivalric virtues to express revised Renaissance attitudes toward human worth and potential, embodied by the powerful Valois dynasty. This skillful rhetorical strategy was complemented by well-known propaganda manifestations of Burgundian glory in courtly ritual and display, ceremonial entries, and religious and secular iconography. Yet these highly visible developments also generated a moral backlash of critiques of chivalric vainglory which chipped away at the epideictic rhetorical bastion, undercutting the revisionist moral mechanics at work in the glorificatory process.

From 1430 onwards, the Burgundian chivalric Order of the Golden Fleece became the focus of a clever moral campaign generated by court *rhétoriqueurs* which deliberately identified the fleece with celestial glory and the goods of grace (the virtues). The inaugural proclamation, delivered by the Toison d'Or King of Arms, Jean le Fèvre, on the occasion of the founding of the order at Duke Philip the Good's wedding to Isabella of Portugal at Sluys in January of 1430, accentuated the supreme honor and prestige which the Golden Fleece conferred upon the members. The resplendent collar would inspire the knights to noble deeds and nourish high moral principles, bringing them good fame (*bonne renommée*) and making them worthy of the high privilege of member-

---

hautes choses ausi, comme s'il en fust dignes, et non est, et por ce fait il biaus dras et autres choses aparissans et de grant renomee, pour quoi il quide estre enhauchiés: les sages le tienent pour fol et por vain homme." Cf. also ii, 82, p. 262. Aristotle's *Ethics* had been translated into French in 1370 by Nicole Oresme at the request of Charles V: *Le livre des Ethiques d'Aristote*, ed. A. D. Menut (New York, 1949). For the manuscripts, see C. Sherman, "Some Visual Definitions in the Illustrations of Aristotle's Nicomachean Ethics and Politics in the French Translations by Nicole Oresme," *Art Bulletin* 59 (1977), 320–330. Another important source for Aristotelian ethical and political doctrines was the *De regimine principum* by Egidio Colonna, a popular mirror for princes translated into French in the late thirteenth century as *Li livres du gouvernement des rois*, ed. S. P. Molenaer (New York, 1899; reprint 1966).

[33] Petrarch (1304–1374) redefined potentials of human worth for the late Middle Ages in his idealized literary portraits of the ancient Roman general Scipio Africanus in *De viris illustribus* and the epic poem *Africa*. Cf. A. S. Bernardo, *Petrarch, Scipio and the "Africa," The Birth of Humanism's Dream* (Baltimore, 1962), 13ff. The linkage between glory and virtue established by Petrarch became a standard element in Renaissance panegyrics. Christine de Pisan had played an important role in transmitting the positivistic Petrarchan doctrine to the French nobility. She advocated the licit princely desire for praise and glory attained through virtuous endeavor in her *Livre du corps de policie* (ed. R. H. Lucas [Geneva, 1967], i, 33, pp. 99–102) of ca. 1404–1407, a work recorded in the Burgundian ducal library.

ship.[34] The formal statutes of the Golden Fleece presented at the first meeting at
Lille on 30 November 1431, however, shifted the emphasis to praise and honor
of the Almighty, the Virgin Mary, and St. Andrew: "à la gloire et louange de
tout puissant nostre créateur et Rédempteur, en révérance de sa glorieuse mere,
et en l'honneur de monseigneur saint Andrieu glorieux appostre et martir. A
l'exaltation de la foi et de saincte eglise et l'excitation de vertus et bonnes
moeurs."[35] A poem written the same year by the Burgundian court poet Mi-
chault Taillevent, the *Songe de la Thoison d'Or*, deftly coalesced the dual no-
tions of celestial and chivalric glory symbolized by the precious fleece. As did
the statutes, Taillevent identified the Golden Fleece with the praise of God, but
he extended its divine import to cover "goods, glory, and good fame" shared by
the distinguished members of the noble order: "Loenge à Dieu, trestout pre-
mièrement, / Et aux bons, gloire et bonne renommée."[36]

Later explications of the fleece's moral import linked *gloire et bonne renom-
mée* embodied in the device with heightened Burgundian conceptions of chival-
ric virtue, expanding upon the traditional ethos that the worthy knight earned
fame and glory through his courageous deeds.[37] According to the doctrine of
"true nobility" (*vraie noblesse*) promulgated at the court, the quest for glory
and good fame was inseparable from the cultivation of noble virtues.[38] Renais-
sance concepts of honor and nobility were developed by Italian humanists in

[34] ". . . fait savoir à tous, que, pour la révérence de Dieu et soustennement de nostre foy chrétienne, et
pour honnourer et exauchier la noble order de chevalerie, et . . . pour faire honneur aux anchiens chevaliers,
qui par leurs haulx et nobles faiz sont dignes d'estre recommandez . . . affin que les chevaliers et gentilz
hommes qui verront porter l'ordre dont cy après sera touchié, honneurent ceulx qui le porteront, soient meuz
de eulz employer en nobles faiz, et eulx nourir en telles meurs que par leurs vaillances ilz puissent acquérir
bonne renommée et déservir en leurs temps d'estre esleuz à porter ladicte ordre." *Chronique de Jean le Fèvre*,
ed. F. Morand (Paris, 1876–81), II, clxiv, pp. 172–173. Cf. D'A. J. D. Boulton, *The Knights of the Crown:
The Monarchical Orders of Knighthood in Later Medieval Europe, 1325–1520* (Woodbridge, Suffolk,
1987), 360–361. Members were obligated to wear the collar every day.

[35] *Book of Statutes of the Order of the Golden Fleece of 1431*, The Hague, Koninklijke Bibliotheek, MS.
76 E 14, fol. 8r. Numerous fifteenth-century manuscripts of the Golden Fleece statutes are extant, since copies
were ritually presented to newly elected members. Cf. R. P. Helyot, *Histoire des ordres religieux et militaires*
(Paris 1792), vol. 8, 351; G. Dogaer, "Des anciens livres des statuts manuscrits de l'Ordre de la Toison d'Or,"
*Publications du centre européen d'études burgundo-médianes* 5 (1963), 65–70; *Trésors de la Toison d'Or*,
exhib. cat., Palais des Beaux-Arts (Brussels, 1987), 98–99, no. 24; Boulton, *Knights of the Crown* (as in note
34), 364–366.

[36] Michault Taillevent, *Le songe de la Thoison d'Or* (Paris, 1841). Cf. P. Champion, *Histoire poètique du
quinzième siècle* (Paris, 1966), vol. 1, 296–299; Huizinga, *Waning* (as in note 1), 84.

[37] L. Kendrick, "Fame's Fabrication," *Studies in the Age of Chaucer* 1 (1984), 135–148, esp. 136–139.

[38] M. Vale, *War and Chivalry* (London, 1981), 14–27; F. Joukovsky, *La gloire dans la poèsie française et
néolatine du XVIᵉ siècle* (Geneva, 1969), 50–51. The doctrine of "bonne renommée" (good fame) had been
disseminated as a princely ideal by Brunetto Latini's *Li livres dou tresor* ("Gloire est la bone renomee. . . .
Ceste renomee desire chascuns. . . . "), as well as by numerous literary offspring of the popular *Secretum
secretorum*, supposedly a letter of advice written by Aristotle to Alexander. Cf. *Livres dou tresor*, ed. Car-
mody (as in note 28), ii, 120, p. 303; and *Secretum Secretorum, Nine English Versions*, ed. M. A. Manzalaoui
(Oxford, 1977), vol. I, 34–35, 129, 211, 296, 300.

didactic texts such as the *Débat sur l'honneur* and *La controverse de noblesse*, translated into French by Jean Miélot in 1449/50 and presented to Duke Philip the Good in a beautiful manuscript illuminated by Jean le Tavernier and another hand (Fig. 1).[39] Lost tapestries woven in the Low Countries for the Valois dukes represented the Burgundian conception of "good fame." Several examples of this type are described in Burgundian and Spanish accounts, where they are titled "Fama," "Fama et gloria mondana," and "Bonne Renommée."[40] This tapestry tradition apparently began in 1399, when the Arras weaver Pierre de Beaumetz furnished the Burgundian Duke Philip the Bold with three tapestries of "L'histoire de Fama" for the considerable sum of 3,000 golden *écus*.[41]

The official formulation of chivalric philosophy underlying the Order of the Golden Fleece, *L'histoire de la Toison d'Or*, written in 1468–73 by Guillaume Fillastre, bishop of Tournai and the order's second chancellor, identified the fleece first and foremost with the knightly quest for eternal glory inspired by the noble virtue magnanimity, which Fillastre traced back to Jason's heroic quest. A second volume linked Jacob's fleece with justice, and a third (Fig. 2) tied Gideon's to prudence. Three additional volumes planned by Fillastre, but never completed, were to explore pertinent virtues embodied in other biblical fleeces: fidelity with that of Mesa, king of Moab; patience with Job's; and clemency with David's.[42] By placing chief emphasis upon magnanimity, Fillastre restruc-

---

[39] P. Durrieu, *La miniature flamande au temps de la cour de Bourgogne, 1415–1530* (Brussels, 1921), pl. 15; and *Trésors de la Toison d'Or* (as in note 35), 112–113, no. 31. Cf. A. J. van der Jagd, "Qui sa vertu anoblist. The Concepts of 'Noblesse' and 'Chose Politique' in Burgundian Political Thought" (Ph.D. diss., University of Groningen, 1981); C. C. Willard, "The Concept of True Nobility at the Burgundian Court," *Studies in the Renaissance* 14 (1967), 33–48. For Jean Miélot's work as translator and illuminator, see G. Dogaer, *Flemish Miniature Painting in the Fifteenth and Sixteenth Centuries* (Amsterdam, 1987), 87–88. A good discussion of the role played by translators in late medieval courts can be found in Green, *Poets and Princepleasers* (as in note 10), 149ff.

[40] G. Delmarcel, "Présence de Boccace dans la tapisserie flamande des XVe et XVIe siècles," in *Boccaccio in Europe*, ed. G. Tournoy (Louvain, 1977), 70–71, with inventory references on 89–90; J. K. Steppe, "Vlaams tapijtwerk van de 16e eeuw in Spaans koninklijk bezit," in *Miscellanea Jozef Duverger* (Ghent, 1968), vol. 2, 721 n. 8. These include the collections of Blanca of Navarre (1411), Jean of Berry (1416), Philip the Good (1420), Maria of Castille (1458), Pedro de Portugal (1464–66), doña Juana Enríquez, queen of Aragon (1469–70), and Queen Isabella of Castille (1503).

[41] C. C. Dehaisnes, *Histoire de l'art dans la Flandre, l'artois et le hainault* (Lille, 1886), 343. The three tapestries later figured in the inventory of Philip the Good. P. de Winter, *La bibliothèque de Philippe le Hardi (1364–1404)* (Paris, 1985), 24, suggests that the suite may have synthesized the three chapters of Petrarch's *Trionfo della fama*. Interest in Petrarch at the Valois court harks back to his ambassadorship at Paris in 1361 and subsequent stay at Avignon. Christine de Pisan established a manuscript iconographic tradition associating good fame with the myth of Perseus on the winged Pegasus rescuing Andromeda in her *Epistre Othéa* of ca. 1400. Cf. S. L. Hindman, *Christine de Pizan's "Epistre Othéa"* (Toronto, 1986), 54, 194; and *The Epistle of Othea*, trans. S. Scrope, ed. C. F. Bühler (London, 1970), 14–16.

[42] Guillaume Fillastre, *Le premier volume de la Toison d'Or* (Paris, 1516). Sumptuous manuscripts of the first two parts are in the Archives of the Order of the Golden Fleece at Vienna, Österreichische Nationalbibliothek MS. no. 1; and at Brussels, Bibliothèque royale MSS. nos. 9027 and 9028. The text of the third part (which was never printed) is preserved in a MS. at the Kongelige Bibliotek, Copenhagen, MS. Thott

tured the traditional order of princely virtues, which had normally begun with prudence in the *Miroirs du prince*.[43] The learned chancellor was no doubt aware of increased emphasis being placed upon magnanimity by quattrocento humanists, who were contemporaneously reviving the Ciceronian and Senecan notion of *magnitudo animi* (grandeur of the soul).[44]

Following the trend of neochivalric ethics, Fillastre derived magnanimity from the virtue of *force* (fortitude) and related it closely to magnificence.[45] Magnanimity gave moral legitimacy to the Burgundian dukes' passion for conquest as well as to their love of sumptuous display, since it subsumed both military prowess and liberal expenditures designed to enhance ducal glory.[46] The court's lavish hospitality impressed the western world with the Valois dynasty's towering status among Christian princes. Though Huizinga tended to ignore the positivistic ethical strategy underlying these external manifestations of Burgundian *gloire*, he rightly observed the political and propagandistic benefits:

> It is well known how much importance the dukes attached to the magnificence of their household. A splendid court could, better than anything else, convince rivals of the high rank the dukes claimed to occupy among the princes of Europe. "After the deeds and exploits of war, which are claims to glory," says Chastellain, "the household is the first thing that strikes the eye, and that which it is, therefore, most necessary to conduct and arrange well."[47]

The enormous sums spent upon the Burgundian household—overawing foreign visitors and ambassadors,[48] and sparking competitive propagandist expenditures at other courts on the continent and in England—were given essential moral justification by these neochivalric virtues. Chroniclers like Chastellain and heralds and ambassadors subsidized by the dukes acted as official publicists and moral arbiters for Burgundian displays of magnificence, providing eyewitness reports of proud displays at rival courts.[49]

---

465. Cf. *Trésors de la Toison d'Or* (as in note 35), 114–119, nos. 32–34; Dogaer, *Flemish Miniature Painting* (as in note 39), 95.

[43] Bell, *L'idéal ethique* (as in note 31), 122.

[44] G. Weise, *L'ideale eroico del rinascimento e le sue premesse umanistiche* (Naples, 1961), 195ff.

[45] Fillastre, *Toison d'Or* (as in note 42), I, fol. 4r.

[46] The accent on military prowess remained fundamental, as observed by the old-school Burgundian knight Ghillebert de Lannoy in *L'instruction d'un jeune prince*, a manual of paternalistic advice composed for the young count of Charolais (the future Duke Charles). For Lannoy, magnanimity meant primarily "force de courage ou hardement" in warfare. *Oeuvres de Ghillebert de Lannoy*, ed. C. Potvin and J.-C. Houzeau (Louvain, 1878), vol. 2, 356–357. Cf. Vale, *War and Chivalry* (as in note 38), 24–26; and *Charles le Téméraire*, exhib. cat., Bibliothèque Royale Albert I^er (Brussels, 1977), 13–14.

[47] Huizinga, *Waning* (as in note 1), 39.

[48] For example, the English John Paston's amazement at the splendor of the "Dwkys coort" when he attended the marriage of Margaret of York and Charles the Bold at Bruges in 1468. Green, *Poets and Princepleasers* (as in note 10), 18.

[49] Ibid., 168ff.

Accent upon magnanimity as the chief virtue associated with the Golden Fleece strengthened ongoing rhetorical glorification of the Burgundian ducal dynasty, for it was through their virtues and great deeds that the dukes would merit the heavenly reward. This optimistic conviction emerged in triumphal entries staged by Netherlandish cities humiliated by Burgundian might who sought to appease the ire of the victorious dukes with supplicatory panegyrical tableaux. On the occasion of Philip the Good's entry into defeated Ghent on April 23, 1458, local rhetoricians devised plays and painted decorations urging clemency and magnanimity, and promising divine blessings for the forgiving duke via an elaborate allegorical journey which Philip made as he passed through the Turre Poorte to the Place de Poel. The route was cleverly staged to symbolize passage from the terrestrial to the heavenly realm.[50] The Van Eycks' famed Ghent Altarpiece expressed a sublime vision of celestial glory on earth that corroborated the positivistic ethos of the Golden Fleece and was naturally assumed into the imagery of the neochivalric order's liturgical paraphernalia. Probably the most visible manifestation of divine munificence showered upon the ducal dynasty were the eight large tapestries representing the *History of Gideon* woven at Tournai 1449–53 and ritually displayed at chapter meetings of the order as well as at ducal triumphal entries and other momentous events. Unfortunately, the Gideon tapestries disappeared in the late eighteenth century, and no clear literary or visual record of their appearance has been found.[51]

Not content with propagating Burgundian *gloire* during the dukes' lifetimes, court poets like Chastellain and Molinet became increasingly ambitious to confer immortal fame upon their masters after they had passed away.[52] This rhetorical strategy harks back to the influential *Livres des fais et bonnes meurs du sage roy Charles V*, commissioned from Christine de Pisan in 1404 by the late king's brother, Philip the Bold of Burgundy. In this panegyrical biography Christine praised Charles as the perfect embodiment of princely virtues and confidently predicted everlasting glory for his soul as well as enduring earthly fame.[53] Similar Renaissance attitudes toward terrestrial glory as a direct con-

---

[50] E. Varenbergh, "Fêtes données à Philippe-le-Bon et Isabelle de Portugal, en 1457," *Annales de la Société royale des beaux-arts et de littérature de Gand* 12 (1869–72), 1–36; J. C. Smith, "The Artistic Patronage of Philip the Good, Duke of Burgundy (1419–1467)" (Ph.D. diss., Columbia University, 1979), 171–173, with further bibliography (171 n. 20); idem, "'Venit Nobis Pacificus Dominus': Philip the Good's Triumphal Entry into Ghent in 1458," in *"All the World's a Stage . . .": Art and Pageantry in the Renaissance and Baroque*, Part I, *Triumphal Celebrations and the Rituals of Statecraft*, ed. B. Wisch and S. S. Munshower (University Park, Pennsylvania, 1990), 1–385.

[51] J. C. Smith, "Portable Propaganda—Tapestries as Princely Metaphors at the Courts of Philip the Good and Charles the Bold," *Art Journal* 48 (1989), 123–129. I wonder whether the large numbers of precious and semiprecious stones incorporated into the weaving may not have prompted the sumptuous suite's destruction.

[52] *Les faictz et dictz de Jean Molinet*, ed. N. Dupire (Paris, 1936), vol. 1, 44–45.

[53] Christine summed up her intent towards the close of the work: "la declaration des fais et bonnes meurs du sage roy, en qui nous les avons prouvées, à qui s'en ensuivi gloire perpetuele à l'âme, comme je tiens, grant preu au corps, et, tant comme le siècle durera, louenge au monde après lui demourée." Christine, *Le livre des fais*, II.iii.69, ed. Solente (as in note 31), 179.

duit to heavenly glory can be noted in funeral lamentations composed upon the death of Philip the Good in 1467. Tentatively advanced by the Burgundian historiographer Georges Chastellain in a mystery play performed at the somber funeral fêtes held at Bruges, this flattering rhetorical doctrine was fully presented in the *Trosne d'honneur*, a florid allegory written by Chastellain's young assistant Jean Molinet, who later succeeded his master as official court historiographer for Charles the Bold. The poem celebrated the duke's unblemished honor, which achieved everlasting celestial apotheosis upon a splendid throne garnished with millions of stars and angels.[54]

It was around this time that humanist orators in northern Europe began to exploit the possibilities of epideictic rhetoric in florid Latin verses flattering their princely patrons as paragons of honor and virtue. This trend, which became universal by the end of the century, had already asserted itself in a lengthy panegyric dedicated to Duke Charles in 1470 by the obscure Simon Mulart, dean of the St. Gangalphus chapter of Heinsberg and graduate of Cologne University who served as diplomatic agent for the Burgundians at the papal curia. Mulart's *De ortu victoria et triumpho Karoli ducis Burgundi* celebrated Charles euphorically as a new Charlemagne who would inaugurate a messianic Golden Age for Christendom. The oration utilized the cloying poetic device of chains of laudatory characteristics beginning with *C* as well as with the letters and syllables of Carolus.[55]

The affirmative Renaissance fusion of virtue and glory which emerged in northern Europe with the creation of the Order of the Golden Fleece was not altogether a happy marriage, however, for the specter of vainglory hovered critically above the energetic Burgundian rhetorical campaign. *Rhétoriqueurs* employed at the ducal court clearly understood the precariousness of their moral strategy. Guillaume Fillastre acknowledged in his *Histoire de la Toison d'Or* that there was a fine dividing line between magnanimity, chief virtue associated with the fleece, and vainglory, its traditional opposite in the *psychomachia* of the virtues and vices. Following Thomas Aquinas's fundamental discussion, Fillastre emphasized that the truly magnanimous man must always keep in mind that the goods of fortune and nature he possesses are gifts from

---

[54] C. Martineau-Génieys, *Le thème de la mort dans la poésie française de 1450 à 1550* (Paris, 1978), 300–317. In another allegorical piece composed after Philip's death by an unknown author, *Le lyon coronné*, a young lion (Charles) who inherits the "glorieux habitacle" of Burgundy is aided in the struggle against wicked Dame Envie by the "comely virtues Loyale Entreprise, Diligente Poursuite and Ample Faculté." At the close, Glorieuse Fin arrives to do away with Envie and crown the brave lion with immortal honor: "Luy declarant digne de los avoir, / Triumphe, honneur et immortel manoir." *Le lyon coronné*, ed. K. Urwin (Geneva, 1958), 62. This rather uninspired work may well have been composed for a *tableau vivant* staged during the early months of Charles's succession.

[55] P. C. Boeren, ed., *Twee Maaslandse dichters in dienst van Karel de Stoute* (The Hague, 1968), 71–107, 198–267.

God and, consequently, it is the Almighty who deserves all of the honor and glory deriving from great deeds, not oneself. Humble recognition of human imperfections will lead the chevalier to avoid dangerous excesses of vainglory, presumption, and ambition. Magnanimity must also be free of the defect of pusillanimity, and take a royal path between pride and cowardice.[56]

Not long after the sensational Feast of the Pheasant held at Lille in 1454, when Philip the Good formally announced his plans for a Burgundian-led crusade to recapture the Holy Land from the Turks, the duke's godson, chamberlain and court poet Philippe Bouton (1419–1515), underscored the arduous moral struggle behind the quest for the Golden Fleece in a little-known poem that implicitly criticized ducal motivations behind the crusade. For Bouton, just as important as a crusade against the infidels was the battle to be waged against the triple temptations, that great triumvirate of moral enemies seeking to prevent the successful attainment of "le Hault don d'honneur insupérable"—"la gloire durable" symbolized by the precious fleece.[57] After contending with the two oxen of carnal sin (luxury/gluttony and avarice), the duke will have to wage war upon the formidable third temptation: the fiery dragon of pride and vainglory, a powerful beast that threatens to corrupt Philip's resplendent triumph and rich endowment of worldly goods.[58] Like Fillastre, Bouton reminded Philip to render gratitude and honor to God for the exceptional goods at his command, since "Que plus a, plus doit rendre de compte."[59]

While Philippe Bouton's moralizing poem probably did not affect his godfather's crusading spirit, it at least served to temper the extravagant romantic sentiments of the Vows of the Pheasant which Huizinga found so excessive. Bouton was well aware that, for medieval moralists, chivalric pursuit of military glory and high honors was not infrequently motivated by vainglory. Toward the close of the fourteenth century, the appalling disasters of the Hundred Years' War had stimulated renewed critiques of the vainglory of knight-errantry. In his *Songe du vieil pèlerin* of 1388, Philippe de Mézières mocked the way the French knights preened themselves following their victory over the Flemish commoners at Roosebeke in 1382. The aristocrats, who had won the battle "by the hand of God at Roosebeke against a crowd of fullers and weavers . . . take on vainglory. And they dare to compare themselves to the valiant chivalry of the company of King Arthur, Charlemagne, and Godefroy of Bouillon."[60] These

[56] Fillastre, *Toison d'Or* (as in note 42), fol. 11r. Aquinas's discussion of magnanimity can be found in *Summa Theologia*, 2a2ae, q. 129–133. Cf. McNamee, *Honor* (as in note 29), 122–128.

[57] J. de la Croix Bouton, "Un poème à Philippe le Bon sur la Toison d'Or," *Annales de Bourgogne* 42 (1970), 5–29, esp. 16. For Bouton, see also M. T. Caron, *La noblesse dans le Duché de Bourgogne, 1315–1477* (Lille, 1987), 143, 213, 281, 293–294, 492, 510.

[58] Croix Bouton, "Un poème" (as in note 57), 19, 21.

[59] Ibid., 26–27.

[60] Philippe de Mézières, *Le songe du vieil pèlerin*, ed. G. W. Coopland (Cambridge, 1969), I, ii, p. 525. Cf.

criticisms did not prevent the Burgundian duke Philip the Bold from ordering a splendid tapestry suite commemorating the victory at Roosebeke which was frequently displayed in the fifteenth century as a reminder to the obstreperous craft guilds.[61]

The ill-fated crusade against the Turks at Nicopolis led in 1396 by the Burgundian Jean de Nevers (the future Duke John the Fearless, sire of Philip the Good) was also widely linked to the eighth deadly sin. Albert, duke of Bavaria and count of Hainault, denied the breathless request made by his young son William of Ostrevant to be allowed to join the crusade, remarking that there was no reason for such an undertaking "fors que pour la vayne gloire de ce monde."[62] Although Philippe de Mézières had been a persistent propagandist for the Burgundian crusade, he was shocked by the lavish procession led by Jean de Nevers from Dijon on April 30, 1396, with its gay green livery, twenty-four wagonloads of green satin tents, numerous pavilions, banners and pennons, and opulent supplies of wines and fine victuals. He remarked that the Burgundians proceeded like kings, "les menistreulx et les hyraux precedens à grans pourpres e à grans paremens, en robes et en vaisselle d'argent, faisans les grans disners des viandes oultrageuses." Mézières predicted disaster for the crusaders, who appeared inspired not by Christian zeal but rather by a chivalric love affair with "une des plus grandes dames du monde, Vaine Gloire." In Mézières's treatise, this splashy lady mocks chivalric virtues of magnanimity and magnificence with her grand entourage of four chambermaids led by the maître d'hotel Nabuserdan: *Largesse*, *Prodigalité*, *Joliveté*, and *Validire*.[63] Sadly fulfilling his dire forecast for the crusaders, the Burgundian John the Fearless was captured by the Turks at the disastrous battle of Nicopolis and had to be ransomed at great cost. The "Religieux de Saint-Denys," anonymous chronicler of the reign of the French king Charles VI, commented on the rout: "Thus the dazzling glory of the Christian evaporated like vapor; their valor, up to then so formidable, was suddenly overthrown, and became the laughingstock of infidels. . . ."[64]

In his *Epistre au Roi Richart* (*Letter to Richard II*) of 1395, Mézières made an impassioned plea for peace, remarking that war should be condemned since it invariable produced the destructive vices "vaine gloire, oultrecuidance, pre-

---

D. M. Bell, *Etude sur le Songe du vieil pèlerin de Philippe de Mézières (1327–1405)* (Geneva, 1955); Hindman, *"Epistre Othéa"* (as in note 41), 144ff.

[61] Smith, "Portable Propaganda" (as in note 51), 129 n. 41.

[62] *Oeuvres de Froissart* (as in note 23), vol. 15, 227.

[63] N. Jorga, *Philippe de Mézières, 1327–1405, et la croisade au XIVᵉ siècle* (Paris, 1896; reprint London, 1983), 489–493, citing Mézières, *Chevalerie de la Passion de Jésus-Christ*, Arsenal MS. 2251, fols. 31–32v. Cf. B. Tuchman, *A Distant Mirror, The Calamitous Fourteenth Century* (New York, 1978), 548–550.

[64] *Chronique du religieux de Saint-Denys*, ed. L. Bellaguet, vol. 2 (Paris, 1840), xvii, 27, pp. 510–511.

sumpcion et avarice."[65] Mézières's high moral standards for European knights led him to formulate a utopian proposal for a new chivalric order designed to unite Christendom in the struggle against the Turks. Members of the Order of the Passion he envisioned would act as virtual evangelists of "holy chivalry" and be required to attain personal moral perfection (*summa perfectio*).[66] His dream of a holy order of Christian knights doubtless played a role in the formation of the Burgundian Order of the Golden Fleece under Philip the Good in 1430. Mézières's observations on the Nicopolis debacle make Bouton's moralizing reactions to Philip the Good's renewal of crusading spirit under the aegis of the resplendent fleece a half century later more understandable.

Concern over excessive worldly magnificence continued to characterize criticisms of chivalric pursuits, though it is unclear how seriously the issue was taken by contemporary nobles bent on garnering honor and glory through their splendid feats of arms. At times, little more than lip service appears to have been paid to a traditional moral *topos*, thus tending to corroborate Maurice Keen's suspicions. In a biographical romance about the life of the contemporary French knight Jean de Bueil, *Le jouvencel* (ca. 1465), which charts the ways for a young noble to acquire *bonne renommée*, vainglory is virtually ignored. Only the outworn custom of resolving conflicts by chivalric duels between two leaders or two opposing groups of knights was ascribed to the vice.[67] While the old-school knight of the Golden Fleece, Ghillebert de Lannoy, took care to attribute the horrors of war to the diabolical vices "orgueil, vaine gloire et convoitise" in his *L'instruction d'un jeune prince*, written for young Charles of Burgundy,[68] the battle-hardened Lannoy actually seems to have held a much more pragmatic view of these deadly sins. In his *Enseignements paternels*, composed for his own son in 1470, Lannoy characterized "orgueil" as a beneficial knightly incentive, "puisqu'on tendroit à bonne et honnest fin et feroit eschiever et fuir mal et deshonneur." Making a classic turnabout later in the same text, the grizzled warrior advised his son against "ce très mauldit péchié d'orgueil."[69] As Huizinga and Joukovsky rightly observed, chivalric ideals of the late Middle Ages were profoundly ambiguous, charged with contradictory dualities of pseudo-religious Christian principles and hard-headed egoism manifested in acts of pride, cupidity, cruelty, and exorbitant displays of *luxe*. Not a

---

[65] Philippe de Mézières, *Letter to King Richard II*, trans. and ed. G. W. Coopland (Liverpool, 1975), 51, 125. Cf. the author's allegorical Garden of War, described in the same letter, which is ravaged by winds of Pride, Vainglory, and Avarice (ibid., 56, 130).

[66] Ibid., xxxiii–iv, 30–33, pp. 103–106. Cf. Huizinga, *Waning* (as in note 1), 84; Hindman, "*Epistre Othéa*" (as in note 41), 154–155.

[67] Jean de Bueil, *Le jouvencel*, ed. C. Favre and L. Lecestre (Paris, 1887–89), vol. 2, xxi, p. 100.

[68] *Oeuvres de Ghillebert de Lannoy* (as in note 46), v, p. 385.

[69] Ibid., 460–461, 470. The attribution to Lannoy of the *Enseignements paternels* has sometimes been questioned, though without firm grounds.

few contemporary critics scored the inconsistencies of the chivalric ethos and exposed the precarious underpinnings of the moral strategy of *bonne renommée* and *vraie noblesse*.[70]

Warnings about *vaine gloire* colored the numerous exhortatory moral tracts directed toward the stubborn and headstrong Duke Charles the Bold by his concerned advisers, but they appear to have had little effect upon his penchant for self-glorification. Among these should be counted Fillastre's *Histoire de la Toison d'Or*, written for the youngish head of the great Burgundian chivalric order in 1468–73. This trend was apparently encouraged by the duke's astute mother, the dowager duchess Isabella of Portugal (d. 1472), whose court translators produced a spate of texts on princely conduct as well as instructive works of Greek and Roman history which noted the perils of excessive ambition and tyrannical behavior, such as Vasco de Lucena's translation of Quintus Curtius Rufus's life of Alexander the Great.[71] Vainglory and related vices figured prominently among these sage counsels. The learned Burgundian court historiographer Georges Chastellain (1415–1475) remarked pointedly on Charles's father Philip the Good's humility and disdain for worldly praises and "vaines gloires."[72] Conversely, in his *Exposition sur vérité mal prise* (1458–59), Chastellain ascribed the English king Henry VI's loss of his country's continental holdings and sudden madness in 1453 to divine retribution resulting from covetousness and extreme passion for the eighth deadly sin.[73] Chastellain flagged the transiency of worldly glory for ducal ears in his *contemptus mundi* poem, "Le pas de la mort," with its nine resonant *ubi sunt* stanzas.[74] Elsewhere, the Burgundian rhetorician approvingly affirmed that Charles had learned the lesson of the poem: "Comme grand prince qu'il fust, sy considéroit-il ce monde transitoire, et sa haute domination et gloire rien estre que vanité et poignie de vent."[75]

Yet Chastellain rapidly found cause for concern in Charles's insatiable passion for warfare, uncontrollable temper, and extremely pompous behavior. In 1469 he expressed alarm that the great military glory the Burgundian duke was accruing might lead him to become unduly proud.[76] Nervous about the course

---

[70] Joukovsky, *Gloire* (as in note 38), 53, with references.

[71] C. C. Willard, "Isabel of Portugal, Patroness of Humanism?" in *Miscellanea di studi e ricerche sul Quattrocento francese*, ed. F. Simone (Turin, 1967), 517–544, esp. 538ff. See Robert Gaguin's critiques of Charles in *Epistolae et orationes*, ed. L. Thuasne (Paris, 1903; reprint Geneva, 1977), vol. 1, 25. Admonitory aspects of a manuscript *Life of Alexander* illuminated by the Master of Margaret of York now in the Ludwig Collection at the J. Paul Getty Museum in Malibu have been examined in an M.A. thesis by Jody Hoppe for the University of California, Santa Barbara.

[72] G. Chastellain, *Oeuvres*, ed. J. Kervyn de Lettenhove (Brussels, 1863–66), vol. 5, 245; vol. 7, 233; cited by J.-C. Delclos, *The Témoignage de Georges Chastellain* (Geneva, 1980), 127.

[73] Chastellain, *Oeuvres* (as in note 72), vol. 6, 348–349.

[74] Ibid., 49ff.

[75] Ibid., vol. 7, 230; Delclos, *Témoignage* (as in note 72), 190.

[76] Chastellain, *Oeuvres* (as in note 72), vol. 5, 371; Delclos, *Témoignage* (as in note 72), 195.

of his rule, Chastellain had in 1467 already composed a well-tooled master-piece of sage counsel, the *Advertissement au Duc Charles soubs fiction de son propre entendement parlant à luy-mesme*, in which he sought to cool his master's ire toward the rebellious city of Ghent via an exquisite moral allegory. Chastellain first reminded Charles of the great glory garnered from "les hautes possessions, les honneurs et les aornemens du monde avecques infinité de biens" that he had inherited from his father.[77] The chronicler went on to compare the young duke to Solomon, not insignificantly recalling the wise Old Testament king's foolish self-glorification in old age: "Se desvoya toutes-fois ce Salomon en sa félicité atout son grant sens, et en l'ivresse de tant de biens et de gloires, il oublia Dieu. Perdit ceste peur que j'ay droit'cy ramentue et courouça Dieu." Chastellain continued in this vein, observing that God refrained from taking vengeance upon Solomon while he was alive due to his love for his father, David (a transparent reference to Philip the Good). However, "en son hoir luy promit décadence et dissipation de son règne." This barely concealed threat of divine retribution was followed by a sharp warning about the perils of excessive thirst for terrestrial glory:

> Touteffois dois bien garder que le désir ne te pende point tant en l'honneur du monde, que le mérite et le fruit de ton oeuvre ne te soit plus chier que la gloire que en ensuit, ou autrement tu déclines à vanité, et vanité te payera de vaine paye.[78]

Chastellain's benevolent cautionary advice, however, had little effect on the Burgundian duke, who was rarely known to heed the advice of his counselors.[79] When the Connetable Louis of Luxemburg, count of Saint-Pol, recommended making peace with Liège, remarking to Charles on the instability of treacherous fortune and the possibility that "toute vostre gloire passée, et de vous et de vostre maison, seroit renversée et retournée en songe," Charles curtly told Louis to stop preaching and stubbornly reaffirmed his resolve to carry out his vindictive military campaign.[80]

---

[77] Chastellain, *Oeuvres* (as in note 72), vol. 7, 293; *Charles le Téméraire* (as in note 46), 91–93, no. 12.

[78] Chastellain, *Oeuvres* (as in note 72), vol. 7, 296–298. Chastellain knew that the Ghent deputies had cited God's forgiveness of Solomon's vainglorious idolatry as an *exemplum* of divine mercy to Charles in their allegorical campaign to induce him to pardon the rebellious Flemish city. A disconsolate bejewelled Solomon painted by Joos van Ghent for the *studiolo* of Frederigo da Montefeltro at Urbino has sometimes been identified as a moralized portrait of Charles the Bold. W. Stein, "Die Bildnisse von Roger van der Weyden," *Jahrbuch der Preussischen Kunstsammlungen* 47 (1926), 29, no. 1.

[79] D. Gallet-Guerne, *Vasque de Lucène et la Cyropédie à la cour de Bourgogne (1470)* (Geneva, 1974), 26, with further references.

[80] Chastellain, *Oeuvres* (as in note 72), vol. 5, 343. The well-known posthumous portrait of Charles the Bold in a frontispiece miniature executed by an anonymous Bruges master for a late fifteenth-century copy of Chastellain's *Advertissement* (Bibl. Roy., Brussels, MS. II 7928) conveys an obvious sense of despondency about the late duke's inability to benefit from the sage counsel offered in the treatise. *Charles le Téméraire* (as in note 46), 91–93, no. 12.

In 1466, Pierre Michault, an ecclesiastic and secretary to the young Charles while he was still count of Charolais, concocted one of the most curious of all the moral allegories penned for the Burgundian court: *Le doctrinal du temps présent* (or *Doctrinal du court*), dedicated to Philip the Good one year prior to his death. The theme of vainglory looms prominently in Michault's treatise, which takes the form of a series of lectures on grammar given by a faculty of twelve vices, led by the devious schoolmaster *Faulceté*. Introductory verses remark upon the corruption of virtues formerly cultivated at the court by "pompe variable."[81] The train of wicked grammar professors is led by *Vantance* (or *jactantia*, "boasting," traditional offshoot of vainglory), who conducts declensions first in the nominative case, satirizing the use of glorificatory names and titles by the aristocracy, and then in the genitive, taking aim at the common tendency to magnify one's noble lineage.[82] *Vantance* is followed on the podium by *Vaine Gloire* (Fig. 3), who gives lessons on *etheroclite*, or *heteroclite* (variable) declension:

> Etheroclite est diction peu ferme
> Qui bien souvent, ainsi le vous affirme,
> Son homme eslieve en hault et glorifie,
> Et tellement l'exaulce et clarifie
> Qu'on dit de lui, sans doubtance, en tous lieux:
> "Cestui la est ung parfait glorieux."[83]

*Vaine Gloire* goes on to treat various manifestations of the "parfait glorieux" at the Burgundian court, including presumptuous learning, vain curiosity, the misuse of abundant temporal goods, and penchant for excessive variation of speech and dress.[84]

First published in French by Colard Mansion at Bruges ca. 1479 and again at Lyons ca. 1484 (Fig. 4), Michault's *Doctrinal* was translated into Dutch and printed at Haarlem in 1486 by Jacob Bellaert as the *Doctrinael des tijts*, accompanied by a number of woodcut illustrations.[85] Since the early published editions

[81] *Le doctrinal du temps présent de Pierre Michault (1466)*, ii, 11.1–12, ed. T. Walton (Paris, 1931), 4. For the author, see A. Piaget, "Pierre Michault et Michault Taillevant," *Romania* 18 (1889), 439–452; G. Doutrepont, *La littérature française à la cour des ducs de Bourgogne* (Paris, 1909), 320–323; Kilgour, *Decline of Chivalry* (as in note 7), 228; H. Guy, *L'Ecole des Rhétoriqueurs*, vol. 1 of *Histoire de la poésie française au XVIᵉ siècle* (Paris, 1968), 17–18; P. M. Smith, *The Anti-Courtier Trend in Sixteenth-Century French Literature* (Geneva, 1966), 46–47; Gallet-Guerne, *Vasque de Lucéne* (as in note 79), 24.

[82] Michault, *Doctrinal* x, 11.1–602, ed. Walton (as in note 81), 10–26.

[83] Ibid., xiv, 11.11–16; ed. Walton, 29.

[84] One wonders whether Charles the Bold's favorite jester, nicknamed "Le Glorieux," may not have been skilled at parodying the foppishly vainglorious courtier with comical rodomontade.

[85] *Doctrinael des Tijts*, ed. W. J. Schuijt (Wageningen, 1946); L. Debaene, *De Nederlandse volksboeken* (Hulst, 1977), 246; *Le cinquième centenaire de l'imprimerie dans les anciens Pays-Bas*, exhib. cat., Bibliothèque Royale Albert Iᵉʳ (Brussels, 1973), 379–380, no. 172. For the woodcuts, see J. Renouvier, *Histoire de l'origine et des progrès de la gravure dans les Pays-Bas, jusqu'à la fin du quinziéme siècle* (Brussels, 1860), 218–219.

all contain the author's dedicatory epistle to Philip the Good, it was perfectly clear to the late fifteenth century that the *Doctrinal* satirized the Burgundian court. Michault's treatise helped to further the belief that the Burgundians had been seriously addicted to the eighth deadly sin and related aristocratic vices.

Concern about vainglory in Michault's *Doctrinal du temps présent* echoed austere Carthusian preaching, especially the eloquent sermons of Denys le Chartreux (d. 1471), who, as Huizinga noted, acted as a moral conscience for the house of Burgundy.[86] Chivalric love of jousts and tournaments aroused the prolific Carthusian's intense concern. Denys strongly condemned *hastiludia* for encouraging the prevailing sin of pride and frequently resulting in sudden death. In a treatise dealing with the moral failings of the nobility, *Directorium vitae nobilium*, Denys reminded the aristocrats to refrain from vainglorious presumption and self-extollation, since the more abundant their goods and gifts, the greater their obligation to give thanks to God and dedicate themselves to his service.[87] He then proceeded to cite Jeremiah 9:23–24, standard scriptural monition to the nobility regarding the eighth deadly sin: "Thus saith the Lord: Let not the wise man glory in his wisdom, and let not the strong man glory in his strength, and let not the rich man glory in his riches: But let him that glorieth glory in this that he understandeth and knoweth me. . . ." For Denys, "noble and excellent persons" blessed with riches and dignities have the greatest need for humility and the fear of God. Not only are they prone to the sins of the flesh from their daily rounds of splendid feasts and entertainments, but the numerous honors and accolades they constantly receive cause them to swell up with pride, pompously extolling and inflating themselves. "Thus elation, presumption, boasting, vainglory, and related abuses and vices abound among lofty and noble persons."[88]

There are indications that the fall of the house of Burgundy was widely connected to vainglorious abuse of ducal power and wealth. Charles the Bold's penchant for lavish ostentation in dress and manners was frequently criticized.[89] Philippe de Commynes, who deserted the Burgundian court in 1472 and went over to the French, linked the emperor Frederick II's abrupt departure

---

[86] Huizinga, *Waning* (as in note 1), 182–183.

[87] *Directorium vitae nobilium*, iv, in Dionysius Carthusiensis (Denys le Chartreux), *Opera omnia* (Tournai, 1910), XXXVII, p. 527.

[88] Ibid., V, p. 529.

[89] As Olivier de la Marche remarked, the Burgundian duke "fut moult somptueulx en pompes et habillemens tant à la guerre que à la paix." *Mémoires d'Olivier de la Marche*, ed. H. Beaune and J. D'Arbaumont (Paris, 1888), vol. 4, 167. Philippe de Wielant contrasted the "superfluous" dress favored by Charles and his court to the "honest and simple" attire worn by his father Philip the Good. P. Wielant, *Recueil des antiquités de Flandre*, in *Corpus chronicorum Flandriae*, ed. J.-J. de Smet (Brussels, 1865), vol. 4, 55; V. Fris, "Les Antiquités de Flandre de Philippe Wielant," *Bulletin de la Commission royale d'histoire* (1901), 393–407. Vainglorious dress had often been rebuked by moralists outraged at hennins, houppelands, poulaines and other "superfluous" types of fourteenth- and fifteenth-century aristocratic garb; A. Piaget, *Martin le Franc* (Lausanne, 1888), 118–119.

from his meeting with Charles at Trier in September, 1473, to the Germans' resentment of the Burgundian duke's proud bearing and pretentious display of wealth. According to Commynes, "Les Allemands mesprisoient la pompe et parolles dudict duc, l'atribuant à l'orgueil."[90] The loss to the Swiss at the battles of Grandson and Morat of fabulous ducal collections of art and jewels which Charles carted along on his military campaigns underscored the folly of his extravagant ostentation and love of ceremonial display. The duke's ignominious death on the battlefield at Nancy in 1477 made a shocking contrast to his former glory: his stripped corpse lay for days in the snow-covered gore until it was recovered. An apocryphal tradition had it that the Burgundian ducal jester, "Le Glorieux," found his master's remains, adding supreme irony to his end.[91]

While Burgundian apologists like Olivier de la Marche and Jean Molinet attributed Charles's defeat to "deceptive Fortune" or to the impersonal intervention of "Accident,"[92] others perceived the retributive hand of an angered God at work. According to Commynes, the Lord punished the Burgundian duke for his proud misuse of the great gifts of fortune and grace that had been conferred upon him.[93] Charles's self-glorification had blinded him to wise counsel as well as to recognition of the true source of his greatness.[94] Commynes remarked on the duke's obsession with military glory and his vainglorious failure to attribute his great blessings to God:

> Je n'ay veü nulle occasion par quoy plus tost peüst avoir encouru l'ire de Dieu, que de ce que, toutes les graces et honneurs qu'il avoit receües en ce monde, les estimoit toutes procédées de son sens et de sa vertu, sans les attribuer à Dieu, comme it devoit. . . . Il desiroit grant gloire, qui estoit ce qui plus le mectoit en ces guerres. . . .[95]

Commynes's views were echoed by the French king Louis XI, who was reported to have observed not long after the battle of Nancy that the late Burgun-

---

90 Philippe de Commynes, *Mémoires*, ed. J. Calmette (Paris, 1964), vol. 1, ii, 8, p. 139; *The Memoirs of Philippe de Commynes*, trans. I. Cazeaux, ed. S. Kinser (Columbia, 1969), vol. 1, ii, pp. 175–176.

91 F. Deuchler, *The Burgundian Booty and Works of Burgundian Court Art*, exhib. cat., Historical Museum (Bern, 1969), no. 6.

92 *Chroniques de Jean Molinet*, ed. G. Doutrepont and O. Jodogne (Brussels, 1935), vol. 1, xlv, p. 208. Olivier de la Marche treated Charles's demise in a fanciful chivalric allegory, *Le chevalier délibéré*, finished in 1483. Charles is killed by Accident, a powerful knight mounted on a black charger Arrogance and armed with the lance of Misfortune, sword of Rashness, and club of Fortune. *Charles le Téméraire* (as in note 46), 118–119, no. 35a; 123–124, no. 38.

93 Commynes, *Mémoires*, ed. Calmette (as in note 90), vol. 1, i, 12, p. 79; trans. Cazeaux (as in note 90), 137. Cf. J. Dufournet, *La destruction des mythes dans les Mémoires de Philippe de Commynes* (Geneva, 1966), 90–97.

94 Commynes, *Mémoires*, ed. Calmette (as in note 90), vol. 1, i, iv, pp. 37–38; trans. Cazeaux (as in note 90), 114.

95 Commynes, *Mémoires*, ed. Calmette (as in note 90), vol. 2, v, 9, p. 154; trans. Cazeaux (as in note 90), 325.

dian duke "a tout perdu par son orgueil, et n'a jamais voulu écouter un bon conseil; aussi a-t-il été pris et detruit par le plus petit duc de mon royaume."[96]

The learned Parisian humanist Robert Gaguin (b. 1433), originally from Artois, a close adviser to the late duke's mother, Isabella of Portugal, similarly viewed Charles's downfall in terms of willful abuse of the great Burgundian glory he had inherited. This is explicit in Gaguin's poem of ca. 1480, *Le debat du laboureur, du prestre et du gendarme*, which expresses the social and moral disruption of the day:

> Quatre ducs furet Bourguignons,
> Dont assez fresche est la memoire;
> Desquelz les ungz sont sages et bons,
> Les autres ont eu tant de gloire
> Et d'entreprinse transitoire
> Que leur maison en est confuse.
> Eaue qui trop croist ront son escluse.
>
> Par cest coquarde imprudence
> Nous ne pensons point aux dommages
> Ne aux lourdes et grandes despenses
> Que guerre fait, ne les oultrages.
> Tout y va, corps, ame, biens, gaiges;
> La vie y branle, et nostre estat:
> Ung seul coup conne eschec et mat.
>
> Telle entreprise est de victoire
> Pour pugnir le mal, ce dit on:
> Je dit, moy, c'est vaine gloire,
> Et pour aultre ne combat on.[97]

Elsewhere in the poem Gaguin indicted the horrors of the day brought upon by "Bobanc, le glorieux" and other cruel consequences of the eighth deadly sin.[98]

The inference that Charles the Bold's fall was due to pride and vainglory became widely accepted during the Renaissance, despite efforts of Burgundo-Hapsburg rhetoricians to polish the luster of his name. Echoes of this moralized historical interpretation can be found in the nickname given Charles by nineteenth-century French historians, "le Téméraire" (properly, "the Rash"), as well as in Huizinga's pejorative opinions about Burgundian ostentation and excess. In the *Histoire de Louis XI*, written in the late fifteenth century by Thomas Basin, Charles's defeat had already been connected with his obstinate "temerity" and proud exaltation that caused him to disregard advice and foolishly fear no en-

---

[96] M. de Barante, *Histoire de ducs de Bourgogne, 1364–1477* (Paris, 1826), 273.
[97] Gaguin, *Epistolae et orationes*, ed. Thuasne (as in note 71), vol. 2, 406, cxix–cxxi.
[98] Ibid., 392, lxxvii–lxxviii.

emy.[99] It is generally accepted that the lesson of the late Burgundian duke informed Erasmus's lengthy critique of military glory in his *Panegyricus*, written for Philip the Fair to celebrate his return from Spain, delivered at Brussels on January 6, 1504 and printed at Antwerp the following month.[100]

The *psychomachia* that we have been tracing between opposing conceptions of neochivalric glory encapsulates the shifting, transformative values of the Burgundian age, when emerging positivistic potentials of secular fame and honor contended with traditional medieval ethical qualms, generating a gleaming but fragile and transparent myth of *gloire* tinged with *vaine gloire*. The failed synthesis of values that Huizinga ascribed to a declining epoch marked by backward-looking romanticism comes into clearer focus when viewed against this perceptual framework of changing values of moral philosophy. The next generation shifted the balance inexorably, assimilating Burgundian chivalric modes within cohesive Renaissance panegyrical strategies adopted from classical antiquity and disseminated by new technologies of printing and printmaking. Humanistic and artistic revivals of antique triumphs and related forms of propagandistic glorification were adroitly merged with the illusion of chivalric supremacy in the elaborate illustrated books and woodcut ensembles commissioned by Maximilian I, whose marriage to Charles the Bold's daughter, Mary of Burgundy, gave dynastic historical continuity to virtuous Burgundian glory and *bonne renommée*.[101]

Vainglory soon became a forgotten deadly sin, long since ceasing to distract us from the illogical passion for fame and glory.[102] Yet manifestations of chivalric vainglory continued to form typical butts of artistic and literary satire. Knightly passion for jousts and tournaments had long been caricatured in misericords[103]

[99] T. Basin, *Histoire de Louis XI*, ed. C. Samaran and M.-C. Garand (Paris, 1966), vol. 2, v, 15, p. 357.

[100] Erasmus, *Panegyric for Archduke Philip of Austria (Panegyricus ad Philippum archiducem Austriae)*, trans. and ed. B. Radice, in *Collected Works of Erasmus*, ed. A. H. T. Levi (Toronto, 1986), vol. 27, 53, 59–60. For the emblematic mentality of the Renaissance, Charles the Bold joined the ranks of legendary figures like Phaeton and Icarus who had fallen due to their overweening ambition. This is demonstrated by the commentary in Alciati's famous *Emblemata*, which cited the duke under the emblem "In temerarios," picturing the recklessly ambitious Phaeton falling from the chariot of the sun. A. Alciati, *Emblemata* (Padua, 1621), lvi, 264–268.

[101] J.-D. Müller, *Gedechtnus. Literatur und Hofgesellschaft um Maximilian I.* (Munich, 1982); W. H. Jackson, "The Tournament and Chivalry in German Tournament Books of the Sixteenth Century and in the Literary Works of Emperor Maximilian I," in *The Ideals and Practice of Medieval Knighthood*, ed. C. Harper-Bill and R. Harvey (Suffolk, 1986), 49–73. In the *Theuerdank*, an elaborate romance recounting Maximilian's wooing of Mary published in 1517, the Burgundian princess was idealized as "Frau Ehrenreich," reviving the traditional allegorical *topos* of Frau Ehre (Lady Honor, or Lady Glory) closely associated with Frau Minne in German courtly love poems. Cf. O. Lauffer, *Frau Minne in Schrifttum und bildender Kunst des deutschen Mittelalters* (Hamburg, 1947), 20–21.

[102] The recent study by L. Braudy, *The Frenzy of Renown, Fame and Its History* (New York, 1986), virtually ignored the subject.

[103] *Age of Chivalry, Art in Plantagenet England, 1200–1400*, exhib. cat., ed. J. Alexander and P. Binski, Royal Academy of Arts (London, 1987), 254, no. 149, misericord, ca. 1379 (Worcester Cathedral). See also L. Maeterlinck, *Le genre satirique, fantastique et licencieux dans la sculpture flamande et wallonne* (Paris, 1910), 189, fig. 115; 204, fig. 124.

and in the margins of illuminated manuscripts.[104] The *miles gloriosus* became a popular subject for mockery in the sixteenth and seventeenth centuries. Northern Renaissance satires by Brant, Bosch, Rabelais, Erasmus, and others revived comical spoofs of foolish praise-seeking and self-aggrandizement by ancient humorists such as Juvenal and Lucian.[105] Studies of the satirical conventions of Renaissance wit promise to reveal much self-critical humanist involvement with the pleasures and perils of the pursuit of glory.

THE UNIVERSITY OF CALIFORNIA AT SANTA BARBARA

[104] For example, the delightful tournament of apes in Queen Mary's Psalter. T. Wright, *A History of Caricature and Grotesque in Literature and Art* (London, 1865; reprint New York, 1968), 97–99, nos. 62–63; L. Maeterlinck, *Le genre satirique dans la peinture flamande* (Paris, 1903), 59–69, figs. 48–49. Cf. also the Joust between Stag on Lion and Ape on Griffon in the same manuscript. An amusing fifteenth-century drypoint by the Housebook Master depicts two wild men jousting rather lamely with uprooted tree trunks. Their mock-armor, decorated with elaborate curlicues and crests of beets and onions, effectively parodies ostentatious knightly regalia. J. P. Filedt Kok, *Livelier than Life: The Master of the Amsterdam Cabinet or the Housebook Master*, exhib. cat., Rijksmuseum (Amsterdam, 1985), 146–147, no. 53. For other examples of chivalric parodies in which wild men combat Christian knights, see T. Husband, *The Wild Man: Medieval Myth and Symbolism*, exhib. cat., Metropolitan Museum of Art (New York, 1980), 138–139.

[105] For further discussion of this neglected aspect of Renaissance satire, see my study *Bosch and Vainglory* (as in note 11).

1. *Débat sur l'honneur*, 1449/50, fol. 1r, illumination by Jean le Tavernier; Jean Miélot, the translator, presenting the manuscript to Duke Philip the Good. Brussels, Bibliothèque royale Albert 1er, ms. 9278 (photo: Bibliothèque royale Albert 1er)

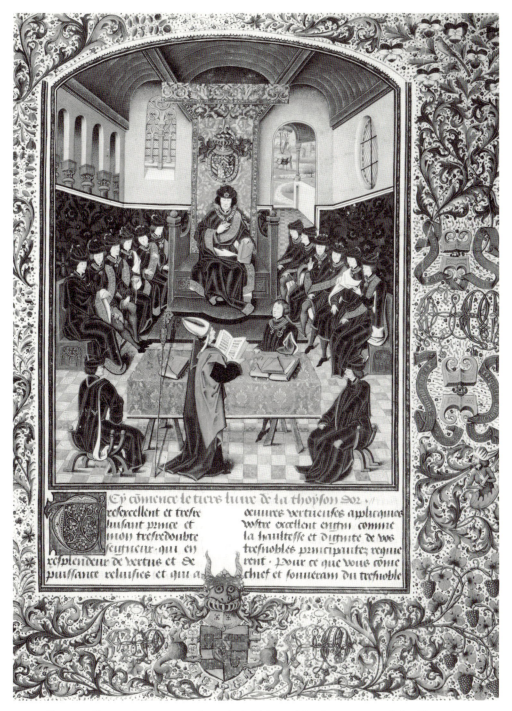

Cy comence le tiers liure de la thoyson dor

rexcellent et tresre
luisant prince et
mon tresredoubte
seigneur qui en
resplendeur de vertus et de
puissance reluisies et qui a

œuures vertueuses aplicquies
vostre excellent engin comme
la hault esse et dignite de vos
tresnobles principautez requie
rent · Pour ce que vous comme
chief et souueram du tresnoble

2. Guillaume Fillastre, *Le troisième livre de la Toison d'Or*, last quarter of the fifteenth century, fol. 1, the Chapter of the Order of the Golden Fleece. Copenhagen, Det Kongelige Bibliotek, cod. Thott 465 (photo: Kongelige Bibliotek)

3. Pierre Michault, *Le doctrinal du temps present*, fifteenth century, fol. 23r, *Vaine Gloire* lecturing. Paris, Bibliothèque Nationale ms. fr. 1654 (photo: Bibliothèque Nationale)

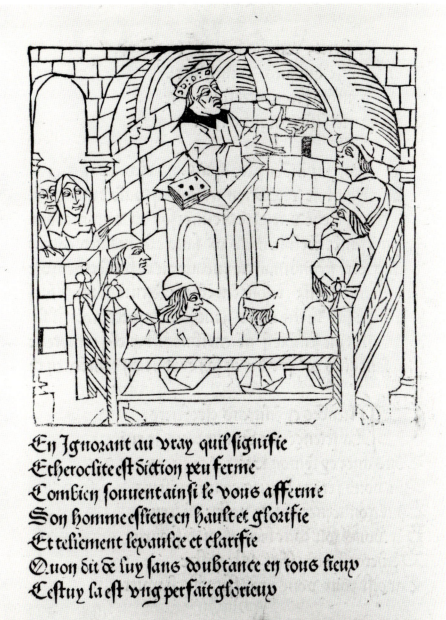

En Ignozant au vray quil signifie
Etheroclite est diction peu ferme
Combien souuent ainsi le vous afferme
Son homme esseue en hault et glozifie
Et tessement sepausee et clarifie
Quon dit de suy sans doubtance en tous sieux
Cestuy sa est vng perfait glozieux

Puisques doncq gloire est auy etheroclites

4. Pierre Michault, *Le doctrinal du temps present* (Lyons, Imprimeur de l'Abuzé en Court, ca. 1484), fol. [C7], *Vaine Gloire* lecturing (photo: Library of Congress)